W9-BPK-315

SSF

A SCULPTOR'S GUIDE TO
Tools and Materials

by Bruner Felton Barrie

S.S.F. Public Library
West Orange
840 West Orange Ave.
South San Francisco, CA 94080

DEC 2008

GAYLORD

Copyright © 1996 Bruner F. Barrie.

All rights reserved. This book or parts thereof may not be reproduced an any form without written permission from the author or his legal representatives.

Second Printing, February 2003

Library of Congress Catalog Number 96-95009
ISBN 0-9631867-1-X

Editing by Sue Avery and HyBar Consulting Group, Pennington, NJ
Photographs by Bruce R. Barrie
Book Typesetting & Design by MK Design, Skillman, NJ

Printed in the UNITED STATES OF AMERICA
Thomson-Shore, Inc., Dexter, MI

A.B.F.S. Publishing
Boca Raton • Philadelphia • Princeton • New York

This book is dedicated
to my wife, Nancy

Table of Contents

Introduction

All of us have had some experience with art. Most people will have at least some knowledge of the art field and the materials used by artists, for example, oil paint, acrylic, charcoal, and canvas, maybe even gesso and turpentine. Most art students will also have a good general knowledge of their specific fields of study, whether it be pen and ink, abstract drawing, painting, or sculpture.

Sculpture, one of the disciplines within the art field, constitutes only about three percent of the entire field. Its major categories, such as ceramics, wood carving, stone carving, mold making and casting, vary greatly. And students, as well as teachers of sculpture, may not know all aspects of sculpture; for example, a stone carving instructor may well know everything there is to know about carving stone, where it originates, and the various hardnesses and colors of stone, but might not know at what temperature to bisque fire a stoneware clay. This is not uncommon; the stone carver should not be expected to know all that a ceramist would know about modeling clay and firing, and vice versa. The same would hold true for wood carvers; they, too, would have limited or no knowledge of mold making and casting bronze.

This is why I have written this manual. With twenty-five years of experience in the manufacture and sale of sculpture materials and accessories, and having been given formal instruction in all areas of sculpture (stone carving, wood carving, mold making, casting, wax work, enlarging, and pottery) I have acquired hands-on experience enabling me to answer questions in all sculpting categories. I can also identify the sources for those items that may be somewhat outside the field of sculpture.

This manual was originally intended for the sales staff of Sculpture House so they could answer questions as they came in to our office, and could provide product information to those purchasing our materials. A second incentive to publish this manual was to support the art stores who sell sculpture materials and supplies. Since trained employees often move on to other jobs after only a few short months, the stores are unable to maintain a solid core of personnel knowledgeable in sculpture. A reference guide to the tools and materials covering the entire realm of sculpture seems a perfect solution to this problem. Finally, it occurred to me that not only Sculpture House and sales personnel could benefit from this manual, but anyone interested in the field of sculpture.

This guide incorporates general product information including tool weights and dimensions, answers to the most frequently asked questions, and troubleshooting tips.

I believe the information will be of assistance to you. If there are any unanswered questions, contact us and my staff will try their hardest to answer them

How To Use This Guide

■ Key Word Technique

When using this guide, first identify the **general topic** you are exploring. Second, define the **medium** in which you want to work, the **function** you want to perform, or the **tool** or **accessory** you want to use. For example: Suppose you want to make a wall tile using clay - wall tile is the topic; and clay is the medium in which you want to work. Next, choose a **key word** used in either the topic, medium, or function. Then refer to the Table of Contents, Glossary, or Index for more information on that key word.

- For information on a **general topic**, refer to the Table of Contents to find where the information will be found in the manual.

- If you are looking for information on a **medium, tool, or accessory,** such as plastilina, Microcrystalline wax, or a wood carving tool, refer to the Glossary or Index using these as key words.

- If you have a specific question, such as "How do I make a mold of a clay figure?", determine what you want to do, or the medium in which you want to work, and look up the key word in the Glossary to find the appropriate page(s).

- To determine the size and weight of a specific tool supplied by Sculpture House, Inc., refer to Appendix E: Tool Weights and Dimensions. All tools are listed by item number; functional ends, weight, and overall lengths are given for each.

- If you are looking for the correct amount of material required to sculpt a head/bust, figure, or animal, such as "How much latex would be required to make a head mold?" or "How much plaster should be used to make a mother mold of an 18-inch figure?", refer to Appendix F: Material Requirements Usage Chart.

Modeling

PART 1

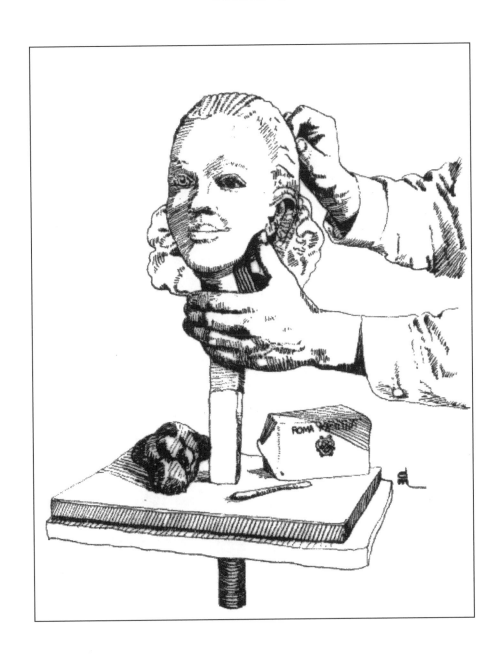

Plastilina

PLASTILINA IS A WAX AND OIL-BASE MODELING MATERIAL used by sculptors for modeling pieces. The main ingredients are wax, oil, and clay flour which is used as a binder. All plastilina is produced hot, and then cooled and extruded into the shape that will eventually be available for sale in art supply stores. There are basically three groups of plastilina: **professional grade, school grade,** and **industrial grade**.

The **professional grade** commonly contains sulfur, to make the smoother, more homogeneous texture required by professionals. A non-sulfur professional grade material in medium consistency, called Prima, is also available. The **school grade**, or amateur grade material, does not contain sulfur and tends to be stiffer and harder to model with the fingers. School grade material comes in a variety of striking colors and is used in the claymation field of movie production and advertising. The **industrial grade** material is usually very hard and needs to be heated prior to use. This type of material is most commonly used by designers in the automotive field for car models and is not available to the retail consumer. The large auto companies use batch lots in large quantities of 2,000 pounds or more, and the material is so hard it cannot be modeled at room temperature.

Plastilina can also be referred to as plasteline, plasticium, and plasticine. I imagine there are a few other spellings, but basically all are wax and oil-base modeling materials. Plastilina is used as a modeling material only and **cannot** and should not be fired in any way. Plastilina cannot be made permanent. A mold of plaster or rubber must be made to obtain a finished piece.

Although the material is permanently pliable due to its wax and oil content, it will dry out or become stiff after a number of plaster molds have been made over the material, or after it has been used over natural wood armatures. After a long period of time, the oil may seep out and evaporate, causing dryness. To refurbish the material, small amounts of household oil or 30-weight motor oil may be kneaded into it, a small amount at a time. Placing the plastilina near a 60-watt light bulb for

twenty to thirty minutes will soften it enough to make it easier to work with. For refurbishing 10 to 20 pounds, purchase a hand hamburger grinder at the local hardware store, add the oil as described above and run the mixture through the grinder several times. For extremely large quantities the plastilina can be returned to the manufacturer and refurbished, usually for a nominal charge.

One disadvantage of plastilina is that there is no way to make the material permanent; so be prepared to make a mold and cast or have one made of the piece.[1] A great advantage of this material is that it may be stored and worked over a long period without hardening; changes, additions, or corrections are easily made.

The **professional grade** material is packaged in two-pound units and comes in three colors: grey-green, off-white, and brown or natural tan. It is available in four basic hardnesses. Number One is the softest and is used for building up large pieces of monumental size. Number Two, a medium grade, and the most commonly used by sculptors, is used for heads and busts and figures ranging up to three feet. Number Three is used for more detailed work and is sometimes placed over the Number One and Number Two when working on facial features. Number Four is the hardest and is used for medallions, coins, and extremely detailed small work.

The **professional grade** material normally contains sulfur and cannot be used with most rubber molds without some form of a separator, such as shellac, between the plastilina and the rubber. It is recommended that a separator coating be used in all cases as a precaution. This separator is not necessary, however, with the non-sulfur professional grade material.

[1] See Chapter 6, Mold Making & Casting.

The **school grade** material is packaged in one-pound and five-pound units and comes in a variety of colors. The cost of production is less than for the professional grade, and the retail price is therefore lower.

There aren't many manufacturers of plastilina in the professional or school grades. Your local art supply store will be able to give you information on the manufacturers of the different materials they carry. You can then refer any questions you have directly to the specific manufacturer.

■ Trouble Shooting/Questions

How can I soften plastilina?

To soften plastilina, if not being used at room temperature, 68° - 70°, place the material approximately two to three feet from a 60-watt light bulb for about twenty minutes. To change the grade consistency (for example, to soften grade No. 3 plastilina to grade No. 2 plastilina), soften the clay as instructed above by placing it near a light bulb and knead in small amounts of oil until an even consistency is achieved.

How can I harden plastilina?

To harden plastilina, place it in the refrigerator for thirty to forty minutes before working with it. There is no technique for permanent hardening. To change the grade consistency (for example, to harden grade No. 2 plastilina to grade No. 3 plastilina), soften the clay as directed above and add softened Microcrystalline Wax in small amounts to the material by kneading it into the softened plastilina until the desired consistency is achieved.

How can I restore dried out plastilina?

Knead household oil, a few drops at a time, into the material until you have acquired the desired consistency.

How can I correct color inconsistencies?
This is not easily done since the raw materials will vary from batch to batch. Purchase enough plastilina for each use, if even color is desired. Most of the time the color will be extremely close, but as with everything made of natural ingredients it may vary.

How can I correct uneven consistencies?
Since the raw materials are of natural origin they will vary. Although manufacturers attempt to guarantee consistency, composition changes over long periods of time cannot be avoided. Consistency will be the goal of the manufacturer but may not always be achieved.

Color. Manufacturers cannot guarantee the production of totally accurate color batches from the pigment producer, but work to achieve the closest possible color consistency. Purchase in batch lots if possible if accurate color consistency is absolutely necessary. Remember the plastilina is only a model to be cast and is not the finished piece.

Hardness. This is regulated by the ingredients in the specific formula and, depending on the variation of the raw materials, may differ slightly, although not commonly. During temperature changes in the weather, the material will also change slightly; in the summer, the material seems softer and in winter months, it may seem harder. Sitting at room tempera-ture for eight hours, all plastilina should return to its stated hardness.

Short-Dry Material. This is caused by lack of wax or oil, or may occur because the manufacturer has not aged the plastilina (that is, allowing it to mature for several weeks, if not months, before packaging). Add household oil or return the material to the supplier.

How can I make plastilina permanent?
You can't. A mold must be made and a cast drawn for the final piece.

Can I microwave plastilina?
Some people do, but it is not recommended, especially with the sulfur-based material.

Can I heat the material in my kitchen oven?
Yes, but it is not recommended. The outside will melt before the center. Rather, place the material two to three feet from a 60-watt light bulb for twenty minutes and it will soften through like butter left on the counter; it will return to its stated consistency when left at room temperature.

Can plastilina be melted and poured?
No! The physical make-up does not allow this. Some of the material's components could ignite when heating excessively. Remember, this is a wax and oil-base modeling material.

Direct Modeling Materials - Air-Dried, Non-Firing Materials

A DIRECT MODELING MATERIAL IS ONE THAT CURES NATURALLY producing a finished piece with no other mold making and casting procedures required.

■ Clays

Air-dried or non-firing clays (also known as self-hardening or air-hardening) do not need to be fired in a kiln, and are generally ceramic clay body formulas with a natural additive, such as cornstarch, to make them harden. They are not meant to replace kiln-fired ceramic clay, cannot be used to produce functional ware, and cannot be left outside exposed to the elements. Pieces made using these clays are items for display only. The material should **not** be fired in a ceramic kiln under any circumstances. It is porous and cannot hold liquid unless sealed on the inside surface.

After a finished piece has dried and been sealed, it can be decorated for display in a number of interesting ways. You can add bright colors using acrylic, oil, latex, or watercolor paint, or you can achieve mute color effects using wood stain, wax pigmentation applications, or clothes dyes. You can also spray the finished piece with special effect paints obtained from hardware stores.

There are two basic types of air-hardening clay. The first type, **Claystone**, works like plastilina and is used over an armature, an internal support device. The clay material generally contains some type of pulp or cotton fiber filler to reduce shrinkage and thus prevent cracking. (The armature will not give when the clay shrinks due to evaporation of moisture.) Please note, there will be some degree of shrinkage when using a water-base material, so expect minor cracking if the piece is thin and modeled over a solid support. Cracking may also appear at sharp angles and joints. The material over an armature will most likely be fatty or more bulky due to the filler that is incorporated in the formula to reduce shrinkage.

The second type of air-hardening clay, **Boneware**, is used for solid direct modeling that in essence will be supported by its own bulk. It will contain a natural hardener, but not fiber, to reduce shrinkage and will probably feel and react more like a ceramics clay to the touch and in workability.

The primary colors of Claystone and Boneware are gray and red. Sometimes referred to as stone gray or even terra cotta, the colors are generally deeper and richer than what is usually expected.

There is another type of self-hardening material that can be air-dried or fired in the kitchen oven to give the piece more durability. An example of this material is Della Robbia. This type of material will not replace a kiln-fired ceramic clay that is fired in excess of 2000°F fusing the molecular structure and becoming vitrified and non-porous. Please note, for any self-hardening clay there is no known method to emulate vitrification.

Note that with all the self-hardening clays the inside of the piece will dry last since the outer coating will harden first sealing the external parts. Drying on a rack, such as a bread rack, is the preferred method to achieve even drying. Drying time will vary depending on the bulk of the material. (In some cases it can take up to three months for larger pieces.) Water constitutes about 20% of the volume of a piece. To determine when the piece is completely dry, first weigh the original, then periodically weigh the piece while it is drying - when the weight has decreased by 20%, you will know it is dry.

To maintain the material's pliability when not working with it, keep it airtight and spray it with water using a plant mister. A damp cloth may also be draped over a piece during short work breaks to maintain its plasticity.

■ Liquid Metal

Sculpmetal is a pliable air-hardening material that can be modeled with a modeling tool or by hand. The consistency is somewhat rubbery and I find the material does not flow smoothly unless thinned with solvent. The final results harden into an aluminum metal such as might be used for a canoe. (I have used the material to repair rust spots on my jeep so it will hold up well under adverse conditions.)

This material cannot be flow cast but can be press molded, usually in the relief form. It can also be applied over existing models of sealed plaster or Styrofoam to make a permanent metal piece. The hardened piece can be sanded and rasped to give a smooth finish; this takes a degree of patience and practice. To color the finished piece, normal metal patinas can be applied or it can be buffed to a matte or gloss finish. In its original form, the metal is a flat gray.

Modeling directly over an armature, unless the form has been built up, will result in a thin form of sculpture. Since the outside hardens first and seals the inner material, only thin coats of Sculpmetal should be applied at one time. A solvent or thinner is available and can be added by kneading it into small amounts of the material until the desired consistency is achieved.

I favor this material for direct metal modeling and press molding of bas-relief pieces, but find it difficult to work with, and its quick drying time to be somewhat of a hindrance.

■ Plaster

Although plaster is considered a direct modeling material by some, it is not widely used as such. The rapid setting time of the plaster (15 to 20 minutes) requires the sculptor to work extremely fast. Therefore a very small percent-

age of highly qualified professional sculptors are usually the only artists who use this material for direct modeling.

■ Polymer Clay (Plastic)

This material is more commonly used in the craft field. It is available in various colors but white is usually the color of choice. Like Sculpmetal, it is a somewhat rubbery material compared to a ceramic clay, and does not model as well because of its flow factor. It may be modeled by hand or with modeling tools and can be fired in a conventional kitchen oven. The final piece will be hard plastic which is quite durable with little shrinkage or distortion.

I do not know of any large head and bust figures being done in this medium so have no comment on the material's ability to produce desired effects in the traditional sculpture field. For small relief figures and medallions, I believe it is the finest material available today. The shelf life of this material, if it remains packaged, is approximately six months before it may harden; and if opened, you can work with it for months with no danger of hardening if it is kept airtight when not in use.

■ Wax

Most waxes are derivatives of oil or petrolatum base materials. The exception is natural beeswax. Waxes will vary in consistency and color. In sculpture two primary waxes are used 90% of the time: Microcrystalline Wax and Roman Casting Wax.

Microcrystalline Wax, also known generically as Victory Brown and micro wax, is by far the most popular wax. It is medium soft, inexpensive, and nut-brown in color. Although it is somewhat sticky, it can be used for direct modeling and the lost wax method of mold making.

Roman Casting Wax, harder, more brittle and varying from purple to black in color, is used to make final detailed definitions prior to casting as well as for carving and modeling small objects. It is also used for casting prior to bronze investment

There are specific formula waxes such as **French Wax,** a mixture of white micro, pure beeswax, and a small amount of number A4 wax (a private studio blend of Sculpture House, Inc.). This material is of medium consistency and is extremely smooth and easy to model. It may also be used for the lost wax process, as any wax can be. This superior material costs somewhat more than micro wax.

Sheet waxes are also available, as well as rods waxes and square waxes. There are paraffin waxes for candle making and special mixture waxes used for jewelry, available in a multitude of colors. All of these may be used in the sculpture field but generally are not. These special shaped waxes can be found through jewelry supply outlets.

■ Trouble Shooting/Questions

What is cracking?
This is a common effect when the material is applied too thinly against a stiff armature or is dried too fast, especially in thin areas or at acute angles. The cracks can be filled with new material and sanded when dry.

What is discoloration?
At times the material will dry with uneven coloration. This is a natural phenomenon and cannot be explained. The cure for this is to apply a thin coat of wood or furniture stain in the desired color prior to sealing the piece for final display.

How can I dry a piece correctly?

The material should be dried extremely slowly for best effect. This may be done by placing a damp cloth over the piece and drying it at room temperature slowly and evenly. It is not recommended that the material be placed in the sun, in an oven, or by a radiator to hasten drying. Remember to allow the piece to dry thoroughly before sealing or applying patina (coloring).

Will the hardened material be vitrified (non-porous)?

No. Air-dried materials are characteristically porous and will not hold liquids or withstand the effects of outside weather over a sustained period of time.

Can these materials be thrown on the potter's wheel?

No. Most of the air-dried materials on the market today will not stand up to the added water required to bring up the side walls on pottery, although there are products that come close.

How can I seal this to hold water?

Generally, this is not doable but applying several coatings of shellac or transparent clear spray enamel on the inner surface of the piece might be a solution. Remember these materials are for decorative purposes only and not meant for use in functional items.

Can the finished piece be colored?

Yes, in a variety of textures, such as clear finish or matte finish, that are directly applied to the piece. For more realistic colors, sealing the surface to be covered with clear or base paint color will allow the final coating color to adhere easily. This may be latex paint, acrylic, oil, or even water colors. I recommend a test tile be made and that you experiment to achieve best results. I number each test tile and write down what steps I have taken to create a given effect on each tile.

How do I stop warping?

With tiles and relief models, it is best to place the piece on a bread drying rack exposing the bottom areas to air; then place a damp cloth on the outer surface so the piece can dry slowly.

Modeling Tools & Accessories

HILE THE THUMB AND FINGERS ARE BY FAR the best modeling implements, sometimes additional tools are required. Modeling tools come in a variety of styles, shapes, and sizes. Their primary uses are cutting, scraping, or shaping modeling material in a certain way to create a desired effect. The tools most commonly used by sculptors are wire end tools for cutting and scraping, and those constructed of solid plastic or wood designed for shaping and detail work.

It is important to mention here that modeling tools are interchangeable. For example, tools used for working with plaster and in mold making may also be used in modeling plastilina and wax, sometimes even for cutting soft wood or detailing harder woods or stone. Whatever their application, all tools are acceptable in the sculpture field. It is always best to consult with an instructor or sculpting professional to determine the best size and shape of modeling tool required for a specific project. A head and bust twice life size will not require the same tools as a small medallion or bas-relief; modeling plastilina, as opposed to ceramic clay, wax, or plaster, may require a different set of tools although many are interchangeable.

Tools wear down over time, wearing faster when used extensively on abrasive materials.

For example, a ceramic clay tool of brass wire which is very soft and used on smooth clay will last ten times longer than the same tool used to trim pottery made of terra cotta with grog, an abrasive material. With time wood modeling tools will even take the shape of a sculptor's thumb or finger. I have seen this quite often.

◼ Wire End Modeling Tools

The wire end series will vary with the type of wire used for cutting and the material it will be cutting. Ceramic sculptors generally use tools with half-round or semi-sharp cutting edges, or a combination tool with one wire end and one smoothing end. Since ceramic clay is so soft the tool need not have a great deal of cutting ability.

When working with wax and plastilina,

however, a tool with a somewhat sharper cutting edge is necessary since the material is firmer and more detail work may be desired. Certain types of wax, roman casting in particular, will need a sharp edge (This type of tool can also be used with ceramic clay when it is in the leather-hard state.) Working on set plaster will also require a heavy sharp cutting edge.

While there may be slight variations among producers of wire end tools, the major types include: **single wire end, double wire end, and combination of single wire and plain modeling end.** These tools have the following types of cutting ends: **soft round, semi-sharpened, heavy sharpened, half round, serrated (curved) and thin round.** The type of metal used to make the wire ends are: **carbon steel for heavier tools, tool steel, piano wire, spring steel, and brass half round.**

■ Wood and Plastic Modeling Tools

Flat or hand modeling tools, sometimes known as thumb tools since the thumb is almost always used to hold the tool while modeling, are produced in hard or medium hard woods or in high impact plastic by injection molding. Since all modeling tools are made by hand, they may vary slightly in size and shape.

The wood may also vary. Boxwood and lignum vitae have been almost unattainable because of the Haiti embargo. Maple has been used as the substitute. Most wood tools will be sealed with wax or varnish but may be customized by sanding or rasping if the shape is not exactly as desired to perform a specific function. A coating of wax and/or shellac will reseal the reshaped tool.

■ Tool Handles

Modeling tool handles may be made of wood such as birch, oak, and fir as well as aluminum tubing cut to the desired length. The majority of wire end tools will have the wires and handles attached with solid spun ferrules normally made of brass or nickel, attached using heavy strength waterproof glue. Wooden handles are round tapered wood turnings of which the rounded end, attached where the ferrules, glue, wire, and wood come together, is ground flat to let the wire sit between the wood and metal. Aluminum handled tools are pressure stamped or crimped, with the wire inside the tubing of the handle, and then polished smooth. At times you may see wire end tools, generally from Taiwan or China, with wire wrapping securing the ends to the handle.

With absorption and evaporation of moisture, ferrules and wires may work loose or crack due to the expansion and contraction of the wood. There is no way to stop this since it is a natural occurrence; however, epoxy or electrical tape can be applied if the cracking or loosening becomes extreme.

■ Modeling Tool Kits

There are several tool kits available with a variety of tools included. These kits are designed for the beginner or intermediate artist since it might be easier to purchase a set than try to decide what may be needed. Most kits are designed to include the most commonly used tools for a given medium, for example, a steel tool set to be used with wax, plaster, and plastilina or a plastic and wood modeling tool set for school children modeling in ceramic water base clay. You should never purchase more tools than are needed for a project. Ask an instructor, art store retailer, or even the manufacturer who produces the tool sets for advice.

■ Plaster Tools

Plaster carving chisels have sharpened ends and are meant for carving plaster, but may also be used on wood, plastilina, and even soft stone.

Plaster scrapers have thick wooden handles to facilitate the cutting or scraping function without undue stress while holding the tool. They have hooked ends which are mostly serrated and made of heavy and lighter weight steel ground sharp. They come in four sizes with the largest in size being the heaviest in weight.

■ Wax Tools

These tools are made of 1095C high carbon steel and can be used with other media just as most of these tools in sculpture can. The difference is that these tools were especially designed and produced for the wax modeling process. The shapes and radial curves of some of the tools make them ideal for heat absorption and concave modeling. Wax tools when heated with an alcohol lamp are used to smooth and sculpt the wax after the basic geometric design has been established. They come in various sizes differing in length and thickness.

■ Steel Tools

Also known as steel plaster and modeling tools, these are made of high carbon steel, these tools can be used in sculpting, mold making, and casting, with wax, plaster, plastilina, or moist clay. They are solid steel, shaped and ground from a single piece of stock. The circumference of the handle or holding shaft varies with

each tool size and has a delicate feel when working.

The tools come in a variety of sizes, shapes, and designs. The palette shaped tools have flexible ends and are generally used in smoothing, mold making, and for mold repairs. Those with heavier stiff or firm ends are used for carving, scraping, and finishing. Usually each end performs a separate function: serrated edges give texture and substance and remove material; curved or hook ends are used for pulling or scraping; cutting or modeling ends for scraping and carving, and rounded, flat ends for smoothing.

Minarettes are fine steel tools used for retouching and small detail work.

■ Modeling Accessories

There are several accessories which can be helpful during a project. One such item is the **banding wheel**, a small plastic turntable that a model can be placed on and that can be rotated like a lazy Susan.

Turnettes are wooden tables that can support a model of several pounds while rotating easily. Some are square and some are round; one even has holes in it to accommodate aluminum wire, another has a 45° slot for a backboard on which you can do relief work. These tables are normally used to hold small models rather than large full figures.[1]

Calipers, though considered by some to be tools, are actually accessories. They are C-shaped expandable devices used to measure distance between points so an exact likeness can be attained. They can be used, either concave or convex, and come in sizes from 6 inches to 12 inches and expanding out up to 18 inches. They are mostly made of press cut aluminum of a heavy gauge secured with lock washers. There are also wooden calipers of the same size, but if they become wet they can warp,

[1] Rotary wheels, or fifth wheels are used for larger items of greater weight. See page 46 for details.

making them unusable. There are also proportional calipers used in the enlargement and reduction of pieces. These are available in sizes from 18 inches to 42 inches and are normally used by professional or advanced sculptors.

Flexible palettes are helpful accessories used for smoothing or scraping, or for pottery trimming and leveling the base of thrown clay. They are available in about six shapes including half round, oval, square, and pointed. They are usually made of blue spring steel or rubber, are about 4 to 5 inches in length, and are extremely flexible.

Block scrapers are rectangular accessories and come in heavy steel with or without serrated teeth. They are used for mold leveling or scraping down mold sides or walls. They can also be used to smooth large models and come in 6-inch and 9-inch lengths.

Aluminum wire, also known as **Almaloy Wire**, is an essential piece of sculpture equipment primarily used to build armatures. This is a very pliable aluminum wire available in five different diameters: 1/16, 1/8, 3/16, 1/4 and 3/8 inch diameters, and three lengths: 32, 20, and 10 foot lengths. The smallest, 1/16 inch diameter, is principally used as wrapping wire allowing clay to more easily adhere to armature sections for build-up. The largest, 3/8 inch diameter, is used to construct specifically designed full size support systems. The other sizes can be used in a number of ways but are usually meant for arms, legs, and appendages of different sorts. Aluminum wire is recommended over other materials for an internal support structure since it will not stain, or rust through a casting in plaster, and it will not corrode. The material is also pliable and light weight.

Almaloy Wire is produced at mills in 80 - 100 pound rolls, each in a specific size. Each run is usually 2 to 3 tons of these 80 - 100 pound rolls in all sizes. The bulk rolls are then cut down, into coils of the most commonly used lengths for sculpture. The rolling and cutting machine chucks are set for these specific lengths and cannot be altered to cut other lengths. Requests for 200 foot continuous wire are sometimes made; they cannot be filled since a chuck large enough to hold that quantity of material does not exist.

An **alcohol lamp** is used for heating the wax tool tips to model hardened wax and detailing wax sculpture prior to mold making and casting.

■ Trouble Shooting/Questions

How precise will a proportional caliper be?
A proportional caliper will measure up to five times a given increment but it is not a high tech tool or a precise device for exacting minute detail. Use it to give approximate measurements for geometrical proportions.

Does the Almaloy Wire (aluminum wire) come in longer continuous lengths other than coils?
Yes. The manufacturer runs these items in coils by weight not length. Each spool can weigh between 80 and 100 pounds in one continuous length. Unfortunately the spools will vary within each shipment so there is no predetermined weight or length until they are individually rewound into the most commonly desired lengths. While not a common practice, some suppliers will sell a complete spool to individuals, but the price will vary depending on the weight.

How clean do I have to keep my tools?
It is best not to leave tools coated with the working medium, such as moist clay and plaster. Keep them clean and dry when not in use, and they will last a lifetime, although normal wear may reduce them in size.

**What about sharpening
my tools - can I do this myself?**

Most wire end tools are not sharpened unless you are a professional sculptor and have the means to do so. Steel tools, however, can easily be sharpened with a bench stone much like sharpening a carving knife for steak, since the steel is high carbon and tempered. There are different shapes and sizes of sharpening stones available to handle any sharpening necessary. See Chapter 10 for more information.

Armatures

N ARMATURE IS AN INTERNAL SUPPORT STRUCTURE or device used to hold the heavy weight of moist clay, plastilina, and other sculpting material that will not support itself. This support structure is usually used when modeling figures and heads over 5 pounds in weight. The armature is much like the human body where the bone structure acts as the armature for the muscle and skin tissue that surrounds it.

Armatures can be made of various materials ranging from newspaper, wax, and two-by-four pieces of wood to screen mesh or chicken wire. Every armature will have a waterproof base board which holds the guts of the structure. Manufacturers design their armatures somewhat differently from each other, but the basic designs are the same. Some use wood as a base, others use pipe on flanges. Take your choice.

When you have sculpted a piece over an armature, you will have to have a mold made of the piece unless you are using moist clay or self-hardening clay. In those cases, remove the piece from the armature when it is leatherhard, cutting and pulling the material from the armature and then reattaching the cut seams.

◾ Types of Armatures

Most commercial armatures are made in three basic types: the **Head** and **Head-Bust; Figures;** and **Animals (horse)**. These three are the principal shapes used in the sculpture field. The armature is secured with a backiron of sturdy steel onto a base of Formica on heavy gauge flakeboard or plywood.

Head armatures, which include the head and a portion of the neck, are available in different sizes: 8 inch life size, 13 inch ½ life size, 15 inch 5/8 life size, and 20 inch life size. The smaller the size the less support is necessary in the base.

Head-Bust armatures, the more widely used of this type, include the head and a portion of the shoulders (bust), and are fitted with a heavy duty backiron support for the Almaloy Wire and the cross bar that makes up the lower

portion of the bust. It is available only in 24 inch life size.

Figure armatures are the most varied and the most popular armatures. They are available in 6, 8, 12, 15, 18, 24, 30, and 36 inch heights. The 15, 18, and 24 inch models have adjustable back irons so the figure can be moved up and down on its back iron support. The others have fixed supports. Wrapping wire is added where necessary for adhesion of the clay.

Animal armatures have the shape of a horse; since most animals have this basic shape, it is the only animal armature available. These armatures are available in three sizes: 6, 8, and 10 inches. The 8 inch armature has an adjustable back iron, the 6 and 10 inch are fixed. If other forms such as birds or frogs are desired, they can be constructed using Almaloy Wire lengths, shaped as necessary.

■ **Building Your Own Armature**

If a specific type of armature is not available through your art supply store, the store will most likely be able to supply you with the Almaloy Wire necessary to construct your own design. Other materials necessary can be purchased from your local hardware store. These include a pipe with flange attachment and a baseboard, "T" fittings that will enable you to attach the wire where necessary, and a few screws to attach the base flange to the board. Working with professionals at a hardware store or art supply store to choose the proper items is both fun and invigorating.

■ **Trouble Shooting/Questions**

The primary difficulty with armatures, in almost all cases, is that the weight of the modeling material placed on it is greater than it was designed to hold. The piece will fall or tilt. You wouldn't expect to load the trunk of your car with ten tons of clay and not have some difficulty driving…would you? The same goes for overloading an armature.[1]

If the Almaloy Wire breaks when adjusting or moving it, can it be repaired?
Not really. The Almaloy Wire or aluminum wire is a pliable metal wire and as with anything pliable, over time it will break. A coat hanger will snap after continuous flexing. Almaloy Wire will hold up for years if not overly flexed. I have seen only a few cases, where arms were moved back and forth and up and down, and the wire finally gave out; but this was after several years of hard use.

Do a mold and cast have to be made over the piece on the armature?
Yes in most cases when oil-based clay, wax, or plaster is used. When water-base clay is used the clay can be removed after it is leather-hard without making a mold or cast.

Can an armature be reused?
Yes. Both the armature and the sculpting medium used on it can be reused, unless the medium is straight plaster. Do not expect to save the sculpted piece though; it will be destroyed in the mold making process in all but a few cases. To remove a water-base clay model from a standard armature, you need to follow several steps: wait until the clay is leather-hard, make cuts along key separating areas, and peel the model from the armature and repair the incision cuts.

[1] See Appendix F, Material Requirements Usage Chart.

Modeling Stands

MODELING STAND SHOULD NOT BE CONFUSED with a pedestal. The stand is used for modeling a piece of sculpture at different heights, whereas a **pedestal** is normally used to display a finished piece of sculpture in a gallery or at a show. The pedestal, solid on all four sides, is laminated white or black micarta.

There are weight restrictions on modeling stands depending on their height; be aware that stands can become top heavy and may tip if more than the recommended weight is placed on the working surface. They also have a rotational device so the stand's top can be easily turned. They are made of wood or metal and have legs, usually with casters as wheels.

One feature which differentiates one stand from another is the method used to raise and lower the stand's top. One method of raising and lowering is by pipe, the top's position being secured with a set pin through a hole drilled in the pipe. The top is raised and lowered with a twisting motion of the hand. A second method of raising and lowering the stand top is by a crank working through a gear system and secured when the crank has been stopped. Lastly, there are hydraulic stands, such as are used in mechanics shops, with a flat metal top and a foot pedal to raise and lower the working surface.

The most common studio, or classroom modeling stands are made of wood or metal having three or four legs. A pipe attached to the stand's top works as a center post to raise and lower the working surface. The three leg stand is designed for working in an area with uneven floors, such as an old mill or loft studio. The four leg stand is designed for working on even floors, such as in classrooms in conventional schools or universities where the floor is relatively level and secure. The legs are tapered flaring out from the top to the bottom base, and welded or screwed at two levels for stability. The legs are fixed and immovable, but the tops can be removed and are usually taken off the base unit when the stand is transferred to another location. With the heavier crank type of stand, the legs fold for

easy transportation and the stand's top is removable. All the tops are waterproof laminated micarta on press board, or a similar material, usually made from kitchen sink top cutouts from the home building industry.

If the modeling stand has wheels, they will be made of heavy duty rubber with locks so they can be secured when the stand is set up in the studio or classroom. These wheels are called **lock casters,** each having its own toggle type locking device preventing the wheels from turning.

Trays to hold tools can be attached to the stands, usually the smaller lighter sculptors' modeling tools for use with clay and plastilina.

Most modeling stands are made for modeling with moist clay or plastilina and for pieces weighing no more than 250 pounds, the maximum weight used by most sculptors being 100 pounds. Larger pieces would be modeled standing on the floor. Crank type stands can hold greater weight (up to 750 pounds) since they are raised and lowered with a gear mechanism and a hand crank.

■ Heavy Duty Stands

The following stands are used by serious dedicated sculptors, usually professionals. All are designed for standing to work; sometimes bar stools are used for sitting for larger projects. The **Hercules Stand** is the heaviest duty modeling stand on the market, can be folded for transporting, and is raised and lowered with a hand crank with internal gears. It has an extra large removable top that is reinforced with wood and metal. When raised, the stand is 47 inches high and will hold 750 pounds. It can be shipped by UPS, usually in two separate cartons. The **Eldorado Stand** is the second heaviest crank stand available, with the same basic design as the Hercules but of lighter weight materials. It is probably the most pre-

ferred of the folding models; it is easy to place in a car trunk and is light enough to be easily handled by men and women alike. When raised, it is 46 inches high and can hold 200 pounds of modeling material. The **Studio Stand** is a four leg floor adjustable stand of heavy welded steel with a reinforced top. The floor adjustment is accomplished by screwing down one of the four legs with an adjustable thread. The top is raised and lowered by hand with an internal pipe and secured with a set bolt through holes in the pipe. The top is heavy duty and sits in a reinforced metal frame for added strength.

■ Studio and Classroom Stands

Because of their designs and affordable prices the following stands are best suited for use in studios or classrooms. The **College Stand** is a four leg, welded angle stand with a top of waterproof micarta and pressboard which is raised and lowered by hand. It has lock casters, weighs only 28 pounds for easy moving, and can hold 250 pounds. The **Jolly King Stand**, a three leg, welded angle steel modeling stand with lock casters can hold 150 pounds of material. It has a waterproof top raised and lowered by hand in the center pipe method. The College and Jolly King Stands are both well suited for schools and universities where they might be subject to strong wear and tear by the students. The **Norska Stand** is a four leg wooden stand secured with nuts and bolts, with lock casters. It has a square wooden shelf built into the center of the stand for tool storage. Tool trays, which slide out from under the stand's top, can be ordered separately at an additional cost. This stand can hold up to 150 pounds. The **Helsinki Stand** is a three leg wooden stand with lock casters and a waterproof top. Able to adjust easily to uneven floors, the stand holds up to 100 pounds of

modeling material. A triangular wooden shelf at the bottom of the stand provides support and can also store tools.

The **Stone Carver's Stand** is an extremely heavy wooden four leg stand with extra reinforcement on the top and at the base. It can bear the weight of stones up to 800 pounds. When the top is removed, a recessed hold area can cradle large stones with sand bags for comfortable work. When the top is in place it locks with the recessed area so it will not shift. The stand does not come with casters but they can be added. You can purchase the casters at a hardware store and attach them to the stand's legs.

■ Troubleshooting/Questions

What stand is better, wood or metal?

It is hard to say. I prefer the wood stands because I just happen to like the feel of wood better. However, if I were to recommend a stand to an eighth grade classroom teacher, I would go with the metal stand, solely for its durability.

Why three leg and four leg stands; what is the difference?

The three leg stand is designed for uneven floors such as those found in the old loft studios in New York City and in Italy. The four leg stands are designed for even set floors where balance is not a problem. Both types hold weight equally well.

What do I do when I lose the holding pin?

You can buy a heavy gauge nail and use that (as I have quite often done) or contact your supplier and have another sent, usually at small or no cost.

How do the lock casters work and will they hold?

The casters lock and unlock with a flipping device in the caster, much like the locks on your home windows. When the stand has been rolled to the desired location, simply set each of the locks on all the wheels. Lock them all for best results. They hold pretty well but remember that if a great weight has been placed on top of the stand and if pushed just so, the stand may well tip over. Use some common sense.

Where can I purchase a pedestal and have a piece mounted?

You can usually find a source in your local yellow pages under Art Supplies or at larger home decorating centers. If there are none in your area, see Appendix B for a sculpture organization which may be of assistance or contact Sculpture House, Inc., Customer Service, 100 Camp Meeting Avenue, Skillman, NJ 08558, Phone: 609-466-2986; FAX: 609-466-2450.

Mold Making & Casting

PART 2

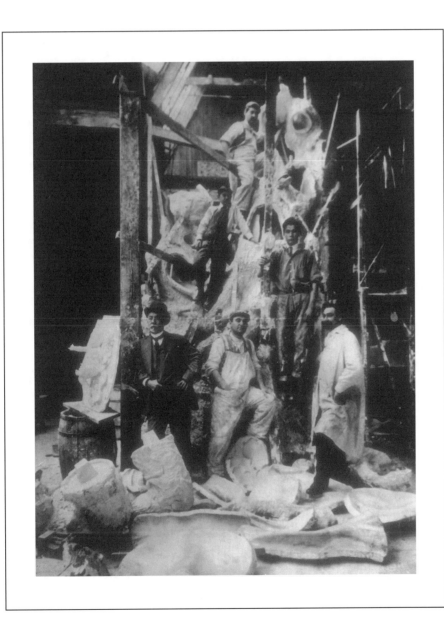

Mold Making & Casting

HEN A PIECE OF SCULPTURE has been completed, oftentimes reproductions are desired as gifts, for display, even for sale. To make the reproduction, a mold and cast of the model must be made in one of a variety of casting mediums, such as plaster, bronze, or bonded bronze. This chapter defines the different mold making and casting materials, explains the methods used to replicate a piece,[1] and also describes enlarging a model.

◼ Mold Making Materials

A mold is the **negative** or hollow cavity produced around a sculpted piece for use in creating multiples of that piece. There are many different ways to construct a mold using various materials. When a series of large proportion is to be made, say 100 pieces or more, a **master cast** is generally made and stored for replacing the mold after deterioration occurs. This is a smart and economical move. If the mold wears down in detail areas the sculptor does not want to have to remake the piece, so a cast is made and molds are drawn from this cast when detail is diminished.

[1] For a more detailed explanation of the various techniques, you can purchase the book <u>Mold Making, Casting and Patina for the student sculptor</u> by Bruner F. Barrie from your local art supply store.

Plaster

Plaster, the most popular mold making compound, is used to make a plaster waste mold. This basic mold is normally constructed in two sections: the front and the back. First, the model is sealed with a sealing agent such as shellac. Once this is dry, a releasing agent, such as soap, is applied allowing the mold to be easily removed from the model. Then plaster, while in a liquid state, is placed over the prepared model in two sections. After hardening or setting, the plaster mold is removed from the model. Casting material is poured into the resulting hollow shell mold. (The recommended casting materials for this project are gypsum materials (casting plaster) only.) Once it has set the outer shell is chipped away leaving the underlying cast.

Mold knives are specially designed for work with plaster molds. They are used to separate mold sections and cut rubber in the mold making process. Due to their heavy usage the blades are not merely attached to the handle, but run through the handle as one continuous piece. The blades are made of high carbon steel so that they can easily be sharpened by honing on a bench stone periodically. Most mold knives come with wooden grooved handles so that turning and slipping will not occur if they are wet with plaster. They come in two sizes: 4 and 6 inch. Since they can rust they should be kept clean and dry when not in use.

With waste molds there will be only one cast from the mold, hence its name. This type of mold is used to create a working model where more definition will be required before a final rubber mold and cast are made, or if only one cast is desired by the artist.

Latex Rubber

Latex rubber is the second most popular mold making compound. Layers of liquid rubber are painted over the model and, after a healthy thickness is achieved, a plaster mother mold is constructed in sections over the rubber. When the final casting material is poured into the rubber it will therefore retain its shape rather than expand since it is a flexible rubber material. Up to 500 casts from a smooth non-abrasive casting material can be drawn from a single latex rubber mold. Recommended casting materials for this product are gypsum (plaster) and waxes of low temperature.

When stored properly latex molds will last for more than 20 years. Store in a cool dry area. Some type of filler, such as sand, should be placed in the interior of the mold when not in use; this will help the rubber maintain its original shape. All molds should be stored in an inverted fashion (upside down).

Paste Maker

Paste Maker is a natural cotton filler used to reduce the amount of pure natural rubber needed to make a mold. It saves time and cost. The paste maker is added to the pure latex after 8 to 10 coats of natural rubber have been applied. (The detail has been captured in the first coats of rubber applied to the piece.) When added to the rubber in small amounts, the paste maker will thicken it and give added support to the mold prior to the mother mold being made.

Moulage

A rubbery material derived from sea weed, moulage is an alginate type of substance that will not adhere to any surface. It is used extensively in prosthetics and death and life masks. It is the only rubber material that can be safely used on the human body and can be applied to inert objects with good results. It will get stuck in hair, but can be combed out.

Heat the semi-firm material in a double boiler and when cool enough, apply it to the face or model, layering to about 1/8 inch, and leave it to set about 15 minutes. Next a plaster mother mold is formed over the moulage and let set. Both the plaster and rubber are then removed and a cast is poured into the cavity of the rubber. Recommended casting materials are PosMoulage (wax) and gypsum (plaster) products.

When kept moist moulage can be reused several hundred times. After use, the rubber can be cut up into pieces and stored in an airtight container for use at a future date.

Gelatin

Gelatin is an old time material from the early 1900's before modern rubber was invented used to make molds which are similar to moulage molds. It is basically horsehide glue which, when heated to flow, is poured into the hol-

low cavity of a mold and left to set up or harden. The material can be melted and reused several times. Sale of this material ceased in the early 1990's.

White Rubber

Another material available for the beginner mold maker, white rubber is a two-part fast setting material with a 1- to 10-part mixing ratio. The rubber is poured into the hollow cavity between the mother mold and model. The material then sets up chemically and is removed after setting. Recommended casting materials are gypsum and wax only. The rubber has been known to deteriorate after four or five years so this should be kept in mind when beginning a project.

Other Types of Mold Making Rubber

Polymer or chemically activated multiple part mold rubbers must be mixed thoroughly, preferably with a jiffy type of mixer, or the component parts will not set properly and wet spots or soft areas will result where the rubber has not set or cured properly.

Other more advanced types of rubber molds can be made, using polyurethane, polysulfide, red rubber, and silicon rubber. They are very difficult to work with and are not recommended for the average amateur mold maker and novice caster. Consult professionals for molds made of those materials.

■ Casting Materials

A cast is the reproduction of an original piece of sculpture in any number of casting materials, most commonly plaster, plastic, or bronze; it is the **positive**. Although mold making materials are limited in their use, casting materials are not. Once a mold has been made of a piece, multiple casts can be drawn from it over a long period of time.

The mold will deteriorate with each casting, but less so when a nonabrasive material, such as Pristine White Casting Plaster, is used. The rougher the casting material the quicker the deterioration. Casting cement or artificial stone will hasten the wear on the mold. Fine details, such as eyelids, will wear faster than plain geometric surfaces such as the cheek.

There are three basic groups of casting material: gypsum, resin (plastic), and metal.

Plaster (Gypsum)

The primary casting material used in the sculpture field, plaster, a gypsum product, is basically a calcium deposit that has been mined and air floated in a powder form. When water is added the composition heats mildly, hardens or sets, and then cures within 24 hours. Green plaster (plaster that has set but is still wet) can be de-molded an hour after setting. A 24-hour cure time is recommended. The mixing and setting time is approximately 20 minutes.

A plaster retarder is available through U.S. Gypsum[1], Chicago, Illinois. This will slow the setting time of the plaster but is not generally available through stores since there is no demand for the retarder. The more commonly used old school method of slowing the setting time is to add lemon juice or vinegar to the mix. Sample or test batches should be made to determine the correct proportion.

To hasten, that is, speed up, the setting, you can add salt to the mix. Again test batches

[1] **Warning** U.S. Gypsum has issued the following warning concerning the use of gypsum-based products: "May cause burns. Use only as directed by manufacturer in current U.S. Gypsum printed directions and specifications available on request. Hazard Caution: Do not take internally. If this happens, call physician immediately. Keep out of the reach of children. Do not allow children to use except under adult supervision. This product may develop sufficient heat to cause burns if a large mass, such as a cast of a hand or arm, is allowed to harden in contact with the skin. Ventilate or use a dust collector to reduce dust in work areas. Use NIOGH-approved respirator for nuisance dust when air is dusty".

should be made to determine the proper proportions of mix and salt.

Once plaster has set up it will not break down but will absorb water. When casting plaster into a plaster mold it is necessary to soak the mold so the casting will not adhere to it.

Gypsum products[2] are not meant for outdoor use under any circumstances, since over a long period of time the elements will cause deterioration of the material no matter how dry and sunny it is. The shelf life of plaster in its powdered state is approximately six months, sometimes longer but not by much. If stored too long the powder when mixed with water will not set properly if at all.

Plaster has a very low shrinkage rate when set, a concern for highly technical designs perhaps but not for the average sculptor. Mixing proportions for plaster are one quart of water to five pounds of powder, two quarts of water to ten pounds of powder, and so forth. The powder is sprinkled into the water; never add the water to the powder. When the powder and water are mixed the setting material will become hot for a short time, maybe as hot as 112°. This should not harm the human body but some areas may be sensitive. After the powder and water have been mixed and the resulting plaster cast, setting (hardening) time is generally 20 to 30 minutes, but you should allow another 45 minutes to an hour before de-molding the "green" plaster. The cast should be left for 24 hours to cure after it has been removed from the mold, during which time flange or seam lines can be trimmed. In areas near water or with high humidity, plaster might take an extraordinarily long time to cure (4 to 10 days).

When using plaster molds for casting other plaster pieces soak and soap the mold in water and let drip dry prior to casting. Other-

wise the cast will adhere to the walls of the mold and it will be close to impossible to remove it. Seal the mold and apply a release before casting. When a mold has been made and cured submerging it in water will not effect its strength or durability as you might think. Plaster can be cast into almost anything, as long as the material has been sealed and a release has been applied. Plaster can be cast into plaster, rubber, milk cartons, aluminum foil, and applied directly to the body when done properly.

There are many grades of plaster ranging from the most absorbent to the industrial grade materials which are extremely hard and less absorbent. **Pottery plaster** is the most absorbent and softest of gypsum products and is used extensively in making ceramic slip casting molds, where the water from the liquid clay is drawn into the mold allowing the residue to be removed, dried, and fired. **Plaster of Paris** is a generic term for a porous grade of construction plaster. It is an industrial homebuilders material and I do not recommend using it for any form of sculpture, mold making, or casting. **Industrial grade plaster**, such as **Ultra-Cal**, may be used in the sculpture field but is not stocked by suppliers due to its short shelf life of 3 months and because it is too hard. **Expansion plaster** expands slightly when cast but for normal sculpture use, not enough to matter.

The three primary casting materials used by sculptors are: Pristine White Casting Plaster (U.S. G. No. 1), Hydrocal, and Hydrostone; each has an effective shelf life of 6 months before they go dead and do not set up. While the material may be kept for as long as a year and a half, a good rule of thumb is to use the material within 6 months.

Pristine White Casting Plaster is the most all-around, general use, mold making and casting material used in sculpture. It can be used

<hr>

[2] For more technical information on gypsum products you can contact U.S. Gypsum in Chicago, Illinois.

to make molds or mother molds and is strong enough to be used for the positive cast. It will take a patina well with any type of coloring (patina), from water-base materials to oil-base materials. It is the best priced and over all the only material a sculptor will need.

Hydrocal, 30% to 40% harder than casting plaster and a medium porous gypsum, works much like casting plaster in mixing, pouring, and setting. It cannot be used to make the outer or mother molds and is recommended for casting only. It is not recommended for outdoor use.

Hydrostone is the hardest and least porous casting material available through art supply stores. More difficult to use, this material is somewhat harder to mix and to pour than the other gypsum products. The set up time and pouring quality are a little different but basically it is used in the same manner as casting plaster and Hydrocal. I would recommend casting plaster or Hydrocal to 90% of the readers of this manual, no need to bother with anything else. Hydrostone is recommended for casting only, but cannot be used for outdoor pieces.

Ultra-Cal and **Super Cal** are industrial grade materials. Not many sculptors, even the professionals, use them. **Fast Cast** is a new outdoor gypsum material which mixes and sets like casting plaster, but is dark brown in color. **Tuf Cal,** a fiber and resin-impregnated gypsum, can also be used outdoors. This white material takes a good patina, and mixes and sets like regular casting plaster. (**Tuf Cal** and **Fast Cast** are relatively new gypsum products. I have not sufficiently tested these materials as to their casting quality; from what I have seen so far, they seem to be very good advanced casting gypsum.)

Vatican Art Casting Stone is a stone-like mixture of casting plaster, Hydrocal, marble aggregate, and water soluble pigments (brown, white, terra cotta, grey-green, and black). The colors are meant as a base coloring for patina and the marble aggregate acts as a stone simulator. Since the material is gypsum, it may not be used as an outdoor casting material. The pigments tend to stain the molds being cast from and the seam lines are hard to repair, but with proper patination this should not be too noticeable.

Tips for Coloring and Strengthening Plaster Casts

To **give plaster color** use a base coloring for patina. Add water-based pigments to the water when mixing the powder. This gives a solid color throughout the material so if the cast chips, or has a break, it will not display the pure white natural material of the plaster. I use Rit clothes dye. Use a strong dose since the water and plaster will dilute the color. The richness of the color will depend on the amount of dye used. Test batches are usually a good idea. **Patina plaster** is a coloring given to a piece for aesthetic effect, and is applied after the plaster has set and cured for at least 24 hours. Colors added to the surface will only penetrate so far into the cast, creating a surface patina. Plaster can be patinaed in any number of ways, using acrylic paint, oil paint, water colors, egg wash, stain, or latex paints. Whatever you use I suggest you make sample tiles or pancakes before coloring the original cast.

To strengthen plaster casts an additive is used with the wet material. Usually burlap or cloth is impregnated with wet plaster and added to the interior of a cast or mold to help support the cast. This does not mean that the plaster material becomes stronger. **Bone Emulsion,** on the other hand, is a liquid that when added to the plaster mix makes the plaster harder. It contains a natural hardening ingredient such as cornstarch and does not make the material weatherproof. When bone emul-

sion is stored, a sediment forms at the bottom of the container. Vigorous stirring loosens the material.

Casts and molds can be made stronger with plaster reinforced strips placed both internally, on reachable areas, and externally for larger molds that need additional support. Separating the halves or sections of the mold will create the greatest stress and reinforcement might be required. On larger projects pieces of aluminum wire are sometimes attached to the outer areas of the mold in strategic places to help with this reinforcement.

Plaster Casts and Anatomical Figures

Plaster casts and anatomical study figures have been used for centuries as a means to view or study proportions of a specific part of the body. These casts can be made of resin but most, for economy, are made of plaster. The casts being discussed here are made of U.S. Gypsum No. 1 pristine white casting plaster. Great care should be taken when handling these casts since they can break easily during shipment and in the classroom if handled roughly.

The **Ear, Nose, Lips, and Eye** make up the primary study group and are made in 8 inch relief casts that are larger than life size. The **Human Skull** is cast solid, 7 inches high, and is actual size with the standard demarcations. The **Blocked Bust** is a stand-alone cast, hollow with a base, and stands 17 inches high. The **Blocked Masque** is a life-size relief casting. The **Hand From David** is larger than life standing 9 inches and is designed from Michelangelo's statue David.

Anatomical figures such as the head, head and body, and animals are sculpted with as much accuracy as possible. There are differing opinions as to the quality of these casts; no two sculptors agree on a finished anatomical cast's integrity. Therefore it is understood that they are for study purposes only. All are cast in solid plaster. The **Anatomical Figure with an extended arm** is a 30-inch model. Its extended arm is cast separately from the body and attached with a nail type of pin. The cast is free standing with its own base and is cast in solid plaster. The **Anatomical Figure with hand on head** is an 18-inch standing figure with its own base and is also cast in solid plaster. All parts are cast in one single piece with no attachments. The **Anatomical Head** is a relief cast with a flat back for easy wall mounting. It is life-size and cast in solid plaster. The **Anatomical Horse** is a 7-inch-long horse with a detachable head attached with a roman joint. The bottom is supported by a solid cast brace and self-supporting base. Two legs are semi-raised and the head is in an inclined position.

Resin

Resin, usually referred to as plastic, can be an epoxy, fiber glass, or a direct casting material. Special types of mold rubbers are required for this type of casting, each specific to the material to be cast. There are silicone rubbers, R.T.V., Tuffy, Red Rubber from Europe, and a number of two- and three-part chemically setting rubbers on the market. Each has its own limitations and the manufacturers of these products can provide information on them. These types of rubber are usually for professional use and are not recommended to those lacking experience in mixing and mold making procedures. Determining tare weight (weight of material less the weight of its container) on digital scales is often necessary as are proper ventilation and appropriate respirators. The fumes can be harmful if inhaled.

Cold Pour Bronze, also known as **Bonded Bronze** are resin materials to which pure bronze powder has been added to give a bronze effect and added weight. Since the proportions vary, you should refer to the

manufacturer's instructions for proper mixing and mold types. I have not seen a resin that will stand up to outside weather conditions over long periods of time so I cannot recommend these materials for outdoor use. No cold pour bronze or cold pour metal casting materials are available for outdoor use. They are, in essence, metal-impregnated plastics.

Metal

Bronze is the favorite metal casting material of all sculptors for outdoor use. **Aluminum** is probably the second favorite but casting aluminum is extremely difficult. Low temperature, lower cost white metals **(pewter)** are used for small castings in centrifugal mold, normally used for indoor sculpture. **Lead** is my favorite material for casting at home. It is relatively easy to work with, using an ordinary stove to melt the lead. Pieces can be cast in **silver** and **gold** but they are generally very expensive. Most metals are a combination of several alloys and therefore differ in effect. Bronze, for instance, can be of various colors and hardnesses.

Liquid metals, such as Sculpmetal and mechanics body filler are not good for pouring. Rather, they can be applied in layers on the insides of molds and then fused together and finished after they cure. With piece molds sections are cast and hardened. These sections are then welded together and their seam lines smoothed creating a completed piece. This is somewhat complicated and costly but can be accomplished with experience and practice. Casting in bronze should give you the same effect and more durability for a not much higher cost.

The best way to find the right metal to cast a specific piece is to consult a professional mold maker or a casting foundry. Also, since all metals have to be molten at very high temperatures and special equipment is required, I recommend consulting a professional.

Other Casting Materials

Casting Rubber is not used to make a mold; it is used to make a positive cast. Casting rubber can only be poured into a plaster mold. The water in the rubber is absorbed by the plaster resulting in a positive cast; therefore the plaster mold must be thick enough to effect this absorption. When casting straight rubber the mold is filled with liquid material and left to stand for about 3 hours. This is the effective absorption time and the maximum that will elapse before the rubber begins to seal itself. A thickness of approximately 1/8 inch will develop. The remaining liquid is then poured back into its original container and the material is left in the mold until it sets and releases from the mold. With slight pulling from the mold the cast can then be removed and cured. When no filler has been added the cast will be flimsy, much like a heavy rubber band, and somewhat transparent.

Casting Filler is a material used to harden casting rubber strengthening the resulting cast, added in amounts depending on the desired degree of flexibility or hardness. Fifty percent filler will result in a semi-flexible cast and a one-to-one ratio of casting filler to casting rubber will produce hardness like that of a Frisbee. Only testing can determine the flexibility that you desire and should be done on a trial-and-error basis. The filler settles rapidly to the bottom of the container; the mixture becomes stiff on the bottom and liquid on the top. Stirring the mixture, pretty hard at times, will bring it back to usable consistency. The finished cast can be painted or patinated in any number of ways. If the object is a flexible one, the paint must be a flexible rubber paint, not ordinary latex paint. It should be air brushed or sprayed on, not applied by brush, or it will be too thick and crack when flexed.

■ Casting Techniques[1]

Mixing Gypsum Products

Most sculptors use the age-old method to mix plaster, that is, by sight and feel. But to determine the correct amount of plaster required to fill a space, multiply the piece's length by its height and width, and convert the total to cubic inches. Then apply the following: **one ounce of liquid material equals one cubic inch of set material**. Water weighs 10 pounds per gallon, and I recommend having more than enough mixed material on hand rather than running short. You may weigh the plaster and water mix by proportion: 5 pounds of powder to 1 quart of water is the accepted rule of thumb for a good mix.

Place the water in your mixing container and sift the powder plaster into the water, breaking up any lumps that may form. Continue adding plaster powder to the water until a small mound rises about 1 inch above the water line. Let the powder settle to the bottom and absorb the water for about 2 minutes; then mix gently from the bottom with open fingers. Scrape down the sides as needed and stir until the mixture is like heavy cream, which is the best pouring consistency. Just before pouring, tap the container on the work bench to dislodge any air bubbles in the mix. Pour into the mold at a 45° angle until approximately half full. Empty the liquid material back into the mixing container, rotating the mold to cover all internal areas. Repour the casting material back into the mold until full, tap the full mold to release any air bubbles and add more material if needed. Let set and then scrape or level the top of the mold area

with a block scraper. Within 20 to 30 minutes the plaster will become warm; it will harden after an hour. Let set for at least an hour before de-molding and then cure the green plaster cast for 24 hours before continuing work. Seam lines from the mold can be trimmed after about an hour.

When making a mold allow the plaster mix to set up a little longer and become thicker before applying to the model. If the material is too thin, it will not adhere to the model, but will fall to the base of the model; all of the material will end up on the work bench, a common occurrence with first timers. Working time is about 10 minutes when making a mold so don't make one large batch of material, but rather several smaller ones for the mold making process. Castings must be poured in one continuous mass, so mix enough to fill the mold. For larger casts place the mold on the floor and place the pouring container on a stool or 50 pound clay box to facilitate pouring.

Types of Casting

Most casting by amateur sculptors is done using latex molds, plaster waste molds, or plaster reproduction molds (molds used to make more than one cast) and casting materials including plaster, resin, and metals such as bronze, pewter, lead, and so forth.

Plaster Casting

Plaster casting in a **latex mold** is probably the easiest. Once the mold has been made and the plaster mixed the positive cast can be made in one of two ways: either slush casting (creating a hollow cast) or solid casting. In slush casting, the plaster mixture is repeatedly poured into and out of the interior of the mold until a desired thickness has built up. This build up can be reinforced with plaster-impregnated burlap. When the plaster has set the mold is

[1] Recommended reading for latex, plaster and basic simple techniques for casting is Mold Making, Casting & Patina for the student sculptor by Bruner F. Barrie. A more advanced book for vents, gates, and bronze casting is Methods for MODERN SCULPTORS by Ronald D. Young and Robert A. Fennell.

opened, that is, mold halves or sections are removed in a process called de-molding or setting the cast out of the mold. The hollow cast is then removed. In solid casting the mold is first filled three-fourths of the way to its top with the plaster mixture. Then the plaster is poured back into the mixing container, and the mold is rotated to ensure that the entire interior is coated with the liquid plaster. When these steps have been done once or twice, additional plaster is poured into the mold filling it entirely. Tap the mold to dislodge any air bubbles, level it, and add more plaster if the casting material recedes.

Tips to remember: Please be aware, if there are areas of the mold that have not been secured or do not fit together properly the casting material might leak. To prevent this, take pellets of moist clay or plastilina and plug these places before adding the plaster. It is important to pour the casting plaster in one smooth motion to avoid layering or striation. Also important: have more than enough casting plaster to fill the mold the first time so you won't have to mix another batch. Extra plaster can always be made into pancakes for testing patina techniques and colors. The cost of plaster is not that great that any extra cannot be thrown away. When removing the cast, water may have to be poured into the mold to release suction build up, but this will not effect the set cast, so don't worry.

A **plaster waste mold**, also used in **plaster casting,** will be destroyed when the cast is complete. These types of molds are used for making master casts or when only one cast is required. The cast is intended to be re-worked correcting any imperfections or defining any details before the final mold and cast are made. The sculptor only wants one cast. After the model is prepared, the plaster mold is applied. (The first coat of plaster is usually colored in some way so that when you chip away the

waste mold in the final casting steps, you will be warned that the cast is near.) More plaster is applied as needed and allowed to set. The waste mold is then removed from the model by pouring water between the plaster and the model and carefully prying sections apart with a mold knife. Its sections are placed back together and prepared for casting. When the cast is complete and set the waste mold is removed by chipping with a mallet and chisel and discarded.

Quite often a **plaster reproduction mold** is made since this is faster and less costly than making a latex mold. This is also recommended if only a few casts are desired, generally not more than five. The mold is made like any other type of mold, but be sure to allow for easy removal of the sections. Apply the plaster to the model, allow it to set, and then remove it as with plaster waste molds. After curing and before casting, soak the mold in water until saturated. Drain off excess water but make sure the mold is still wet when pouring the casting material. Seal the mold with shellac and soap the interior of the mold or have a release applied to it so the cast will not adhere to these interior sections. Sprinkle a few drops of water on the interior of the mold; if they bead up on the surface you are fine, but if they are absorbed into the plaster walls of the mold don't pour the casting material until this situation is corrected. Mix the casting plaster and follow the casting steps outlined above in plaster casting. To remove the cast after setting and curing, pour water into the mold to facilitate parting of the mold's sections.

Please note, when casting plaster, reinforcing rods or burlap may be needed in delicate areas such as arms and ankles. Place the rods when the plaster begins to set so they will not float to the outside of the cast. Use rust proof material, as rust will come through the plaster.

Resin Casting

Resin casting generally requires special types of rubber for the molds. The component parts that make the resins set heat up to a point where latex types of rubber might distort the casting. Latex cannot withstand these high temperatures and will constrict. This does not always happen but don't take the chance. Use proper rubber recommended by the manufacturer of the resin. Personally, I prefer to have a professional mold maker and caster do the job.

This type of casting is also used for what is sometimes called Bonded Bronze or Cold Pour Bronze. There is no such thing as cold pour bronze; resin impregnated with bronze powder is as close as one can get.

Metal Casting

Bronze is a metal that must be molten to be poured and thus requires high temperatures. It also requires a ceramic shell coating to withstand the high temperatures when cast.

The basic process in **bronze casting** is to make the model and a rubber mold. Next a wax positive is drawn from the mold. The wax is then coated with a ceramic slurry (shell or investment) and melted out (this is called the **lost wax process**). Molten bronze is poured into the empty shell and when cooled the shell is chipped away leaving the bronze cast. An intricate system of vents and gates is required so gas will not build up and crack the investment mold (the ceramic shell into which the bronze is poured after the wax is melted out). The bronze cast will be the color of matte brass and will have a seam line that must be removed. Any flaws or defects must be corrected and seams removed by a qualified professional through a process called **chasing**. When the cast is finished it must be patinated or polished, requiring another professional, since metal must be colored with acids. Most contemporary statues are chemically patinaed in this way no matter what their color. I highly recommend that bronze casting be left to professionals.

Lead casting can be accomplished by the average individual. Here is what it takes: a mold that has been properly gated and vented so that any gas build up does not explode the mold when casting; hot metal plaster that can withstand the high temperature of the liquefied lead; and a black iron pot to melt the pigs of lead (this pot should be large enough to hold sufficient lead to fill the entire mold in one continuous pouring flow). A hot metal plaster mold is made around a wax cast or model and the wax is melted out. The lead is then poured and the plaster chipped away leaving the cast. If the mold is not made properly and warmed prior to casting, or if it is moist, the lead may spit out and burn exposed parts of the body. The mold may even explode and spit hot lead all over the place. If you are not sure what you are doing don't try it. I have seen too many people burned or injured casting low melting metals. Apprenticeship or proper instruction should be a prerequisite before casting in this manner.

■ Enlarging and Reducing Sculpture

Usually the largest increase for an enlargement is about four times the size of the original piece. Most models are usually not more than 18 to 24 inches in height prior to enlargement. If the piece needs to be enlarged further, work from the enlargement. If a 24 inch model is to be enlarged to eight feet, the enlargement process will be done twice, once to four feet and then again from four to eight feet. For larger sizes, work in sections, such as the legs, mid section, head, and bust. These sections will be enlarged individually and then welded together making the entire piece.

The enlargement process requires a pantograph machine.[1] This machine has a point on one end and at the other a fifth wheel, or rotary wheel, that holds the enlarged model. An armature with proper framing is built to the size of the enlargement and clay, usually soft plastilina, is built up over the armature. Hundreds of toothpicks are then inserted into the larger model. The small point of the pantograph is placed on the smaller model and a corresponding larger point is placed on the larger model giving the proper dimensions for enlargement. Plastilina is added or subtracted to the end of the tooth picks creating the basic geometric design of the piece. The sculptor applies finishing details to the enlargement. Then a mold and a cast are made.

It is very important to have the proportions of anatomy, shoes, buttons, and the like exactly correct on the original model since any variations will be magnified on the enlargement. For example, if a shoe lace is off a fraction of an inch on an 18 inch model and the model is enlarged to 20 feet, the enlargement's shoe lace will be out of proportion by almost ten times that of the original.

Reducing models is done in the same way in reverse. However, not many pieces are reduced; some professionals make a ceramic mold and cast the piece in porcelain, fire the piece, and get about a 20% reduction with each firing. This is normally done with small pieces under 10 inches.

■ Troubleshooting/Questions

Keep the tops of containers tightly sealed so that the latex is not exposed to air. Otherwise a film will develop on the top surface like the skin on an old milk container. This can be re-

moved without harm to the latex but it wastes material.

Do not let the latex set up on brushes or tools when applying. Rinse them frequently in water so they will remain clean.

Clean and dry tools and containers after use to keep them fresh for the next application.

Do not store cured rubber in areas of sunlight or outside the mother mold. This will cause deterioration. Place the rubber back inside the mother mold for storage. Remember, as more casts are made the rubber will lose definition. To keep sharp casts remake the rubber mold from the master cast. Fill the unused stored mold with clean sand to maintain definition. For storage, place the cured rubber back inside the mother mold.

Clean the interior of the rubber after each casting and before storing.

Can latex rubber be poured and set solid?
No. Latex must be applied one coat at a time and air dried before adding another coat. If poured, the latex will seal on the outer layers, preventing the inner latex from setting. Only a material with a chemically curing agent can be poured solid, such as white rubber, Tuffy, and silicone.

How long will a latex mold last?
Up to 20 years, if stored properly. You can boil the cured rubber to vulcanize it: submerging it in boiling water for 20 minutes will give the rubber longer life.

Can latex be colored?
Yes. A water soluble pigment, such as clothing dye, can be mixed with the rubber while it is still liquid.

[1] There are different types of enlarging machines available with heavy rails and/or stand alone features. They are used mostly by professionals or sculptors with a lot of experience since enlarging is a specialized field of sculpture.

Can you cast latex?
Yes and No. Mold making latex is for negative molds only, latex casting rubber is for positive rubber casts only. They cannot be interchanged.

How long will latex keep in its container?
If the container is kept airtight the latex will last for years. When exposed to light the material will take on a pink hue but this does not effect its workability.

How do you clean up after using latex?
Latex is an ammonia- and water-base natural rubber and tools and brushes can be cleaned with warm water. Keep the brush in a water solution while working and then dry with a cloth when finished. Set rubber can be peeled from tools and other surfaces when dry.

If the latex thickens how can it be thinned?
Latex can thinned with either water or household ammonia. Do not thin the latex too much since it will weaken the strength of the material.

How do I stop pooling?
Pooling is caused by allowing the rubber to build up; a film will then cover the outer layers before the inner material has set. This usually occurs in cavities or at joints. Take a pin, or sharp pointed object, and puncture the semi-sealed area and let dry. Sometimes a Q-tip will work well.

I get soft spots. How can that be avoided?
Soft spots occur where the rubber has set before the inner material is dry. The interior rubber remains liquid or semi-liquid and leaves a blemish on the positive cast. This can be avoided by applying the latex in thinner coats and allowing each coat to dry thoroughly before applying another one. Once the mold is made this defect is very difficult to correct, if at all. Sorry.

Can latex be applied over dried latex?
Yes. Although this is not recommended if the material has been cured for more than 24 hours, since layering will occur. Apply the next coat of latex when the previous coat is dry. Trouble occurs after it cures for 24 hours - additional coats of latex won't adhere properly.

The mold takes on the color of the casting material. Can this be avoided?
The rubber will pick up the color of the casting material especially if it is black or dark brown. Casting lighter materials will alleviate this somewhat. From experience I have learned to make light casts first, then the darker ones. If a series is to be made of different colors, I recommend separate molds for each color be made from the master cast.

The latex has a pink tint. Is this a problem?
No. When latex has been exposed to sunlight, even in its container, a pink hue will result. This will not affect the integrity of the latex.

Can latex be applied directly to the human body?
No. This will block oxygen from the pores and cause damage to the epidermal tissue.

Who is best trained to cast in resin and bronze?
When casting with resin, plastics such as fiber glass, or even soft metals, special types of rubber molds and releases are required. Each manufacturer will recommend the proper releasing agent for a specific rubber depending on the material being cast into that rubber. To cast in resin and bronze is an advanced technique and professional mold makers and casters should be retained for these projects. Bronze casting should definitely be left to the professionals.

Wood & Stone Carving

PART 3

Wood Carving

Wood carving, in sculpture, and woodworking,[1] in cabinet and furniture making, are two entirely different fields. Although they are similar in many regards, the tools for each are not quite the same. In woodworking, the bevels on the different tools may be at a greater angle; a thinner cutting edge is prominent with carving tools. The steel grade, 1095C (a high carbon steel, tempered or heat treated to harden the steel so it will maintain a sharp edge), will range approximately .59 to .62 on the Rockwell Black Diamond hardness testing device. Most carving tools are made in the United States, England, or Germany. Other countries manufacture these tools but these are the most common countries of origin. Wood turning tools are in an entirely different category, having longer handles and using a lathe as the turning device and the tool being placed against the wood for removing wood.

◼ Types of Wood Carving Tools

There are eight styles of basic wood carving tools: **Straight Chisel**, with a straight flat edge; **Straight Gouge**, with a curved cutting edge which will range in depth; **Short Bent**, with a small spoon-like dip used for quick deep cuts; **Long Bent**, which will make a long deep cut; **Straight Skew,** with a diagonal cutting edge; **Parting Tool** or **Veiner,** which is a furrowing tool with a cutting edge that looks like a "V", **Fishtail** which flares out on the left and right tips like a fishtail; and the **Back Bent** with a concave curve bending away from the normal face. These tools are available with cutting edges in different sizes ranging from 1/8 inch to 1 inch. There are smaller, micro tools and some even made up to 4 inches; however, these are the standard sizes.

The **sweep** of the tool is its cutting edge from left to right. On a gouge this edge would be measured from the right tip to the left tip. A number indicates its depth or angle of the tool, such as a number 9 3/8" - the 9 indicates

[1] Answers to questions on woodworking and wood turning may be found in the magazine <u>American Woodworker</u>, PO Box 7579, Red Oak, IA 51591, 800-666-3111.

the sweep and the 3/8 indicates the cutting edge. Most tools are drop forged and ground to their final size, usually by hand.

The **bevel** or slant that the blade will take on the carving surface is normally at a 45° angle; it should be sharpened at this angle, using a figure eight motion, on a bench stone or combination sharpening stone, either wet or dry. It is not suggested to sharpen tools on high speed grinding wheels since the heat may remove the temper of the steel and ruin a tool's ability to cut properly.

There are three basic parts of a wood carving tool: the **blade** which is the primary cutting section of the tool; the **tang** which is inserted into the handle of the tool to hold the blade; and the **handle**. Handles must be drilled to accommodate the proper size tang or the handle may crack.

Handles are attached to the tool blades to complete the carving tool. Most are octagonal in shape so the tool will not turn or twist while carving. Depending on the size of the tool, handles will vary in size and diameter. There are three basic sizes for the majority of tools from ½ inch to 1 inch.

There are handles with **Leather Tips** which will not mushroom the ends when they are being struck with a mallet, and handles with **Metal Tips** (metal caps and rings) on the percussion end, again so as not to mushroom the handle end. **Oversized Handles** are used in the round (that is, with one large solid round piece of hard wood) for very large (up to 3 and 4 inch) tools; however, they are not commonplace.

Imported tools generally cost more than domestically produced tools. They have a gun metal finish with the number and size stamped on the blade. U.S. made tools are of equal quality if not better than some imported tools. The steel is high carbon; and heat treating and tempering are well regulated with the use of a

Rockwell Black Diamond steel hardness testing machine.

The **temper** or hardening of most tools is mainly in the first few inches of the tool. If a tool has been used over a long period of time it should be retempered. Tools should also be sharpened about every 20 minutes or when they seem to drag or feel dull. This is done using a figure eight motion at 45° on a bench stone. **Honing** is an extra sharpening step that makes a tool's cutting edge razor sharp, usually done at an additional cost; the tool tip is then coated with a plastic for safety. To remove the coating hit the tool on a piece of wood as though carving and the plastic will break off. Most tools will last a lifetime if properly cared for, whether imported or made domestically.

Some imported tools are made with Sheffield steel, from England, which some believe to be the best. Steel produced in America and Japan is also thought to be of very high quality. Regardless of the steel the tool must be properly heat treated and tempered to work well and hold an edge.

Wood for carving can be secured in many varieties. The most common are Bass Wood and Pine, although Birch, Maple, Mahogany, and Cherry are also very popular. Exotic woods such as Cocabola, Lignum Vitae, Boxwood, Purple Heart, and Zebra, to name a few, are difficult to obtain in bulk form and are most commonly available in veneer, or very thin sheets.

It is hard to find a good source for wood in the best of times. It is too expensive to stock wood in large carvable sizes, and it may crack or check and become unusable. **Kiln dried** wood is the most sought after since the wood has had the moisture removed by drying in an oven. A **flinch** is a piece of wood cut and waxed so that it will air dry and cure naturally.

The hardest thing to avoid in wood carv-

ing is the **checking** or **cracking** of the wood after it has been carved. This is caused by the absorption and expulsion of moisture, which can occur at any time, even after a period of years. Although the cracks can be filled and sanded, I have never seen a foolproof way to correct checking.

■ Other Wood Carving Tools

Wood carving mallets are available in three basic sizes and three styles. The sizes are small, approximately 12 ounces in weight, medium, 14 ounces, and large, 16 ounces. The weight is determined by the diameter of the striking head. The smallest size is used primarily for detailed light work, the medium for general carving, and the largest for carving pieces over 3 or 4 feet, such as totem poles. How holding the mallet for extended periods affects the individual sculptor will also determine the size used; the medium size is the most commonly used.

The material used for mallet heads can be maple, lignum vitae, boxwood, or resin with a wood handle. Boxwood and lignum vitae give greater density to the feel and weight of the tool, but they come from Haiti and have not been available for several years. Maple, the next most desirable hardwood, is used in producing mallets that have been turned and shaped from a single piece of solid wood. The resin mallets are in two pieces, with the striking surface made of resin and the handle of wood.

To remove or replace a handle, place it in a vise held at the base of the blade, and tip in a downward motion releasing the handle from the tang Then drill a hole of the proper size in the new handle to accommodate the tang.

Carving sets are available from most manufacturers and come preassembled and in various price ranges. Thus the novice can easily select the set containing the required tools at a fixed cost rather than choosing and pricing individual items needed. Sets come in small or large wooden boxes, canvas rolls, or plastic pouches and can contain a full line of everything needed or just the basics. A good basic set should include a mallet, sharpening stone, rasp, and sandpaper as well as individual carving tools.

Most **handheld tools**, or palm tools, are sold in sets. They are generally meant for chip carving or relief work and have shorter shafts and smaller cutting edges. The tools can have round handles or half rounded, and flat palm grip handles, all of which are made of a hard wood. The shapes are normally straight chisel, gouge, skew, short bent, and long bent gouge.

The wood carvers' **adz** is a hatchet type of cutting tool and is available in three basic sizes (small, medium and large) and two styles. The primary style has a gouge and a flat cutting edge; the secondary style has a hammer square end with a curved gouged cutting edge. The handles on all adzes are long and resemble the handles of hatchets.

The **heavy duty adz** is an oversized adz with a larger handle and cutting edges of almost 3 inches. It has a straight hatchet cutting edge and a medium straight gouge cutting edge. This tool is used as a reduction device for extremely large pieces of wood. Since it is too large for use by all but advanced carvers, it can also serve as decoration in a studio or workshop!!

Carving knives are used mainly for chip carving but can also be used for finishing and detailing. There are 7 shapes with the 3 primary shapes being a right hand chipper, a straight knife like cutter with a handle dovetailed to fit the hand for whittling, and a double sided curve. The handles are elongated with a taper and the blades are attached with a rivet.

A **draw knife** is generally associated with shipbuilding and used in smoothing planks. In

wood carving the draw knife is quite often used for reducing large areas to form a geometric surface. It is used as a planing device and is pulled or drawn toward the user. The cutting edge can vary with the normal length being about 9 to 10 inches. The blade is solid high carbon tempered steel and a wooden handle is attached directly to the steel.

The **hook knife,** most commonly used to clean horses hooves, has been adapted to the carving field for its versatility. It has a high carbon tempered steel blade and a rounded hooked cutting edge that is pulled toward the user in a shaving or drawing manner.

■ Trouble Shooting/Questions

How do I prevent my tools from becoming dull?

This is the most common complaint. Remember a tool will get dull when used over a period of time. Most tools should be sharpened after 20 to 30 minutes of use on hard wood. Quite a few carvers I have known do not even have a sharpening stone and wonder why their tools do not hold up. Even steak knives and turkey carving knives need to be sharpened after a while, and they are used on soft meat not hard wood.

What is a steel fracture?

At times a tool will develop a hairline crack or fracture. This should not happen and can be the fault of the tempering process. If the tool is dropped, or hits a nail in a piece of old wood, it can develop a crack.

What causes fraying of the handle?

The percussion of the mallet hitting the contact surface can have a mushroom effect on the handle. Electrical tape wrapped around the handle end will diminish this.

How do I sharpen my tools?

Most tools are sharpened on a bench stone or a combination bench stone (a sharpening stone with two coarsenesses). For gouges and parting tools a specifically shaped sharpening stone is used. The sharpening process is done at 45° angle to the stone and in a figure eight rotation. Basic sharpening should be done every 20 to 30 minutes when carving hard wood.

What is honing?

After basic sharpening, this is an advanced sharpening process done with an extremely fine sharpening stone. It takes about 20 minutes per tool and gives a razor sharp cutting edge to the tool.

What type of steel is used for the tool?

Usually 1095 high carbon steel is used for most wood carving tools whoever the manufacturer is. This may vary with the country producing the tools, but almost all tools are of this quality.

Which are the best tools made and from what country?

This is hard to say. United States manufacturers generally use steel imported from Japan, Taiwan, or England. Domestic steel is sometimes used, but the U.S. does not manufacture enough for volume production. Wood carving tools from Germany, Sweden, and England are the most sought after although they may be more expensive. Tools from England can be made with Sheffield steel which some believe is the best. (It comes from the Sheffield region of the country.) These foreign companies that produce only wood carving tools have an advantage in that these are the only tools they make. As to quality, however, I feel that if a tool holds an edge well and stands up over time, U.S. manufactured tools are the best buy dollar for dollar.

The tempering or hardening process is probably the key to a good tool. If this is not done properly then the tool will falter no matter who makes it. If the tools are hand ground or shaped, rather than machine ground, the shaping and consistency may vary. I have not found a bad tool yet, with the exception of those produced in countries just entering the field, China and Taiwan; their quality could be improved.

Stone Carving

O CARVE THE MANY TYPES OF STONE AVAILABLE sculptors use the basic handheld carving implements, various hammers, and specialty tools and accessories.

▪ Stone

There are so many types of stone used in this field, it would be difficult to name them all, so I will mention the primary types and a few exotic stones that I have found interesting.

Most instructors agree that a pure even stone is best for carving by most students. The reason is simple. With a pure even-colored stone the carving will not be dictated by any color or veining. If a student were carving a face in an exotic multi-colored stone, however, veins would most likely appear diagonally, horizontally, or even in a circular configuration across the face, ruining the effect and the piece. I have often seen this happen. Since there is little or no veining in a pure stone, this will not occur, and the piece will flow naturally with the instructor's guidance.

The primary carving stones are **Italian alabaster**, either **translucent white** (where light will pass through the stone) or **opaque white** (where light will not penetrate the stone), and **soapstone (talc block)** which will be mostly light and dark green in color. Other common stones used in carving are marble, sandstone, limestone, tiger eye, wonder stone, and granite.

Stone is usually classified into four groups each defined by its hardness or carvability. **Soapstone** is the softest. Some carvers include serpentine and Eskimo soapstones in the soapstones. There are soapstones from Taiwan (greenish with iron deposits), Canada (pink mixed with cream), India (cream color), Kenya (dark olive green), and the southern U.S.(black). All of these are not readily available and may be somewhat harder than the material commonly referred to as soapstone and therefore not suitable for beginners.

Alabaster is the second hardest and is considered a medium hard stone as are sandstone

and limestone which are abrasive stones. It comes in many colors: Occhio Tigre and Rosso, Bruno Carmello, Italian Brown Agate, Oyster Shell, Red Vein, White on White, Raspberry, Root Beer, Orange, Creamsicle, and Tropical, to name a few. In addition to green soapstone I would suggest only the translucent and opaque alabaster as carving stones for beginners. All these stones are available at the larger sculpture supply houses.

Marble is the third hardest stone, the hardness varying with the geographic locale from which it is mined. Vermont marble is very hard; Italian marble (the highest grade known as Carrara marble) has a standard medium hardness as does Colorado marble. Carrara marble is favored by professionals; the number one pure white is by far the best. Also known as statuario, this last stone was used by Michelangelo. (I have not seen this grade of stone in the United States since 1978 when a friend had several pieces and even then, no one was permitted to touch the pieces he had.) Other marbles include Statuario Puro, Bianco Pi, Statuario Venato, Bardigilo, Belgium Black, Portuguese Rose, Vermont White, Tennessee Pink, Colorado Yule, California Crystal, Chinese Black, Alabama White, and Danby White. They range from soft to extremely hard. Consult your supplier for the hardness of marble best suited to your needs.

Granite is the fourth hardest carving stone. This is recommended for only the most advanced sculptors having a lot of time to spend on the piece.

Most of the quarried stones are mined in sizes of between 50 and 100 pounds. While larger stones are available, smaller stones must be cut from these larger boulders, and an additional charge is normally attached to the per pound price to cover the cost of labor and blades. If everyone could place a 75 pound stone on his or her mantel or bookshelf all

would be fine, but few people can, so stones are cut to a more reasonable size, usually with two to three flat sides and one rough. Cutting thin slabs is extremely difficult and normally not done due to possible breakage. When a stone is cut to size the entire boulder must be purchased before cutting; you are also buying the waste, as in a butcher shop, you buy the meat before, not after, the fat is trimmed. In order to get a stone with a dimension of 12 cubic inches a boulder of between 200 and 300 pounds may be required. A one foot cube (12" by 12" by 12") will weigh approximately 108 pounds since the density factor of most stone is 1 cubic inch to 1 ounce in weight.

When choosing a stone to work with, look for any fracture lines, large veins, iron deposit areas, or fissures. These may cause breakage when the piece is being carved. Also, tap the stone with a light hammer in various areas; you should get a clear ringing sound. Somewhat like giving a physical to the stone you are considering for purchase!

A final note, always consult your local art supply store for details on its stock.

■ Stone Carving Tools

The basic steps in stone carving are design, percussion removal in three stages (roughing, secondary shaping, and smooth finish), hand rasping, sanding and finally finishing and mounting. The stone carving tools used to perform these functions are considered handheld unless specifically described as pneumatic or electric. The basic tools needed are the point, rake (tooth chisel), the flat straight chisel and a hammer, all of varying sizes and weights. All are made of high carbon steel. The **point** removes the primary bulk material and comes in three sizes, small, medium and large. All taper down to a four-sided point and the thickness, or size of the point, will be determined

by its heaviness. The smaller the size, the finer or lighter the point. The **tooth chisel or rake,** for the second stage of removal, is a flat straight chisel with slightly beveled teeth. It is available in four basic widths, the smallest having four teeth, the next five teeth, the next six teeth, and the largest having eight teeth. The tooth chisel is principally used in the geometric reduction of a larger piece of stone.

The **straight chisel** is the finishing tool used before the final abrasive finishing, rasping, and sanding. It has a straight edge with a slight bevel of possibly 30° and is available in three sizes, small, medium, and large.

There are also **specialty tools** which are not normally used in standard carving but by intermediate and advanced carvers for added assistance in multiple projects. They include the **diamond shaped point**, used for parting ferrules width-wise. (In stone carving there are no "v" or veining tools as in wood carving; points do this job.) The **roundel** is a rounded curved tool for concave carving; the cutting edge is a round bevel. The **fish head** is an outward, "c"-curved tool that, held sideways, looks like a sunfish. Its cutting edge is flat on the outer curve and is used to make slight long strokes similar to those made by a long bent gouge in wood carving. The **needle nose point** is an inward shaped point (concave) that comes to a dramatic point used in removing bulk stone. The **straight gouge chisel** is used for making trench-like, or half-round grooves. All these tools are available in one standard size.

Carbide tipped tools are stronger than standard carbon steel tools; as such they will need less frequent sharpening. However, they will not take a harder blow as most people believe. This is because the carbide, although stronger, is much more brittle than carbon steel and hence more susceptible to shattering or breaking on hard impact. Please take this into

account when using these tools; they cannot and should not be hit harder.

Available in the standard handheld style, they come in point and chisel shapes in two sizes. They are also available in a pneumatic series including a straight chisel, three-point tooth chisel, and point.[1]

The carbide tips are welded in high carbon steel shanks, and, if not used properly, will shatter or break loose from the welded area. Always use a light touch at a 45° angle when using carbide tipped tools. The fragile carbide will shatter if the tool is struck too forcefully.

Miniature stone tools are made of high carbon steel and were developed for detail work (small tools were formerly not available). They are about a fourth the size of the standard tools. The tooth chisel comes in two, three, and five tooth points that are very fine. There is a four point flat tooth chisel, a one of a kind, very useful in finishing. There are also a diamond shaped point, a roundel, and two flat chisels. The shanks on all these tools are half the size of those on standard tools, used for fine detail work and delicate definition.

Stone carving hammers come in three weights and are made of soft iron, so the percussion is easier on stone, tool, and user. There are two standard sizes of steel heads which are measured in pounds but these are not commonly used due to the strong percussion on the tools and stone. The sizes of the heads are: 1 pound used for small detail work, 1 ½ pounds for the most common type of carving, and 2 pounds for larger carving. The handles are heavy strength, the hammer heads attached to the handle through a center hole in the head with several steel wedges ensuring the fit. Unless you are very muscular, the 1 ½ pound hammer is the tool of choice.

[1] Pneumatic tools are discussed in greater detail later in this chapter.

Bush hammers are available in three sizes ½, ¾, and 1 inch, measured along the outside edge of the tool. The face of the tool is square and is similar to a waffle iron having small points on the face. The tool is used like a hammer and is for surface reduction of stone. The **bush and pick** tools are available with 1/2 and 3/4 inch face surfaces on one end (the bush) and with a point on the other end (the pick). These are also used to reduce large quantities of bulk stone in the roughing out stages.

A **frosting tool** is a handheld tool, its face being a bush-shaped cutting surface with a percussion hitting end, but somewhat more rounded. Used as a reduction device for fast and easy removal of bulk stone, as well as for texturing, it comes in three sizes: ½ ¾, and 3/8 inch.

A **rotary wheel (fifth wheel)** is a device made of heavy duty steel bands with ball bearing rollers for supporting large pieces of stone, weighing up to 3,000 pounds. The name fifth wheel derives from the manner in which train engines are turned around in station yards to head back in the direction from which they came. The engines are placed on a fifth wheel in the yard, turned around, and attached to the cars for the return trip. When a stone is so large that it is difficult to carve in a stationary standing position or from one spot, a carver places it on a rotary wheel so he can turn the carving rather than walk around it. I have seen a posing platform electrically attached to one of the larger rotary wheels with the model rotating slowly 360° so students could view all sides of the pose easily.

■ Carving Sets

These sets contain a basic set of carving tools placed together as one unit. The **basic carving set**, designed for the beginner, includes the primary tools necessary to carve simple pieces, plus a 1 1/2 pound hammer, in a canvas roll. The **professional stone carver's set** contains all the standard tools, plus a heavy hammer, in a canvas carrying roll. It is meant for the more advanced carver. The **miniature stone tool set** contains standard tools, small detailing tools, and a bush hammer all geared for detailing work by the amateur as well as the more advanced professional. The **stone sculpture set** is probably the most advanced set available. It includes standard carving tools, a bush and pick hammer, a firmer straight chisel which is a one of a kind oversized heavy-duty flat chisel, a 1½ pound hammer, goggles, a sharpening stone, and finishing paper, all in a wooden carrying case.

■ Pneumatic Handpieces and Tools

Before going into descriptions of specific pneumatic tools, I will explain what the pneumatic handpiece and tool unit consists of: you need an air source, most likely provided from a compressor with a 3 gallon tank (larger if you don't want to hear the motor running all the time). The compressor should have an oil attachment and a moisture filter. It will come with a ¼ inch hose for attachment to the tools to be used with the compressor. A one horsepower motor is generally enough since the handpiece will operate on 70 PSI (pounds of pressure per square inch). When buying a compressor, do not let the salesperson confuse the PSI needed to operate the handpiece with the pressure of the inside of the tank, or the horsepower needed. A 3 gallon tank and a ¼ horsepower motor will work fine, but, although less costly, the motor will run continuously and will be noisy. (For the first few years I put mine in the room next to where I was carving or outside in a shed with a longer extension hose to my workbench.) With a larger tank (50 gallons) and a motor with more horsepower, the

motor will only turn on occasionally once the pressure is built up to maintain the pressure. This type of unit is normally used in large shops where a number of handpieces run off of one large compressor. It is not normally for home use.

I recommend a quick disconnect for detaching the handpiece easily from the air hose, and a fine air valve to reduce (or cut off) the air flow to the handpiece so it will not bounce around the workbench when not in use. Without some type of shut off, the air will continue to flow directly to the handpiece and it will flop around like a fish out of water. Both can be found in NAPA auto parts stores at reasonable cost.

The handpiece is attached to the hose and holds the tools which fit loosely in the handpiece and are activated with pressure on to the surface to be cut. Pneumatic tools are steel cutting shafts that look like standard tools, except they have a turned ½ inch round shaft end. They are available in carbon steel for wood carving and carbide tipped steel for stone carving. The two piece unit runs on air power that is again separate from the tool and handpieces.

Although there are several sizes of handpieces, the most common are the 5/8, ½, and the ¾ inch. The lighter-weight tools are easier on the arms, especially after continuous use and vibration. Smaller and larger sizes are available from Italy and several U.S. manufacturers, but they are not stocked by most suppliers for lack of demand. They can be special ordered, however. The size is measured by the piston size in the handpiece shaft, which also determines the weight and diameter of the outside of the handpiece. The smaller size handpiece is the choice of most carvers since it weighs less and is easier to handle with stones ranging from 40 to 200 pounds.

The handpiece is held in the right hand and the tool shaft, after it has been inserted into the handpiece, is held in the left hand (left handed users will reverse this). When pressure is applied the tool will begin striking the stone in about 1 inch sweeps. Rotary hand grinders and sanders are available but normally they are used by professionals and steel welders for finishing.

Pneumatic tools can reduce bulk material in about one-third the time standard handheld tools require. Any serious carver will never go back to carving by hand once he or she has used a pneumatic.

The piston, inside the housing of the handpiece, is very sensitive to dirt and dust, and should be kept clear of stone refuse when not in use. The majority of operational problems are due to dust clogging the piston causing it to stick or seize. The cost of cleaning usually takes this possibility into account.

As I mentioned, a **pneumatic tool** works in conjunction with a handpiece. There are two ends of a pneumatic tool, one is the cutting surface and the other is the shank. Place the shank of the tool in the shaft of the handpiece and apply pressure. The piston within the handpiece causes the striking motion of the tool. The higher the air pressure used, and the greater the pressure applied by the carver to the stone or wood, the faster and the harder the striking action. The appropriate time period for continuous use of these tools is about 20 to 30 minutes, since the vibration and rapid percussion tire most people out in that time.

The majority of handpieces have a ½ inch shaft. (There are smaller, even miniature, handpieces that have 5/8 inch and smaller shafts, which work with smaller shank pneumatic tools. These are not interchangeable with larger handpieces and are in short supply; they can be found in Italy.

In addition to sculptors' pneumatic handpieces which are cylinder shaped, there

are mechanics' handguns (with triggers used to remove rivets on mufflers) that also work on the pneumatic air system. These guns do not really work well for sculptors although the principle is the same.

There are three general types of pneumatic tools that work with the various handpieces. They are carbon steel stone carving tools, carbide tipped stone carving tools, and carbon steel wood carving tools. All will have ½ inch shanks to fit the standard handpieces. Sizes and styles are limited by demand and by production facilities both here and abroad. The common shapes used in stone carving are points, rakes, and straight chisels, and are short bent, straight chisel, gouge, fishtail, and parting tool used in wood carving. Carbide tips are available only in the stone carving series on a smaller point, tooth (three-prong) chisel, and a straight flat chisel. Please remember, carbide will shatter if hit with too much force on a hard stone.

The largest producers of pneumatic handpieces in the United States are Trow & Holden and Bicknell; in Italy, Cuterri. The American tools seem to hold up superbly; any difficulties are easily corrected and the cost is reasonable. With the Italian handpieces this is generally not the case since they are usually returned to the manufacturer in Italy.

■ Electric Tools

While pneumatic tools and handpieces work on a percussion method, back and forth, electric tools work by a rotary method. They run on household current and normally have foot rheostats to govern the RPM (rotations per minute) of the tool bits. The basic components are a motor (1/10, 1/8, or even 1 horsepower), a turning cable (replaceable when worn) covered by a sheath that is attached to a handpiece (also detachable and in a variety of styles), and bits or burrs of various shapes and composition that attach to the handpiece usually with a ¼ inch (with smaller tools 1/8 inch) shank.

There are basically two sizes of electric tools, small and large. Both sizes can be either table top or wall mounted. Most larger machines have an option for a variable speed foot rheostat to control the RPM (normally 14,000 maximum) from zero to the maximum. Or some have a dial set device that holds the speed at set intervals within the minimum and maximum range of RPM. The smaller machines have interval settings, usually in the handle of the machine, set at low, medium, and high. There are hundreds of different burrs that can be attached to these machines available in craft stores or specialty houses for sculpture.

The **Foredom Power Tool** is probably the most versatile and all around best machine that I have seen. It has standard replacement parts that are consistent in size with those of other manufacturers and that last forever. The foot rheostats turn at 14,000 RPM with a 1/10 horsepower motor. The set comes with a hanging device, a set of burrs, and standard handpiece. The **Dremel Motor-Tool** is more of a craft or finishing tool where the entire device (motor and burr) is held in one hand and the speed is regulated by a setter. The motor is encased in a Lexan housing for durability, and it comes with a set of grinding, polishing, and buffing burrs.

■ Troubleshooting/Questions

What is the best all around pneumatic handpiece?
The 5/8 or ½ inch handpieces are the most commonly used because of their size and weight.

Is there a difference in temper between wood and stone tools?

Yes. The stone tools are slightly harder due to the wear demanded of them. Consequently they must also be sharpened more often.

Why do tools chip off teeth or chip on their edges?

This happens quite often to beginners who do not know how, or at what angle, to hold the tools, or the strength they should use when hitting with them. Usually the end teeth or left and right sides of the tool are damaged, rarely the center teeth or midsection of the tool. Most damage is done due to the inexperience of the user, not the quality of the tool.

How do you clean marble?

Marble is usually cleaned with non-corrosive abrasives, such as scratch-free Comet. Some sculptors use Clorox or even toothpaste. Larger pieces may be sandblasted by professionals.

Rasps & Rifflers - Wood, Stone, & Plaster

ASPS ARE DEVICES USED IN THE FINISHING PROCESS after basic carving is completed. These can be used for reducing wood and stone and are sometimes used in finishing metal. They are double-ended tools with small, medium, or large teeth and are made by hand, each tooth hand punched. Most rasps have a radial curve on at least one side but some may be flat. The teeth are located on both sides as well as on the edges.

Millani and Casselli, in Italy, are the primary manufacturers of rasps; they are best known for the fine quality of their products. Chinese-manufactured rasps are also available but the teeth do not hold up well as of this writing.

Rasps range in size from the miniature to the heavy 10 to 12 inch. There are basically four styles of rasps and a variety of shapes to suit most applications. The styles are **fine cut** with small teeth, **medium cut** with medium teeth, **coarse cut** with larger teeth and, **miniature rasps** with extremely fine teeth for detailing work. The size and placing of the teeth will vary with each tool since they are made by hand.

Rasps can be rounded like a spoon, pointed like a knife or in any number of other shapes. Importers have illustrated catalogs to help you choose the appropriate rasp to use.

Carbide coated rasps come in basic shapes and are coated with a diamond or carbide finish. The coating, like little chips, may or may not flake off depending on the producer. These rasps are usually coated in the U.S. using Italian tools or tool blanks.

The **rat tail rasp** has teeth like a hand-held rasp but is completely rounded and generally used with an attached handle.

Knife rasps are so named because they have the shape of a knife blade. The rounded end or handle is a rat tail rasp in itself with punched teeth over the entire surface.

Plaster rasps are rounded and concave, like a spoon, at both ends unlike conventional wood and stone rasps. They are perforated, much like a cheese grater, with sharpened cutting edges to accommodate the set plaster. This allows the plaster material to pass through the holes so the rasp will not clog up with dis-

carded refuse. The tools come in three basic sizes: 6½, 7½ and 9 inch. You may find larger sizes but these are the most commonly used. They are usually rectangular with rounded ends and are made of blackened steel. As with most sculpting tools, they can be used for functions other than plaster work, such as carving soapstone or dried ceramic clay. However, they are primarily used with hardened porous materials that are easily scraped.

Rifflers are usually referred to as jewelry or silversmithing files and are not commonly used in sculpture. Used for finishing just prior to sanding, they have cross cut grooves like a nail file, and are extremely fine. They come in a variety of sizes, are normally made without a handle, and have a plain steel circular end and a filing end.

Cabinet rasps are flat surface rasps used in the cabinet industry as well as in the sculpture field. They are used for fast reduction of large amounts of material. They are half round on the upper side and flat on the lower. There is also a combination style, four-sided with teeth or teeth and a file. The rasps are available in sizes from 6 to 12 inches and are normally held with a wooden handle secured by the tang of the rasp. As the rasp increases in size, the teeth become heavier. The tools are produced in Italy, Poland, the U.S., and in other countries as well.

The **rasp brush** is an essential item when working in wood and especially in stone. Since material particles will clog the teeth of almost any rasp, they should be cleaned out when necessary. (The finer the teeth of the rasp and softer the stone, the faster the rasp will clog.) The rasp brush does this cleaning easily and quickly. The accessory has metal brushes facing at a 30° angle toward the holder. Simply pull the clogged rasps over the bristles at a perpendicular angle a few times. I nail my rasp brush to a dust pan brush so I can dust off the piece and clean the rasp at the same time.

■ Troubleshooting/Questions

Why does the rasp wear out so fast?
Generally because the rasp has not been cleaned properly, and greater force has been applied when running the teeth against the surface being cut. Don't forget to use a rasp brush to clean all of your rasps.

Why do some rasps wear faster than others?
The temper determines the hardness of the steel cutting edges and their ability to hold up under rasping. The hardness and coarseness of the stone being carved is also a large factor; for example, sandstone will wear out a rasp faster than a soft soapstone. Tooth size and firmness of stroke have a minor effect. Some think that manufacturers offer tools of different quality, but if the proper steel and temper are used they should all hold up equally well.

Accessories For Wood Carving & Stone Carving

CCESSORIES FOR WOOD CARVING AND STONE carving include sharpening stones, finishing materials, safety devices, and other items that make specific jobs a little easier.

■ Sharpening Stones and Special Oils

Also known as whet stones, oil, and slip stones, these accessories come in a soft texture which is coarse and a hard texture which is fine, and are available in a variety of sizes and shapes. For most carvers a combination bench stone (which lies on a table top rather than held in the hand) will suffice. The type of the stone may be Ozark, Arkansas, Burma (India), or a crystolon (trade name of Norton Co.) combination.

All tools made of high carbon steel or carbide need to be sharpened after extended use on hard woods or stone. Usually after about 20 to 30 minutes of continuous use on a medium or hard material, a tool will require a touch up sharpening; after 2 to 3 hours of use it will require a detailed sharpening. Do not confuse sharpening, which gives a tool a good cutting edge, with honing, which gives it a razor sharp cutting edge. The standard sharpening position is a 45° angle to the tool's bevel; to sharpen the tool, drag it in a figure eight pattern, then remove any burr on the edge with a quick horizontal sweep, similar to doing your finger nails.

The **Burma gouge slip** is a large tapered cone shaped slip stone with a concave center and is used with the larger and deeper gouges. The **round edge slip** has tapered rounded edges for use on gouges, parting ("V" shaped) tools, and straight chisels and are usually of Burma stone composition, a medium coarse brown material used for rough sharpening. Sizes vary, the 4 inch slip being standard. The **hard Ozark round edge slip**, a very hard stone with a super fine texture, is for fine detailing and honing and will last forever.

Combination bench stones and combina-

tion stones are sharpening stones having one coarseness on one side of the stone and a finer texture on the other. They are generally rectangular in shape and lie flat on a table top. They are made of India, crystolon, or Carborundum stone. The Burma (India) has a coarse texture and the others have a finer texture. A 6 or 8 inch crystolon or Carborundum stone is fine for beginner or intermediate carvers. These stones can be used wet or dry, but at the speed you will be using you will not need to use them wet. I put a few drops of oil or a little spit on my stones; although not necessary, I do it anyway.

Handy Oil is used like regular household three-in-one oil to keep the carving tools in good shape while sharpening, honing, and storage. All tools should be wiped down with a few drops of oil after sharpening. **Rust Proofing Oil** is recommended for use when tools are stored over long periods or are exposed to high humidity. The oil prevents rust from developing on the steel blades which will decrease the tools' ability to carve efficiently.

■ **Finishing Materials**

For finishing a wood carving or stone carving piece, follow these simple steps: After the final rasping, sand with coarse or heavy sandpaper or a mesh carbide screen, beginning with the coarsest and ending with the finest.[1] Next use wet-dry paper, again from the coarsest to the finest, and finally use a paste made with powdered pumice. Use abrasive papers or a smoothing screen in the step before the final finishing and buffing process. Finishing paper can be cut into more workable strips for easier handling. A basic sheet is 8 by 10 inches and hard to handle; cutting it down to 2 by 6 inch strips makes for easier use.

[1] Please note, the lower the number of grit, the coarser the cutting action of the material.

Adalox Paper is a sandpaper available in a variety of grits, or coarsenesses ranging from extra fine to heavy coarse. This is a long lasting material called openkote and is primarily used in wood carving.

Durite Screen-Bak is an open mesh screen material coated with a silicon carbide. It comes in 100, 180, and 400 grit. Particles will come off the paper after prolonged use but it lasts for hours of finishing. One piece should finish 3 square feet of medium stone. With use screen-bak will become softer and more pliable until it has to be discarded. It is used primarily in finishing stone. It can be used for finishing wood and plaster, but the sawdust or plaster must be continuously removed by slapping the material against a hard surface to keep the openings clear.

Wet-Dry Paper, available in 200, 320, 400, and 600 grit in 9 x 11 inch sheets is similar to a black Carborundum paper and can be used dry as well as with water. It is an excellent finishing material in the final sanding stage. Although it is mostly used on stone, it may be used successfully on harder woods. When used with stone in the wet form, the stone can be placed in water and the paper used to make a thin paste for each of the abrasive finishing steps. As the water washes off the paste from the stone, the stone will begin to exhibit the appearance of its final polish. As it dries the stone will return to its original luster until final polishing is completed. Since the paper clogs when wet, you should wash it to remove the excess material that has accumulated; the paper also needs occasional cleaning when used dry.

Powdered pumice is an abrasive material used in polishing after the initial sanding. It is made into a thick paste by adding a small amount of water and then rubbed over the areas to be finished.

Tin oxide is a powder that is <u>not</u> an abra-

sive like powdered pumice but a deep penetrating polish that will bring out the essence and inner beauty of the piece. It is made into a paste by adding a small amount of water, and then rubbed or buffed on the piece by machine until the finish (matte buff or high polish) is completed. On softer stones this polishing is accomplished quite easily, but on medium to hard stones it will take much more effort.

Jewelers rouge (rotten stone) is used to achieve highly polished surfaces and is applied with an electric buffing wheel at extremely high speed. It comes in hard block form and is impregnated into the buffing wheel and then applied to the surface to be buffed. Polished marble walls, headstones, and table tops are finished in this way. This material is usually used only by the professional or by more experienced stone or wood carvers.

Paste wax is an instructor's short cut to real polishing (I like Goddard's furniture polish myself). A few coats of butcher's wax on stone or hard wood will give good results in minimal time, but sculptors from the old school, true to tradition, will always take the long route, with no cheating. If you are working in soapstone wet-dry paper will produce its own paste and a simple buffing cloth (an old tee shirt is fine) can finish the piece to a high gloss. This may work with softer alabaster, but you will not get the high gloss usually desired. With the harder stones, forget it - you have to polish to achieve the gloss.

■ **Safety Devices**

Safety goggles, for eye protection only, are usually made of high impact plastic, can be worn with or without glasses, and have an adjustable elastic band that goes around the head. They cover the eyes and the bridge of the nose and should be worn whenever working in stone, wood or plaster (that might come into contact with the eyes). This is only common sense.

A **face shield,** a helmet-like device used for eye and face protection only, is a piece of high impact plastic that covers the entire face and is supported by an adjustable head brace that fits on the head like a cap. It can be used with or without glasses. When not in use the mask section can be flipped up over the head and out of the way.

The **dust mask,** a triangular padded device that covers the nose and mouth, is used to reduce the inhalation of flying particles, such as sawdust or dust, produced when sanding or finishing wood, stone, or ceramic pieces. The most commonly used masks have a cotton filter that is replaceable and are meant for light dust situations. There are heavier-duty masks for specific situations which can be found in larger hardware stores.

There is an extensive assortment of **respirators,** which provide higher levels of protection than the dust masks. They are differentiated by the toxic levels they withstand. For sculptors, the highest level of danger facing them would probably be met when casting in resins (plastics); however, most people will not be doing this type of casting. In other words, the average sculptor, working with material having a danger level no greater than paint, paint thinner or latex rubber, should use the common respirator found on the market with cylinder type filter devices. If you need more information, please consult a professional. Professionals will know the proper respirator to use.

Replacement filters for dust masks and respirators can be purchased separately.

■ **Other Accessories**

Wood carver's bench screws are 3 inch long

steel screws used to fasten a carving block and hold it securely to a workbench. The carver would clamp a board onto the work surface, and run the screw through the board and into the piece of wood being worked on. When carving is completed, the piece is removed from the screw and mounted for display.

Canvas rolls are used for holding miscellaneous loose wood carving and stone carving tools if they have no wooden set container. The rolls may also hold rasps, and even steel tools for mold making and some ceramic tools. (These last two, however, are usually carried in a plastic case since water is used in mold making and ceramics.) They are of roll type heavy canvas secured with tie strings, double stitched on the seams, and are available in 6-, 9-, 14-, and 22-pocket sizes.

Aprons are like chefs' aprons with specially designed pockets for holding various wood carving, stone carving, and ceramics tools. They fall just above knee level and have a cotton tie string fastened behind the back. At one time they were made of leather, but, due to the cost and scarcity of this material, most aprons are made of heavy denim today.

Sand bags are meant to brace or secure a large piece of raw stone or wood so that while carving it will not shift and fall over or move - like padding furniture when moving. They can be arranged like pillows on a couch for comfort if you take a rest. Normally made of heavy canvas, they are approximately 8 by 10 inches in size and usually have Velcro closings or securing devices. They are sold empty. While you don't have to put sand in them you should put some material in them that will give a little. I imagine that 4 sand bags should be sufficient to balance any piece you work on.

Pottery & Ceramics

PART 4

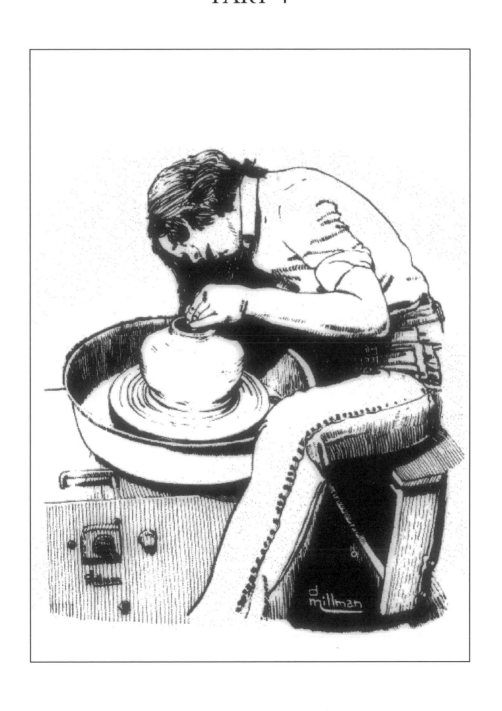

Pottery & Ceramic Clays, Equipment & Accessories

ottery clays and ceramic clays are virtually the same; they are all made with a water base and need to be fired in a kiln to vitrification to become permanent. The primary types of clay bodies are earthenware and stoneware which turn red, brown, or white when fired. Specialty clays such as Raku and porcelain are used by the more advanced potters.

Clay used for pottery is indigenous to only certain regions of the world and every manufacturer uses the same base clay. United States clay body formulas are generally a mixture of several different types of clay, derived primarily from clays mined in Georgia, Tennessee, Ohio. Small amounts of darker clays that make up a formula, such as Van Dyke Brown, are found in New Mexico. Clay mined in California has a gritty coarse texture and therefore, is not usually used in formulas. Fine grolegg clays from England are used for making porcelain clay bodies.

The manufacturer develops a formula or receipt and mixes the ingredients with a ribbon blender or pug mill, adding water. Some producers have a vacuum chamber on the extruding end of the mixing machine to de-air the extruded clay, thus calling the final product **de-aired.** However, I recommend that all clay, when taken from the container, be wedged, that is, remove the air pockets before using and firing in a kiln to make sure no air is captured in the final piece to be fired. In the kiln, as the heat gains in temperature, gas may form in the air pockets, causing them to explode and ruin the piece. Experienced potters have all had this happen at one time or another.

Some formulas I know of have very unusual additives, such as vinegar, to the mix. I have not noticed that this makes much difference to the quality, smoothness, or outcome of the finished product, but who knows? Bentonite is the only additive I know that enhances a clay body, making it more plastic without the normal aging process (where the clay is allowed to set for a few weeks to let the molecules migrate).

Special formulas are made up by potters

who experiment with various raw materials over time. They express individual preference, serve generally as a signature of the potters, and are kept very secret. Special formulas can be developed for both glaze and clay. When using anything other than a standard clay or glaze, test both the clay and glaze to ensure they match. If they are not compatible, trouble will ensue when the piece is fired. It is a good idea, when a new clay and glaze are going to be used, to make test tiles of the two to be sure there will be no problems.

Slip is a liquid clay with suspension additives that enable the clay to be cast into plaster molds made of pottery plaster for its water absorbency. The mold is filled with slip and left about 3 hours to absorb the water from the clay until a thin skin about 1/8 inch thick has formed. The remainder of the liquid clay is poured out and the resulting cast of clay left to harden. It is then removed from the mold and when dry, the seam lines from the mold are trimmed and the piece is bisque fired. Glaze is then applied and the piece is glaze fired. The piece is now completed. Figurines, plates, and ash trays are commonly done in this manner, as well as most porcelain pieces. On mass produced items you will see seam lines where the pieces of the mold have been joined together.

■ **The Equipment**

Potter's Wheels
Potter's wheels are disks which when rotated enable clay to be shaped by a potter. There are several types of wheels on the market today, although fewer than in the 1970s when making pottery was in its prime. Most wheels are electric or kick powered; some of the electric wheels have variable speeds or set speeds of high or low. The power of a wheel influences the amount of clay that can be thrown

and/or centered. When purchasing a wheel the essential points to be considered are the horsepower, how much weight the wheel will hold without jerking while centering, and the stability and levelness of the wheel head, since, if the balance is off, so will be all of the pottery. The best wheels that I have thrown on are the **Shimpoo** with a cone drive and a large horsepower motor (this is the top of the line in electric wheels and centers 100 pounds of clay usually taking two people to center), the **Brent Wheel** (designed by Robert Brent), the **Amaco two speed** (which will center 25 pounds of clay), and the **Spinning Tiger**. Other wheels cannot hold the weight of the clay without the wheel stopping or resisting. If you only intend to throw small pots, bowls, and the like, a more powerful wheel is not really necessary. Your supplier will be able to advise you as to the best wheel for your specific use.

The size of a pot is determined by the amount of clay used to make the piece. Most mugs, cups, and similar pottery require 2-3 pounds of clay. The clay must be centered precisely on the wheel head in order to bring up the side walls of the piece. To obtain the centering of the initial ball of clay, it must be pushed downward and inward. The greater the weight the more restriction on the throwing head which may jerk or even stop. This is how wheels are gauged as to the weight they can handle - 25 pounds, 30 pounds, 50 pounds, etc.

Kick Wheels
A kick wheel is basically a potter's wheel head attached to a shaft that is turned by pushing a large heavy fly wheel with your foot. The bottom and top of the shaft are held in position with bearings used to adjust the level of the wheel head. Most kick wheels are made with cast cement reinforced fly wheels and heavy steel plates or bricks set between two sections

of wood. Standard throwing heads and shafts of 2 to 3 feet are the center pieces and are built around a frame that usually contains a seat and a shelf. The wheels are usually shipped in component parts requiring assembly. A few offer motorized attachments that will power the fly wheel.

Kilns

Kilns are the ovens used to fire ceramics at a high temperature, normally at greater than 1,400°F. There are three types of kilns, each having a different effect on the finished piece: the **electric kiln** (the standard), the **gas fired kiln** (more professional), and the **wood fired kiln** (not common). The more complex kilns such as down draft, wood stacked (wood fired) and gas fired kilns, are used by old time potters, production potters, or businesses but because of their cost, size, and difficulty in firing are not normally used by craft potters or school systems. There is one another type called the **enameling kilns,** smaller in size than ceramic kilns and used to fire metal objects usually in sheet form such as copper.

Kilns are usually either round or square; the size, voltage requirements, and inside firing chamber dimensions vary depending on the desired temperatures. There are low fire kilns with temperatures to cone 06 (1841°F) and high fire kilns with temperatures to cone 9 (2345°F) and above. Low fire kilns reach maximum temperatures within 6 hours or so. High fire kilns need more power and take longer to reach their maximum temperature.

Kilns are constructed of grooved fire brick encased in a metal shell with a peep hole to see inside the kiln. Metal elements for running the electricity are embedded within the fire brick. Some kilns have thermocouples and rheostats to measure and control the temperature and automatic shutoffs to turn off the kiln when the desired temperature has been reached. The majority of kilns have low, medium, and high settings and are turned up at intervals until the highest firing stage, low, medium, high, has been reached.

Automatic shutoffs and kiln setters are usually used with cones that melt and sag at a certain temperature; they disconnect the electrical circuits thus shutting off the kiln. The cone is placed in a three prong position with two base rods and a top rod securing the cone. When the cone melts the top rod drops, breaking the circuit. A **pyrometer** is a gauge, with its display on the outside of the kiln, used to measure the internal temperature of a kiln. It is used where there is no auto shutoff.

■ Firing[1]

There are two types of firing: **bisque firing and glaze firing,** both done in kilns at temperatures which can range from cone 014 to cone 10. Most clay is bisque fired at cone 06 and vitrifies around cones 5, 6, or 7, depending on the clay body formulation. Most commercial glazes are also fired at cone 06.

Bisque firing

Bisque firing is the initial or first firing of a dried piece of pottery or ceramic, also known as greenware, performed before glaze firing. It is used to bring objects to a state more accepting of the glaze. Normal bisque firing takes about 6 hours at cone 06 (1841°) in a three-stage electric kiln. The pieces can be stacked within one another or close to each other and can touch so more pieces can be bisque fired at one time. (This is not the case with glaze firing.) Not all pottery has to be bisque fired first; especially with smaller pieces, the glaze can be applied directly to the dried clay and

[1] There are several unique firing techniques such as **reduction firing**, **salt glazing**, and **pit firing** with tree leaves which won't be dealt with in this manual, although they are fun to experiment with when you are more advanced.

the piece fired only once. I do not recommend this for the novice, however.

Glaze Firing

Glaze firing is the second or final firing after the piece has been bisque fired. Glaze is a colored liquid material that can be matte, gloss, speckled, of burst design. It is a silica which when heated fuses together and forms a glass-like coating. There are hundreds of glazes on the market for use at different firing ranges. Talk to your local ceramic supply store for specifics on particular items or effects desired. Gold, platinum, and silver leaf are specialty low fire glazes used for edging plates and bowls in the china industry as well as in intrinsic pottery design.

Unlike bisque firing technique, separate all pieces when glaze firing; if they touch, the glaze will run and fuse the pieces together. **Stilts,** fired pieces of ceramic of various sizes with three metal points that will withstand any kiln temperature, are used to support the pieces in glaze firing so when the glaze melts they will not fuse together or to the inside of the kiln.

With standard off the shelf commercial glazes, three coats are applied. Each coat should be applied in a different direction and left to dry thoroughly before the next coat is applied. Do not overapply the coats or the glaze will run and pool off the piece when it is fired. Most commercial glazes are fired at cone 06.

A material called **Wax Resist** can be used for areas of the piece where glaze is not desired. It can be found in ceramic supply stores. **Kiln Wash,** a powdered material, can be placed on kiln shelves and the bottom of a kiln to prevent excess glaze fallen from a piece during firing from sticking to the shelf or bottom surface. When firing **beads** place them on wire supports running through the inside of the bead like a clothes line.

Since most commercial ceramic and pottery businesses do not do outside firing, preferring to be responsible only for their own pieces, and you don't have a kiln and want to fire some pieces, try an adult school with ceramic classes or the local YMCA or YWCA.

■ Firing Ranges/Temperatures

When a kiln is used for bisque or glaze firing the internal temperature of the kiln must be regulated to avoid under-heating or overheating. This is done by with the use of cones, prefired clay in triangular form, that sag or bend at given temperatures. The higher the cone number the higher the temperature range. Cones are placed at the bottom, middle, and top of the kiln, since temperatures vary in these areas. (Most people use three cones in a row at the each of these levels with one cone at a temperature lower and one higher than the firing requires.) The sagging of the cone as seen through the kiln's peep hole lets the user know when the correct firing temperature has been reached.

Firing temperatures are called cones and can range from 014 (lowest) to 10 (highest). As I mentioned earlier most commercial clay and glaze are fired at cone 06.[1] They will vitrify at a higher temperature, that is become non-porous. However, normally the lower firing range 06 glaze will be poured/applied to the inside of a container, allowed to fuse, and thus enable the container to hold water without the clay having to vitrify. Most clay is made up of silica and when fired at high temperatures (over 1,000°) fuses or meshes together making it hard although it may not be vitrified (non-porous). When a glaze, which is also a form of silica or glass, is applied to the inside of a

[1] High fire kilns in the cone 10 and higher range are expensive and take longer to fire, preventing the one-day firing most schools require.

container, the piece is fired in the same manner, the glaze fusing and creating a non-porous surface and often a high gloss. The stated firing ranges of clay and glazes are those generally used for the bisque and glaze firings; while most clays can withstand a higher temperature, the color will darken and if the temperature becomes too hot the clay may sag or warp.

The higher the temperature at which a piece is fired, the darker and richer the color, or the greater the brightness of white clays. If the clay is a lower firing clay it may warp, sag, or even break up when over-fired. Glazes also react to different temperatures. Red glaze can become brown and blue glaze can turn black. Unless fired at the proper temperature funny things will happen to both the clay and glaze. Be sure to consult the manufacturer for proper firing ranges.

Since there is a wealth of information on ceramic and firing processes available to the amateur sculptor, I will discuss only the basic firing cones of each clay here. The first number is the bisque firing cone, the second is the vitrification temperature. For example, for cone 06-10, the 06 is the bisque firing temperature, the 10 the temperature at which it vitrifies.

Earthenware

These clays generally vitrify at a lower temperature than the stoneware or porcelain clays. Basic earthenware clays include: **Malone Red,** red, cone 06-2, **Artware** white, cone 06-2, **Cedar Heights,** red, cone 05-2, **Dresden,** white, cone 06-2, **Van Dyke Brown**, dark brown, cone 06-2 , and **Terra Cotta**, brick red, cone 06-2 .

Stoneware

These clays include: **Hugo**, off white, cone 06-7, **Standard Buff**, light buff, cone 06-7, **S.C.M. Stoneware**, toast brown, cone 06-7, **Speckled Stoneware**, rich brown with manganese specks, cone 06-7, **Brooklyn Mix**, reddish brown cone

06-10, **Samson Throwing**, light brown, cone 06-7, **Studio Throwing**, light brown, cone 06-7, and **Dover White** with grog, white, cone 06-7.

Porcelain

Porcelain, translucent white, cone 2 to cone 9, is in a class by itself. Porcelain is usually used in the liquid slip form for small figurines and doll parts such as the head, hands, and feet. Most porcelain is slip cast in molds and then fired. For wheel throwing it is very difficult to manage due to its fine texture. The firing technique for porcelain is also somewhat complicated since special struts are usually constructed around the pieces so that sagging and distortion do not occur. I would suggest using porcelain only if you have the time and patience or are extremely familiar with the procedures required to throw, cast, and fire it.

■ Potter's Tools and Accessories

Tools

Most of the tools used for sculpture can also be used for ceramics and pottery, but there are also tools that have been designed especially for ceramics.

Loop tools are medium size, heavy, sharpened steel tools with palm size handles for easy use when working on the potter's wheel during the trimming and footing process. The shapes, designed for hard to reach places and flat scraping, are diamond, curved, round flat, and one with the coined name "**pear corer**" having a duck nose shape. The **trimming or needle tool,** an essential item for the potter, is used to level the excess from the top of a pot. Some have metal handles with a single needle end; others with wood handles have a needle on each end of the tool. **Fettling knives**, available in different lengths from 4 to 8 inches and made with firm or soft steel blades, are excellent for scrap-

ing, cutting, and removing dried clay from seams and other areas. A **notch knife** or hooked blade is used for grooving channels in the mold so it will not shift in casting. **Elephant ear sponges** are natural Mediterranean sponges, 2 to 5 inches in size, that have the shape of an elephant's ear; their shape allows them to be held comfortably in the hand while throwing pots. Their strength and shape help to absorb excess water applied when bringing the walls of the pot up. **Turning tools** are long-handled handheld tools with metal pre-shaped cutting edges used to shape internal areas of pottery.

Accessories

It is essential to know the internal temperature of a ceramic kiln when firing. **Pyrometric cones** of prefired ceramic triangular in shape and of various sizes fulfill this requirement. Placed in the kiln during firing, they sag or collapse at certain temperatures. If the kiln has a shutoff device, this sagging will cause the kiln to be automatically turned off. Or, viewing the sagging through the kiln's peep hole, the operator can adjust or turn off the kiln. They are also used to determine the temperature in different areas of the kiln since temperatures can vary within the kiln. Typically 3 cones are set in each of 3 rows at 45° angles with the lower temperature on the left, the required firing temperature in the center, and the higher temperature on the right, and should be visible through the peep hole. When the cone sags so that the tip falls half way to the cone holder (or plug of clay into which the cones have been placed) it indicates the correct firing temperature has been reached. If it melts all the way down the temperature is too high and if it does not melt at all the temperature is too low.

Kiln shelves are either round, half round, or (most commonly) square. They are used to separate glaze fired pieces in the kiln during firing and are supported by **posts**, which are triangular, round, or square and come in different lengths. They are of high fire material and can withstand temperatures of any range in commercially produced kilns. Stilts support the pieces of pottery being glazed so they do not fuse together.

Potters ribs, which have thumb notches and index finger holes for easy gripping, are used to assist in pulling up the inside of a pot, contouring the pot's outer surface and for shaping on the interior and exterior of a large bowl or pot. Also known as **modeling ribs** or **wooden potters ribs**, these tools come in numerous shapes and sizes. The shapes enable the potter to achieve almost any type of form. A **toggle clay cutter** is a 36-inch piece of wire, secured at each end to a wooden handle, used to cut sections of clay in the wedging process and for removing thrown pots from the wheel. **Throwing sticks** are used extensively for pulling up interior walls of small necked pots and vases.

There is a basic pottery tool kit which includes the tools essential for throwing and removing thrown pots from the wheel head while they are still wet. There is a full set of trimming tools including a needle tool for trimming and leveling the top of the thrown pot when necessary, a sponge for water absorption while throwing, and a potter's rib. With this kit, all you need is some clay, a wheel, a kiln, and some skill to make any type of pottery you'd like.

■ Troubleshooting/Questions

If the clay is dry what can I do?

Sometimes when water-base moist clay has not aged properly or does not contain enough water it will seem dry. Add a little water and knead it into the clay body (25 to 28% of water to clay flour mix is a good ratio), then let the clay sit in the closed bag for a few weeks.

If the clay is too wet when removed from the bag what can I do?

This occurs naturally with normal condensation of water-base clay kept in a container, more often with porcelain and stoneware than with earthenware clays. Roll the clay in several layers of newspaper until it dries up a little.

There is a funny smell when I open the bag; what is this?

Clay is a naturally formulated earth material. When water has been added and it is contained in a bag, a smell often develops. This is no indication the clay is bad or defective; it is natural. Let the bag air out for a few minutes and then use the clay as usual.

The color changes between separate orders of the same clay; why is this?

Remember clay is mined from the earth in different areas of the country. The clay may vary in color but not generally in texture, composition, or workability. As long as the chemical composition remains the same, the clay should work and fire the same.

Why does the clay crack when I bend it?

This is usually indicative of what is known as short clay. Add a little water and age it a few days.

When cooled why does the glaze have cracks like a spider web?

This is not uncommon and can be caused by several things. First, the clay and glaze may not be compatible. For future firings make test tiles trying different glazes with different clays to determine compatibility. Second, the glaze may have cooled too fast and constricted. This occurs when the kiln is opened too soon before the pieces are ready. Third, the glaze may have been applied too thinly or all coats may have been applied in the same direction rather than altering the direction with each coat.

Why are there glaze bubbles on the clay?

This can be caused by incompatible clay and glaze or the glaze may have been fired at too high a temperature. Too much glaze may have applied which will happen when the piece is dipped rather than applying the glaze by brush.

Why does glaze drip off the piece and fall on the shelf or bottom of the kiln?

This is a result of over-glazing. The dried glaze can be sanded off before firing if there is too much of a build up. The glaze on the shelf presents a small problem. It can sometimes be chipped off, using a wood carving or stone carving tool and hammer without causing damage, but not always.

What causes crazing, running, bubbling and flaking?

These mishaps, faced by all ceramists, can be caused by firing with incompatible clay and glaze, by cooling the kiln too rapidly, by firing the kiln too high, or by over-applying the glaze. Don't be discouraged; just follow the instructions and try again!

General Questions

Can you melt down plastilina and add ingredients to make it white or colored?

Plastilina is an oil and wax base material and cannot be melted and have components added to it to give it color. Although the material can be made liquid by heating in a specialized method, the oil soluble pigments are not readily available to the consumer and regular pigments will not adhere properly. The ingredient that colors plastilina "white" is called whiting and must be added when the batch is first made hot in the mixer, usually a large dough mixer or sigma blade mixer not readily available to the average consumer.

Does armature wire (aluminum wire) come in larger rolls than the coils normally sold?

Yes, this wire is made at a mill that produces this material to exacting standards. Unfortunately the bulk rolls weigh between 80 and 100 pounds each and the weight of each roll is not consistent. The bulk rolls are therefore not available for sale to the average consumer since the cost to determine the true length is prohibitive. Most consumers do not need the larger rolls of material, in any case.

What is Moulage used for?

Moulage is principally used for prosthetics for replacement limbs, fingers, etc. after amputation. The material produces a good likeness. In the sculpture field it is used extensively for face masks, relief molds, and body parts. Since the material is an alginate and can be used repeatedly, its expense is justified.

What is the Cesta bucket reinforced with?

This bucket is a heavy impact rubber reinforced with fiber glass strands making it one of the most durable mixing buckets available.

What can you add to plastilina to make it harder or softer?

Wax is the hardening material used in plastilina. Melted wax is mixed with the formula's other component, the final material then setting to the appropriate state of hardness. While it is very difficult to mix in additional wax after the material has set to achieve additional hardness, you can try by following these steps: Place the original plastilina about 2 feet from a 60-watt lamp until the material becomes soft enough to knead with your hands. Next soften the wax of your choice,

either by melting it or warming it near a light bulb. (I suggest using Microcrystalline Wax, not paraffin which is too brittle.) Knead the liquefied wax into the softened plastilina, and let set at room temperature until hard. By testing, you will determine the amount of wax needed to achieve the desired hardness of the final plastilina.

Oil is the <u>softening</u> material used in plastilina and can be added to it to achieve additional softness. A regular grade household oil is sufficient for softening small amounts of material. Three-in-one oil is good or a 10/30 weight motor oil can be used. Soften the plastilina near a lamp bulb and knead the oil, in small amounts, into the plastilina.

For grinding or mixing, I suggest using an old fashioned hamburger grinder from the hardware store when either hardening or softening large amounts of material.

Can different grades of plastilina be mixed together for different effects?

Yes. The same procedure should be used as in hardening and softening. Place the material near a lamp and when soft, knead them together.

Plastilina looks as though it is layered when pieces are torn from the block. Why is this?

When plastilina is produced it is extruded through a heavy duty worm gear mixer extruder and thus the internal areas are layered. The outside surface is smooth because the extruding head forces the material into a given shape.

Can mold rubber pieces be used repeatedly?

When the mold rubber is cured after setting, it can be used to make about 100 simple casts of nonabrasive material such as casting plaster. Abrasive material such as cement causes more rapid deterioration. When a positive cast is made from casting rubber, the piece, once set and cured, cannot be re-used. Once either the positive or negative rubber has set it cannot be re-used.

What are shims and which is better, aluminum or brass?

Shims are the separating pieces that mark the areas of a piece mold where the divisions are made to remove the mold for casting. They can be of clay, wood, metal, or other material that enables easy separation of the sections. Most sculptors use brass or aluminum because it is thin, flexible, and can easily be cut to conform to the areas needing separation. A shim is generally not more than an 1 ½ inch in width since the mold walls will not be more than an inch or so thick. When the shim is placed in the model this inch is all that should be exposed since the plaster mold will only come to the top of the shim. Brass was used before aluminum but brass rusts when exposed to the water in the plaster, turns green, and can even corrode. Aluminum does not have these problems, so I suggest aluminum shims if you have a choice.

Is there silicone in White Rubber?

No. Silicone is a rubber specifically made of silicone. White rubber is not a silicone rubber.

What is the difference between positive and negative molds?

A negative is referred to as the mold since it creates a cavity into which material is poured to make a cast. The positive is the cast derived from the negative mold. The piece or model of which a reproduction is made is the **positive** and the mold made of the model for casting reproductions is the **negative.** Making a cast is positive; making a mold is negative no matter what mold making material is used.

What is the difference between Mold Rubber and Moulage?

Mold rubber is a latex base rubber that once exposed to air sets and cures and cannot be reused. It is an excellent material where multiple casts are required; the mold will give years of use. It can be stored and reused for casting for as long as 20 years.

Moulage is an alginate type of material used for quick body part casts. It can be stored for only short periods of time since it has to remain moist. An advantage of Moulage is that it is reusable and can be melted down after an initial mold and cast have been made. Moulage can be used to make molds of the face whereas latex cannot since it inhibits the breathing of the skin during the time it takes to set and dry. Moulage is removed after a few minutes while it is still somewhat moist.

How does Bone Emulsion compare to Hydrocal, Hydrostone, and Vatican Art Casting Stone for hardness?

Hydrocal and Hydrostone are natural gypsum products with their own tensile strength. Vatican Art Casting Stone is a mixture of different grades of gypsum and marble aggregate. Bone Emulsion is a water-base mixture of hardening ingredients such as cornstarch, etc. Adding Bone Emulsion to gypsum or moist clay enhances their strength but does not make regular casting quite so strong as Hydrocal. Of gypsum materials, casting plaster is the hardest, followed by Hydrocal, Hydrostone, and finally Ultra Cal. Industrial grade gypsum is the strongest but is only used industrially due to its coarseness. Each material has its own specific use. Casting plaster can be used for molds and casts, Hydrocal should be used for casts and sometimes, if you are experienced, for molds. Hydrostone and the harder casting materials should only be used for casting, not mold making.

What is a brush up mold?

A brush up mold is made of a thixotropic mold making material. Chemical components are mixed together to form a paste. The mixed material will have the consistency of mayonnaise and when set will be a flexible rubber. The mixing proportions can be somewhat difficult to achieve and its use is not common among artists with average experience. It is a good material for making molds of ceiling or crown molding when remodeling older homes.

What is the difference between alabaster, marble, and soapstone as far as hardness is concerned?

The softest stone is soapstone, yet there are different hardnesses of this material. The next hardest stone is alabaster, which also comes in different hardnesses. Marble is the hardest of the group and has different hardnesses depending on where it is quarried, Colorado, Vermont, Spain, Italy, or Portugal.

In addition to these stones there is granite which is extremely hard and not recommended for the average carver. Fieldstone is a "don't touch" stone for carving. Wonder stone (soft), Feather Rock (volcanic ash), and Maple Rock (compressed clay, unfired) are specialty stones and are generally hard to find.

What stone and types of tools would be good for carving letters?

The best stone for carving letters would naturally be a harder stone; a good all-around stone that is easy to carve is alabaster. The specific tools are the smaller flat chisel and miniature stone carving tools available individually or in a set. Carving letters takes some practice since the ends of the letters tend to chip; that is why you see roman letters with a small tang on the ends.

Which clays contain sulfur and which do not?

The only clay containing small trace amounts of sulfur is professional grade plastilina. School grade plastilina and water-base ceramic clays do not contain sulfur.

What is the difference between Boneware and Claystone?

These are trade names for self-hardening clays offered by Sculpture House, Inc. Boneware is a natural ceramic type of clay that has no fillers. Claystone is also a natural clay but contains a cotton fiber filler to reduce shrinkage. Claystone is used over armatures as the filler prevents cracking. Boneware is used as a direct modeling clay without the use of an armature, or for press molding or casting, where the clay is directly pressed into a mold and left to harden to a leather-hard state before removal. Other manufacturers of self-hardening clays have different formulas and should be contacted directly regarding specific uses of their material.

What is the difference between Della Robbia, Claystone, and Boneware? And what is the hardness difference?

Della Robbia can be fired to a deeper richer color in the kitchen oven without adverse effects although firing is not essential to this material. Boneware and Claystone should not be fired in any way, but left to air dry. All three achieve virtually the same hardness and no significant difference can be seen by the naked eye. The only differences are in the color and how you use the material. None of the self-hardening or kitchen oven baking clays will come close to what a fired ceramic piece can be so don't think of these clays as a replacement for the real thing. They are for decorative use only, will not hold water, and are definitely not for functional use.

Can you get a Pliatex instruction book without getting the entire kit?

No. The instruction books are available with the kit or a more comprehensive book can be purchased separately by ordering Mold Making, Casting & Patina for the student sculptor by Bruner F. Barrie.

Where do I get directions for mixing plaster, Moulage, etc.?

Mold Making, Casting & Patina for the student sculptor contains the required information. Mixing plaster is by water and powder proportionately. Instructions are usually on the container. The mixing proportions are approximately one quart of water to five pounds of powder. Since so many types of molds can be made, all of which must conform to the specifications of the model, I suggest referring to the above mold making book. For bronze, vented, and gauged molds, Methods for MODERN SCULPTORS by Ron Young is suggested.

What is the difference between circular and bas-relief modeling turnettes?

The bas-relief turnette has a back board so that a model can be made at an angle whereas the circular turnette has holes for aluminum wire to support an armature. Bas-relief is a raised design on a flat surface. In the round describes a three-dimensional sculpture.

Which wax is the hardest for making jewelry?

Wax is available in many different hardnesses. The hardest used in the sculpture field is roman casting wax. This is poured into a mold in wax form for bronze casting investment where the wax is melted from the mold before pouring the bronze. Beeswax, French, and Microcrystalline (micro) waxes are used more for direct modeling. The nut brown micro wax is the most commonly used although not the

best; cost is a factor here. Jewelry wax is normally made specifically for jewelry making and comes in rounds, squares, and even sheets and tubes. Sources are specialty houses in the craft field. It is available at most craft supply stores.

Is Pliatex mold rubber flammable? Is it the same as latex?

Yes. Pliatex mold is latex rubber and yes, as with any rubber it is flammable but at very high temperatures of 600°F.

What is the difference between Hydrostone and Vatican Art Casting Stone?

Hydrostone is a pure gypsum product with a low absorbency rate and high degree of hardness. Vatican Art Casting Stone is a mixture of several gypsum products and marble aggregate to produce a stone-like effect and hardness. It is still essentially a gypsum base product and should be treated as such, meaning it is not for outdoor use.

What is the difference between Mold Rubber and Casting Rubber?

Mold rubber is the material used to make the negative mold from which a cast will be drawn. Mold rubber is the negative. Casting rubber is the material that is poured or cast into a plaster mold and is the positive. It is used for dolls heads or hands. Casting rubber is the positive.

Can you cast casting rubber into a latex mold?

No. The casting rubber to make a positive rubber cast can only be poured into a plaster mold. The plaster absorbs the moisture in the casting rubber leaving a solid surface that in essence becomes the cast when dry. If casting rubber were poured into a rubber mold of any type there would be no absorption and thus no drying or setting. The rubber would be self sealing.

Can you pour latex solid?

No. Latex mold rubber must be applied in thin coats, a layer at a time. Each coat must be thoroughly dry before the next coat is applied.

What materials can you cast into latex rubber molds?

Only gypsum products (such as plaster and cement) can be cast into latex molds. The heat source from any other materials can distort the interior surface of the mold and thus the cast. This does not always happen, but I cannot recommend anything other than gypsum products. Why take the chance? Once the mold is distorted, there is no fixing it.

What is the difference between French wax and pure beeswax?

The French wax is a combination of several waxes to make a smooth modeling compound. Beeswax is a natural wax from the hive. Beeswax is more expensive and is usually used for dressing wood or for batik and tie dye shirts. They are both good waxes; your choice of which to use is one of preference.

What is hot metal plaster and how is it different from casting plaster?

The thermal expansion and heat absorption of hot metal plaster can withstand the high temperatures of molten metal such as lead and pewter, but not bronze. The mold (made from hot metal plaster) will not crack or explode when lower melting temperature metals are cast into it. Casting plaster will not withstand high temperatures and may crack or break if these materials are cast into this type of mold.

What are low temperature metals?

Lead is the first that comes to mind; pewter is also low melting but is a combination of lead and tin and is not that easy for the average sculptor to cast. Lead isn't that easy either since

it has to be cast in one continuous flow or striations and layering will occur.

What does ceramic firing 06-7 mean?

It stands for the cone firing ranges of the clay. The 06 is the bisque firing temperature of a ceramic clay body (1841°F) and the 7 is the vitrification or maturing temperature of the clay (2280°F). The vitrification and glazing temperatures are not necessarily the same. A clay that has a cone 7 vitrification can be glazed fired at cone 06 with no adverse effects. At the vitrification temperature the clay becomes nonporous.

What is PosMoulage?

It is the positive casting material that can be used in conjunction with the mold material Moulage. It is a wax that can be brushed or poured into the moulage mold to create a positive cast. Microcrystalline Wax or any other wax can also be used in the same way. The natural color of the PosMoulage is a main advantage of this material; the ease with which it can be brushed on is a second advantage.

Sources - Specialty Items

Your local Yellow Pages are generally the best source of information regarding the location of specialty items.

If, however, you cannot find what you want, try two fine sculpture publications that carry advertisements for bases, pedestals, mold making, casting, patina, and casting wax. They also contain information on all the carving stones imaginable as well as exotic woods and classes in sculpture. These publications are:

Sculpture Review published by
the National Sculpture Society; and

Sculpture Magazine published by
the International Sculpture Center.

You can contact these organizations for general sculpture information, their associations and membership costs.

National Sculpture Society
1177 Avenue of the Americas
New York, New York 10036
(212) 764-5645
FAX (212) 764-5651

International Sculpture Center
1050 17th Street, NW
Suite 250
Washington, DC 20036
(202) 785-1144
FAX (202) 785-0810

Some sculpture-related companies (manufacturers and dealers) have information available on the Internet and can be accessed by computer, searching the World Wide Web, at www.sculpturehouse.com, for one.

How Sculptors' Tools Are Made

There is not enough demand for the many diversified tools used in the sculpture field to mass produce them. All therefore are individually hand crafted, a time consuming and sometimes complicated process. To give users some insight into what it takes to produce a tool, I shall define the production assembly process for tools in each of the basic categories: wire end tools, wood modeling tools, wood carving tools, steel tools, rasps, and stone carving tools. If you are more knowledgeable about the production of these tools you will be better able to care for them and use them more productively.

■ Wire End Modeling Tools

There are three basic steps in making these tools: making the handle, the wire ends, and attaching the ends to the handles.

The Handle

For single wire end tools (cutting wire on one end and modeling tool on the other) and double wire end tools (wire on both ends), the handles are made of wood turned on a lathe in wood turning mills from Vermont, New Hampshire, to Oklahoma. The size of the handle depends on the size of the tool. They are usually round with nipples on one or both ends depending on the style of the tool. The nipples must be ground flat on two sides to enable the wire end to be placed next to the tool handle and the ferrule to be mounted with glue. This is accomplished with a double sided grinding wheel set to the proper dimension of the nipple. The handles are the only part of the tool that is mass produced, although not in great volume. Orders are usually placed for about 10,000 of a single type of handle. For most wood turning mills this is an extremely small order and it is hard to find mills to do the work.

The Wire Ends

The materials of which wire ends are made vary. They can be made of: spring steel, brass, carbon steel, or piano wire. There are about 20 different shapes, and 10 different sizes, formed on a device called a "jig." This is a type of machine with a form made of a steel template in the shape of the wire end tool to be produced. Two butterfly handles are lifted, the proper length of wire is inserted, and the handles

are brought together thus forming the shape of the wire. The wire material is purchased in bulk coils of approximately 2,000 feet. All the wire for each tool must be cut from the same spool. The wire must be cut to the proper length; if it is not and extends too far from the handle of the tool, it will be unusable on clay or plastilina as intended. The wire ends must be flattened, or flared out, so they will grip and not come loose when placed on the tool handle with the ferrule attached. There are circumstances where the teeth are ground into the wire or a sharp cutting edge is required. This work is done before the wire is shaped and attached to the handle. The steel wire ends on some tools must be heated by a propane torch to soften the steel to allow easy forming; you may see discoloration on these tools.

Attaching The Wire

Once the wires are shaped and formed they are attached to the prepared handles with waterproof glue. The tool handle is first placed in a vise that has a plastic guard so the metal of the vise and pressure of gripping the wood will not bruise the handle. Then glue is placed on the end of the handle where the wire will be attached. Finally the wire ends, held together, are placed in a ferrule (a solid spun piece of metal in the shape of a cone that looks like an open ended cap) and attached to the handle by tapping the wire and ferrule level with the handle with a "u" shaped steel tong that fits over the wire end and rests on the top of the ferrule.

When the glue dries, the tool is ready for use. Please be aware that as moisture is absorbed into and evaporated from the wood handle, over time the wire ends may become loose or the ferrule may crack. Unfortunately there is not much we can do about nature so this is a phenomenon all sculptors must deal with.

Modeling tools made with aluminum handles are fashioned in the same manner with the exception of the wire placement. This is done by inserting a metal plug in the handle end, which is hollow, with a hydraulic press compressing the wires under hundreds of pounds of pressure. The resulting flange or webbing is cut off at each end of the tool and the ends are smoothed and polished.

■ Wood Carving Tools

Wood carving tools are manufactured primarily in Europe most of them in Germany, England, but some in Italy. The principal manufacturer in the United States is Sculpture House, Inc. Buck Tools is a specialty tool producer.

The U.S. tools are made from drop forged blanks, forged and ground to specific sizes (measured from left tips to right tips of the blade) and sweeps (depth of a given cutting edge). The steel can be Sheffield (from a steel producing region in England) or high carbon steel, normally 1095C (usually imported from Japan, the most proficient country in quality steel production). The blades are heat treated and tempered either in a salt bath or by oil quenching, depending on the manufacturer. The steel is tempered to a hardness of .59 - .64 Rockwell, and periodically tested on a Rockwell Black Diamond Steel Hardness testing device. After heat treating and tempering, the blades are attached to the handles of the proper size. The tools are generally shipped sharp but not honed (a special razor sharp edge).

Forging The Tool

There are three primary blanks from which all blade sizes and shapes are produced. These blanks are ¼ , ½, and 1 inch in width and all about the same thickness. The blanks are heated in a forge, to an extremely high temperature producing a cherry red color to the steel, and then shaped by heavy duty drop

hammers of 50, 100, or 150 pounds, depending on the amount of steel to be forged. The hammers have a male and a female die the general shape of the tool to be made and the hot steel blank is drawn past the two dies until it is the proper shape. Special care must be taken to keep the surface of the tool even to avoid excessive time in finishing by grinding and wear and tear on the costly grinding wheel.

Shaping/Grinding

The blanks are ground and shaped into final form on high speed grinders using Carborundum wheels. All tools are ground by hand[1] and thus may vary slightly, but not noticeably. The sweep and cutting edge are measured against a template to keep the sizes consistent.

Heat Treating (Tempering) and Honing

After the blades have been shaped the steel must be hardened so it will hold an edge usually either in a salt bath or by quenching in oil. The tool is again heated red hot and then submerged into the liquid bath until the proper hardness is achieved. After the blades have been hardened they are returned to the grinding wheels for sharpening, special care being taken not to remove the temper. (Some carvers sharpen their tools at home on high speed wheels that turn so fast the heat from the wheel removes the hardness in the tips of the tool. This should be avoided at all cost.)

Honing is advanced sharpening, done by hand, that gives the tool edge a razor sharp cutting surface. It takes about 20 minutes per tool. The ends of the tools are then coated with a protective plastic guard that can be removed by tapping the tool on a piece of wood.

[1] Apprenticing as a grinder is approximately six months; to be a full-fledged, competent grinder usually takes about two years. Our craftsmen in this category have an average on the job experience of twenty years.

Attaching The Handle

In attaching the blades to the proper size handle, holes are drilled in the handle so, when the tang of the tool is inserted and hammered true in a vise, the handle will not crack, but will hold the blade firmly. The size of the handle depends on the size of the blade. It would be unusual to have a 3 inch blade attached to a handle meant for a 1 inch blade. Once the handle is attached the tool is ready for use.

■ Stone Carving and Steel Plaster Tools

These tools are made from high carbon steel, generally hexagon in shape. The steel is purchased from the mill in bulk quantities, in long, 10 foot sections. The length of steel required to make a particular tool is then cut to size, the diameter depending on the size and shape of the tool to be made.

Cutting and Forging

The longer lengths of steel are cut on a steel cutting machine with a diamond rotary cutting blade. The sections, cut to lengths of 6 to 10 inches, are placed in a furnace and heated cherry red. Each tool is then hand forged[1] with a 50 or 100 pound hammer. The tool ends are key here since they must be forged to the approximate shape desired before grinding. Tool ends that are too thick or too thin make the grinding process extremely difficult and very time consuming.

Shaping and Finishing

Stone carving tools are shaped to the width desired. For tooth, or rack, tools the teeth are cut after shaping. The tools are then hardened and sharpened, and polished when necessary.

[1] The apprenticeship period for forging is about 8 months with 2 more years experience needed to become a master.

Steel tools are shaped in the same manner except those with flexible palettes. These tools must have the steel drawn out so thin that after grinding the blade will be flexible but still be able to return to its original shape after flexing.

Wood Modeling Tools

Handheld solid wood modeling tools without wire are formed from large blanks of kiln dried wood. These blanks are about 10 feet long by 4 feet wide and usually around 6 inches thick. The larger blanks are cut down with a table saw to thin sections about the size of a ruler in width and about an inch thick, then cut to the approximate size of the tool desired. Each tool is then shaped by hand to the desired design using grinding wheels and sanding belts. Completed tools are coated with a sealant of shellac or wax and are then ready for use.

Plastilina (Oil-Base Modeling Clay), Professional Grade

Basic Ingredients
Plastilina is a mixture of wax, oil, and clay flour binders. The wax is brought to the manufacturer hot in heated tanker cars and pumped into storage containers. The oil, of various types from whale oil, fatty acid, or motor oil, is also delivered by tanker truck, and is pumped into thousand gallon storage tanks. Manufacturers usually have their own private blends of wax and oil. Bulk deliveries help maintain consistency in the composition of these products. Unfortunately the quality of wax and oil may vary with each shipment and the formula should be corrected accordingly. This also applies to oil compatible pigments which are added to the plastilina to give it color and are also purchased in bulk quantities.

Mixing
These primary ingredients in appropriate amounts to achieve specific clay hardness, are heated to a liquid state and then placed hot in a sigma blade mixer, similar to a bakery dough mixer. Generally speaking the more wax and clay flour and the less oil the harder the consistency, the more oil and less wax the softer. The ingredients are mixed for at least 30 minutes, the craftsman continuously scraping down the sides of the mixer during its rotations. When the mixing is complete the hot material is removed to skids for setting and curing and then extruding. Each batch contains about 800 pounds of material.

Extruding
After the plastilina has cooled and has a "set" to it, pieces are separated and run through a double auger extruding machine, similar to a butter extruder. The material is extruded through a die kept hot by heaters and turned out in rounds, which are easier to store. They are stored for about 6 months, giving the molecules time to migrate and form a homogeneous flowing texture. During storage they also acquire a crusty set. The rounds of plastilina are again extruded in a final blending and to remove the set. The plastilina will not get this set again. The extruded material is formed into squares of two pounds each, and boxed twenty two-pound units per case, and is ready for sale.

Aged plastilina and used reground plastilina are valuable commodities. When a professional sculptor passes away, his supply is greatly sought after, fetching usually three to four times the current price. Plastilina does get better with age!

■ Plastilina, School Grade

Basic processes for mixing and extruding are the same; the big difference lies in the ingredients. School grade plastilina is normally only wax and clay flour, is only extruded once, and is not aged.

■ Pottery Clay-Water-Base, Ceramic

Pottery clay is a ceramic, water-base, wheel throwing, and modeling clay. Unlike plastilina this clay is made with water rather than wax and oil. It is generally fired in a ceramic kiln at temperatures above 2,000° so it will vitrify. The piece is then glazed and a decorative and functional piece of pottery is the result. In the United States the raw clay materials are found mostly in Georgia, Tennessee, Ohio, and New Mexico, with a few clay bodies found in California. All clay is mined from the ground, cleaned of impurities, air floated, and then ready for use. Most of these clays cannot be used effectively as stand alone, but are mixed with other clays to form a clay body. The dry clay body is mixed with water to render the material workable, and shaped before drying and firing.

Formulas

A clay body is a mixture of different clays from around the country designed to produce specific textures and colors when fired. These formulas are developed by trial and error; a few ceramists, with knowledge and experience in the field, will have a good idea of what they are doing in developing formulas. All new formulas are tested. This ensures a good fit with certain glazes, either private or commercial, and that the clay will withstand the high temperature firing ranges. Some clays can withstand only so much heat before deteriorating.

Mixing

When the mix of dry clay flour has been decided on, usually by weight per batch (200 pounds of "x", 50 pounds of "y", and 50 pounds of "z", for example), this proportion will be maintained henceforth. Most dry clay flour is packaged in 50 pound bags, making such formulas easy to produce. The dry clay formula is placed in a ribbon blender, that holds about 1,000 pounds of dry material. The dry ingredients are then passed through an auger to a blending machine with heavy duty paddle wheel blades. Water is added (about 25 to 28% by volume per formula) and extruded as the formula is compression-packed to eliminate air that may have entered the mixture. Most large extruding machines can run about four to six tons an hour through the mixing process. The moist clay is packaged in either 5, 25, or 50 pound containers and is ready for use.

Books

Books on sculpture deal with the primary categories of Modeling, Stone Carving, Wood Carving, and Mold Making and Casting and can usually be found in art supply stores or university and larger local libraries. Since the demand for books on sculpture is limited, it stands to reason that there is not a very large selection. In addition, many good reference books have gone out of print because publishers see little profit from them. You may also find that books originally printed in hard cover sometimes become available only in soft cover and at a higher price.

Books on modeling will generally cover working in moist ceramic clay and plastilina. Since the demand for them is greater than books in any other category, the selection is greater. Books on stone carving, wood carving, and mold making and casting are very limited. Books on wood working (for example, cabinet making and chip carving), on the other hand, are a little more extensive.

Sculpture: Principles & Practices by Louis Slobodkin is a comprehensive all-around book on the basic techniques of modeling with a brief section on mold making and casting. It is a good reference book for those who want information quickly presented in one book.

■ Modeling

For creating a figure in clay, Modeling The Figure In Clay by Bruno Lucchesi and Margit Malmstrom is an excellent publication. Mr. Lucchesi is a teacher of the old school. As such, he builds his figure from the inside (bone and muscle structure) out (through the skin and final detailing of the piece). The process of removing the piece from the armature and the firing technique are explained. His work is done in moist clay, which is normally kiln fired or can be cast when hard, but the same principles of instruction apply to creating an oil-base plastilina model. The book's pictures are clear and self explanatory.

In Modeling The Head In Clay, also by Bruno Lucchesi, the reader learns how to create a full-size head from modeling the skull (muscle and skin structure) through finishing the piece with detailed features of the face and hair. This book takes the reader along the steps from placing the modeling material on the arma-

ture to the modeling procedure itself. Its instructions can be applied to both ceramic clay and oil-base plastilina.

■ Mold Making and Casting

To the best of this author's knowledge, only two books on this subject are available. A third was written and published by a man who has died. His estate has prohibited further publication perhaps because of the high cost.

One of the two available books is <u>Mold Making, Casting & Patina for the student sculptor</u> by Bruner F. Barrie. It is a basic primer on the principal techniques of making simple molds such as plaster waste molds, plaster piece molds, and latex molds. It also covers mold making and casting from life with alginate materials, casting in positive rubber, casting the positive, finishing and mounting in gypsum materials (plaster). It contains a section on basic enlarging and bronze casting and good glossary of terms. This is an excellent book for the amateur or beginner sculptor who needs to make simple basic molds without undercuts or complexity. There are many pictures and line drawings, plus the step-by-step mold making and casting methods that are easy to follow.

The book does not go into detail on such subjects as hollow cavity molds or silicone and polysulfide molds since they require advanced techniques and are usually beyond a beginner's capabilities. For these more intricate molds and casting, a professional moldmaker should be consulted.

<u>Methods for MODERN SCULPTORS</u>, by California sculptor Ronald D. Young and Robert A. Fennell deals primarily with the more advanced techniques of bronze casting, venting, and investment. It is highly recommended for the advanced mold maker who is sculpting intricate pieces for production casting. It may be a little too advanced for the novice.

■ Wood Carving and Stone Carving

<u>Carving Wood and Stone</u> by Arnold Prince is a wonderful soft cover "how to" guide to the selection and direct carving of wood and stone. The <u>Book of Wood Carving</u> by Charles Marshall Sayers is a beginner's book on chip relief and form carving and plaque work. It defines the techniques required for wall and flower designs and for a few styles of inlaid work. It is recommended for the basic designer rather than for the in-the-round carver.

<u>Contemporary Stone Sculpture</u> by Dona Z. Meilach is more of a reference book on different styles and finished pieces of sculpture than a detailed instruction book on actual carving methods. It provides a good look at the different effects and techniques that are achievable with different types of stone and styles of carving. It is a great "idea" book, not an instructional reference.

■ Ceramics

<u>Terracotta,</u> another Bruno Lucchesi book, describes how to use terra cotta clay (red clay with grog) to build small figures, heads, and busts for kiln firing. It does not deal with the anatomical details to the extent his other books do, but more with sculpting techniques and design. It is recommended for the sculptor with a knowledge of anatomy who does not require basic build up instruction.

Tool Weights & Dimensions

The following pages contain several tables of tool weights and dimensions. I've designed these tables by category to make it easier for you to find a particular tool. For example, there is a table for modeling tools, another for stone carving tools and yet another for ceramic tools.

Please note, the tools referenced are from the current Sculpture House, Inc. catalog. If you have a catalog, you can locate the tool described in its respective table. If you don't have a catalogue, please write us at 100 Camp Meeting Avenue, Skillman, NJ 08558, and we'll send one out.

Finally, the weights and dimensions of the tools are approximations. Since these tools are hand-made the weights and dimensions may vary somewhat.

Modeling Tools

Tool Type	Item No.	Length	Weight	Handle Diameter	Handle Length	Left Edge	Right Edge
Double Wire End	700	7 ½"	½ oz.	½"	5 ½"	½"	½"
Double Wire End	701	7 ½"	½ oz.	½"	5 ½"	½"	¾"
Double Wire End	702	7 ½"	½ oz.	½"	5 ½"	½"	½"
Double Wire End	703	7 ½"	½ oz.	½"	5 ½"	½"	½"
Double Wire End	704	7 ½"	½ oz.	½"	5 ½"	½"	½"
Double Wire End	705	7 ½"	½ oz.	½"	5 ½"	¼"	½"
Double Wire End	706	7 ½"	½ oz.	½"	5 ½"	½"	½"
Double Wire End	707	7 ½"	½ oz.	½"	5 ½"	½"	½"
Double Wire End	708	7 ½"	½ oz.	½"	5 ½"	½"	½"

Tool Type	Item No.	Length	Weight	Handle Diameter	Handle Length	Left Edge	Right Edge
Double Wire End	709	7 ½"	½ oz.	½"	5 ½"	¼"	¼"
Double Wire End	710	7 ½"	½ oz.	½"	5 ½"	½"	¼"
Double Wire End	711	7 ½"	½ oz.	½"	5 ½"	½"	½"
Double Wire End	712	7 ½"	³⁄₁₀ oz.	½"	3 ¾"	½"	point
Double Wire End	713	7 ½"	½ oz.	½"	4 ½"	½"	point
Double Wire End	714	7 ½"	½ oz.	½"	5 ½"	round	¼"
Tool Set	700AZ Set of 15 tools		7 ³⁄₁₀ oz.				
Single Wire End	750	7 ½"	½ oz.	½"	3 ½"	⁵⁄₁₆"	⁹⁄₁₆"
Single Wire End	751	7 ½"	½ oz.	½"	3"	½"	1"
Single Wire End	752	7 ½"	½ oz.	½"	4"	⁵⁄₁₆"	¾"
Single Wire End	753	7 ½"	½ oz.	½"	3 ½"	½"	¾"
Single Wire End	754	7 ½"	½ oz.	½"	3 ½"	¾"	1"
Single Wire End	755	7 ½"	½ oz.	½"	4"	½"	⁹⁄₁₆"
Single Wire End	756	7 ½"	½ oz.	½"	3"	½"	1"
Single Wire End	757	7 ½"	½ oz.	½"	3 ½"	½"	1 ½"
Single Wire End	758	7 ½"	½ oz.	½"	4"	½"	½"
Single Wire End	759	7 ½"	½ oz.	½"	4"	½"	½"
Single Wire End	760	7 ½"	½ oz.	½"	3"	½"	1 ½"
Single Wire End	761	7 ½"	½ oz.	½"	3 ½"	½"	1"
Tool Set	750AZ Set of 12 tools		6 oz.				
Modeling Tool	269	10"	1 ¾ oz.	¾"	5"	1 ¼"	1 ¼"
Modeling Tool	283	8"	1 oz.	½"	4 ½"	¼"	½"
Modeling Tool	294	11"	2 oz.	¾"	5"	1 ¼"	1 ¼"
Modeling Tool	295	11"	1 ½ oz.	⁷⁄₁₆"	4 ½"	1 ¼"	1 ¼"
Modeling Tool	296	8 ½"	1 oz.	½"	4 ½"	⁹⁄₁₆"	⁹⁄₁₆"
Modeling Tool	297	8"	½ oz.	½"	4"	¼"	⁷⁄₁₆"
Modeling Tool	298	9"	1 oz.	½"	4 ½"	⁹⁄₁₆"	½"
Modeling Tool	299	9 ½"	1 oz.	½"	4 ½"	⅝"	½"
Modeling Tool	311	10"	1 ½ oz.	¾"	4 ½"	⅝"	½"
Tool Set	294AZ Set of 9 tools		11 ¼ oz.				
Modeling Tool	204	10 ½"	1 ½ oz.	¾"	4 ½"	1"	1 ½"
Modeling Tool	206	9"	1 oz.	½"	4 ½"	¾"	1"
Modeling Tool	207	8"	½ oz.	½"	4 ½"	½"	½"
Modeling Tool	208	10"	1 oz.	½"	4 ½"	¾"	¾"
Modeling Tool	220	9"	1 oz.	½"	4 ½"	⁹⁄₁₆"	⁹⁄₁₆"

Tool Type	Item No.	Length	Weight	Handle Diameter	Handle Length	Left Edge	Right Edge
Modeling Tool	240	7"	½ oz.	½"	4 ½"	½"	¼"
Modeling Tool	242	8"	½ oz.	½"	4"	¾"	1 ¼"
Modeling Tool	243	8"	½ oz.	⁵⁄₁₆"	5"	1 ½"	1"
Modeling Tool	244	6"	¼ oz.	¼"	2"	½"	2"
Tool Set	204AZ Set of 9 tools		6 ¾ oz.				
Modeling Tool	203	8 ½"	1 oz.	½"	4 ½"	½"	⁵⁄₁₆"
Modeling Tool	215	8"	½ oz.	½"	4 ½"	½"	½"
Modeling Tool	216	8"	½ oz.	½"	4 ½"	⁷⁄₁₆"	¼"
Modeling Tool	217	8"	½ oz.	½"	4 ½"	⁷⁄₁₆"	⅜"
Modeling Tool	219	9"	1 oz.	½"	4 ½"	⁹⁄₁₆"	⁹⁄₁₆"
Modeling Tool	404A	8 ½"	½ oz.	½"	2 ½"	¼"	2 ½"
Modeling Tool	405A	7 ½"	½ oz.	⁷⁄₁₆"	3"	½"	3"
Tool Set	405AZ Set of 7 tools		4 ½ oz.				
Modeling Tool	205	9"	1 oz.	½"	4 ½"	⁹⁄₁₆"	½"
Modeling Tool	212	9"	1 oz.	½"	4 ½"	¾"	⅝"
Modeling Tool	213	9"	1 oz.	½"	4 ½"	¾"	⅝"
Modeling Tool	214	9"	1 oz.	½"	4 ½"	1"	½"
Modeling Tool	221	9"	1 oz.	½"	4 ½"	⅞"	⅝"
Modeling Tool	222	9"	1 oz.	½"	4 ½"	¾"	⅝"
Tool Set	221AZ Set of 6 tools		6 oz.				
Modeling Tool	209	11"	1 ½ oz.	¾"	4 ½"	1 ¼"	1"
Modeling Tool	210	11"	1 ½ oz.	¾"	4 ½"	1 ¼"	1"
Modeling Tool	211	11"	1 ½ oz.	¾"	4 ½"	1 ½"	1 ¾"
Modeling Tool	218	9"	1 oz.	½"	4"	¾"	⁹⁄₁₆"
Modeling Tool	219A	10"	1 ½ oz.	¾"	4 ½"	1"	¾"
Modeling Tool	401A	13"	1 ½ oz.	½"	4"	1 ¾"	4 ½"
Modeling Tool	402A	11"	1 ½ oz.	½"	3 ½"	1 ¼"	4"
Modeling Tool	403A	10"	1 oz.	⁷⁄₁₆"	3 ½"	¾"	4"
Tool Set	218AZ Set of 8 tools		11 oz.				
Modeling Tool	231	12"	3 ½ oz.	1"	6"	2 ¾"	N/A
Modeling Tool	232	8"	1 oz.	½"	4"	1 ½"	1 ¾"
Modeling Tool	233	14"	3 oz.	½"	5"	3"	5"
Modeling Tool	234	11 ½"	1 ½ oz.	1"	6"	2 ½"	2 ½"
Modeling Tool	235	10"	1 oz.	½"	4 ½"	1 ¼"	2 ½"
Modeling Tool	236	8"	½ oz.	⁵⁄₁₆"	4"	⁹⁄₁₆"	1 ¼"

Tool Type	Item No.	Length	Weight	Handle Diameter	Handle Length	Left Edge	Right Edge
Modeling Tool	237	8"	1 oz.	¾"	4 ½"	1 ¼"	2"
Modeling Tool	238	8"	½ oz.	½"	4 ½"	⅝"	1 ¼"
Modeling Tool	239	6"	½ oz.	½"	4"	1"	1"
Modeling Tool	241	6"	½ oz.	⁵⁄₁₆"	2"	2"	1 ¾"
Tool Set	231AZ Set of 10 tools		13 oz.				
Custom Made Tool	258	7 ½"	½ oz.	½"	6"	⁹⁄₁₆"	1"
Custom Made Tool	259	7 ½"	½ oz.	¾"	4 ½"	2"	2"
Custom Made Tool	280	8"	½ oz.	¾"	3"	2"	2"
Custom Made Tool	284	7 ½"	½ oz.	1"	2"	2"	2 ½"
Tool Set	280AZ Set of 4 tools		2 oz.				
Handcrafted Tool	265	7 ½"	½ oz.	⁷⁄₁₆"	4"	⅝"	1 ¼"
Handcrafted Tool	266	7 ½"	½ oz.	½"	4 ½"	⅞"	1 ½"
Handcrafted Tool	267	8"	½ oz.	½"	4"	1"	1 ¼"
Handcrafted Tool	268	8"	½ oz.	½"	4 ½"	1 ½"	1 ½"
Tool Set	265AZ Set of 4 tools		2 oz.				
Polished Hardwood Tool	260	6 ½"	¼ oz.	¼"	4 ½"	½"	½"
Polished Hardwood Tool	261	6 ½"	¼ oz.	¼"	3 ½"	⁷⁄₁₆"	⁷⁄₁₆"
Polished Hardwood Tool	262	6 ½"	¼ oz.	¼"	4"	point	½"
Polished Hardwood Tool	263	6 ½"	¼ oz.	¼"	3"	1"	1"
Polished Hardwood Tool	264	6 ½"	¼ oz.	¼"	3 ½"	¼"	⁵⁄₁₆"
Tool Set	264AZ Set of 5 tools		1 ¼ oz.				
Polished Hardwood Tool	234	11 ½"	1 ½ oz.	1"	6"	2"	2 ½"
Polished Hardwood Tool	278	11"	1 ½ oz.	¾"	4"	1"	1 ¼"
Polished Hardwood Tool	285	9 ½"	½ oz.	½"	6"	¼"	½"
Polished Hardwood Tool	286	10 ½"	1 oz.	½"	5"	½"	½"
Polished Hardwood Tool	287	10 ½"	1 oz.	½"	5 ½"	1 ½"	⁹⁄₁₆"
Polished Hardwood Tool	288	10 ½"	1 ½ oz.	½"	5 ½"	1 ½"	1 ¼"
Polished Hardwood Tool	289	11 ½"	1 oz.	½"	4"	1"	1 ¼"
Polished Hardwood Tool	290	11 ½"	1 ½ oz.	1"	6"	2"	2 ½"
Polished Hardwood Tool	291	11 ½"	2 oz.	1"	7"	2"	2"
Polished Hardwood Tool	292	11"	1 ½ oz.	¾"	6"	1 ¼"	1 ½"
Polished Hardwood Tool	293	10 ½"	1 ½ oz.	1"	6"	1 ¼"	1"
Tool Set	290AZ Set of 11 tools		14 ½ oz.				
Duron Modeling Tool	400	6"	2 ½ gr.	³⁄₁₆"	5"	³⁄₁₆"	³⁄₁₆"
Duron Modeling Tool	401	6"	2 ½ gr.	³⁄₁₆"	4"	½"	⅛"

Tool Type	Item No.	Length	Weight	Handle Diameter	Handle Length	Left Edge	Right Edge
Duron Modeling Tool	402	6"	2 gr.	¼"	4 ½"	⅛"	²⁄₁₆"
Duron Modeling Tool	403	6"	2 gr.	¼"	4"	¼"	³⁄₁₆"
Duron Modeling Tool	404	6 ½"	2 gr.	¼"	4"	1"	¼"
Duron Modeling Tool	405	6 ½"	2 gr.	¼"	3 ½"	1 ½"	¼"
Duron Modeling Tool	406	6 ½"	2 gr.	¼"	4"	⅞"	¼"
Duron Modeling Tool	407	6 ¼"	2 gr.	¼"	3"	⅜"	¼"
Duron Modeling Tool	408	8"	3 gr.	¼"	4 ½"	⅞"	¼"
Duron Modeling Tool	409	8"	3 gr.	¼"	4 ½"	⁷⁄₁₆"	¼"
Duron Modeling Tool	410	6"	2 gr.	¼"	2"	2"	³⁄₁₆"
Duron Modeling Tool	411	6"	2 gr.	½"	4"	¾"	¼"
Tool Set	400AZ Set of 12 tools		27 gr.				
School Tool	600	7 ½"	1 oz.	¼"	5"	½"	¼"
School Tool	601	6 ½"	1 oz.	¼"	4 ½"	½"	⁵⁄₁₆"
School Tool	602	8"	1 oz.	¼"	5 ½"	⁷⁄₁₆"	½"
School Tool	603	8"	1 oz.	¼"	5 ½"	⁹⁄₁₆"	½"
School Tool	604	6"	1 oz.	¼"	4"	⁷⁄₁₆"	¼"
School Tool	605	6"	1 oz.	¼"	4 ½"	½"	¼"
School Tool	606	6 ½"	1 oz.	¼"	4 ½"	½"	½"
School Tool	607	6"	1 oz.	¼'	4"	½"	⁷⁄₁₆"
Tool Set	6AZ Set of 8 tools		8 oz.				
Clean Up Tool	245A	7 ½"	1 oz.	½"	4"	point	¾"
Clean Up Tool	245B	7 ½"	1 oz.	½"	4"	1"	¾"
Clean Up Tool	245C	7 ½"	1 oz.	½"	4"	1"	⁹⁄₁₆"
Tool Set	245 AZ Set of 3 tools		3 oz.				
Tulon	246A	6"	2 gr.	¼"	4"	point	¼"
Tulon	246B	6"	2 gr.	¼"	5"	¼"	¼"
Tulon	246C	6"	2 gr.	¼"	5"	¼"	¼"
Tulon	246D	6"	2 gr.	¼"	5"	⅜"	¼"
Tool Set	246 AZ Set of 4 tools	6"	8 gr.				
Ceramic Series Tool	100	7"	1 ½ oz.	½"	3"	¾"	1"
Ceramic Series Tool	100A	6 ½"	½ oz.	½"	3"	½"	½"
Ceramic Series Tool	100B	5 ½"	½ oz.	½"	3"	½"	⁵⁄₁₆"
Tool Set	100AZ Set of 3 tools		2 ½ oz.				
Thin Line Tool	608	6"	1 oz.	⅜"	5 ¾"	¼"	¼"
Thin Line Tool	609	6"	1 oz.	⅜"	5 ¾"	³⁄₁₆"	⅛"

Tool Type	Item No.	Length	Weight	Handle Diameter	Handle Length	Left Edge	Right Edge
Thin Line Tool	610	6"	1 oz.	³⁄₈"	5 ¾"	³⁄₁₆"	⁵⁄₁₆"
Thin Line Tool	611	6"	1 oz.	³⁄₈"	5 ¾"	³⁄₁₆"	¼"
Thin Line Tool	*612*	6"	1 oz.				
Tool Set	608AZ Set of 5 tools		5 oz.				
Boxwood Tool	1A	6"	¼ oz	½"	N/A	⁹⁄₁₆"	¼"
Boxwood Tool	2A	6"	¼ oz	½"	N/A	½"	⁵⁄₁₆"
Boxwood Tool	3A	6"	¼ oz	½"	N/A	¾"	¼"
Boxwood Tool	4A	6"	¼ oz	½"	N/A	2 ½"	2"
Boxwood Tool	5A	6"	¼ oz	½"	N/A	½"	⁵⁄₁₆"
Boxwood Tool	6A	6"	¼ oz	³⁄₈"	N/A	¾"	½"
Boxwood Tool	7A	6"	¼ oz	¼"	N/A	1"	1 ½"
Boxwood Tool	8A	6"	¼ oz	⁵⁄₁₆"	N/A	2"	½"
Boxwood Tool	9A	6"	¼ oz	½"	N/A	¾"	¼"
Boxwood Tool	10A	6"	¼ oz	⁵⁄₁₆"	N/A	½"	2"
Boxwood Tool	11A	6"	¼ oz	¼"	N/A	½" point	1" point
Boxwood Tool	12A	6"	¼ oz	⁵⁄₁₆"	N/A	¾"	½"
Boxwood Tool	13A	6"	¼ oz	⁵⁄₁₆"	N/A	1 ½"	¼"
Boxwood Tool	14A	6"	¼ oz	⁵⁄₁₆"	N/A	1 ½"	½"
Boxwood Tool	15A	6"	¼ oz	¼"	N/A	½"	1"
Boxwood Tool	16A	6"	¼ oz	⁵⁄₁₆"	N/A	⁹⁄₁₆"	½"
Boxwood Tool	17A	6"	¼ oz	¼"	N/A	1"	1 ½"
Boxwood Tool	18A	6"	¼ oz	⁵⁄₁₆"	N/A	¾"	1"
Boxwood Tool	19A	6"	¼ oz	¼"	N/A	1"	1"
Boxwood Tool	20A	6"	¼ oz	¼"	N/A	½"	¾"
Boxwood Tool	21A	6"	¼ oz	⁵⁄₁₆"	N/A	½"	1 ¾"
Boxwood Tool	22A	6"	¼ oz	⁵⁄₁₆"	N/A	1"	¾"
Boxwood Tool	23A	6"	¼ oz	⁵⁄₁₆"	N/A	1" point	1 ½"
Boxwood Tool	24A	6"	¼ oz	⁵⁄₁₆"	N/A	¾"	2 ½"
Boxwood Tool	25A	6"	¼ oz	⁵⁄₁₆"	N/A	1"	1 ½"
Boxwood Tool	26A	6"	¼ oz	⁵⁄₁₆"	N/A	½"	1"
Boxwood Tool	27A	6"	¼ oz	⁵⁄₁₆"	N/A	½"	1"
Boxwood Tool	28A	6"	¼ oz	¼"	N/A	1"	1"
Boxwood Tool	29A	6"	¼ oz	¼"	N/A	2"	1 ½"
Boxwood Tool	30A	6"	¼ oz	⁵⁄₈"	N/A	1"	¾"
Boxwood Tool	31A	6"	¼ oz	⁵⁄₁₆"	N/A	1"	1 ½"

Tool Type	Item No.	Length	Weight	Handle Diameter	Handle Length	Left Edge	Right Edge
Boxwood Tool	32A	6"	¼ oz	⁵⁄₁₆"	N/A	½"	½"
Boxwood Tool	33A	6"	¼ oz	⁵⁄₁₆"	N/A	1 ¼"	1"
Boxwood Tool	34A	6"	¼ oz	¼"	N/A	½"	1"
Boxwood Tool	35A	6"	¼ oz	¼"	N/A	1"	1 ½"
Boxwood Tool	36A	6"	¼ oz	⁵⁄₁₆"	N/A	1"	1 ½"
Boxwood Tool	37A	6"	¼ oz.	¼"	N/A	2"	½"
Boxwood Tool	38A	6"	¼ oz.	½"	N/A	⁹⁄₁₆"	1 ½"
Tool Set	38AZ6 Set of 38 tools		9 ½ oz.				
Boxwood Tool	1B	8"	½ oz.	½"	N/A	⅝"	½"
Boxwood Tool	2B	8"	½ oz.	⅝"	N/A	⅝"	⁵⁄₁₆"
Boxwood Tool	3B	8"	½ oz.	½"	N/A	1"	¼"
Boxwood Tool	4B	8"	½ oz.	½"	N/A	2 ¾"	1 ½"
Boxwood Tool	5B	8"	½ oz.	½"	N/A	3"	1"
Boxwood Tool	6B	8"	½ oz.	½"	N/A	1"	½"
Boxwood Tool	7B	8"	½ oz.	⁵⁄₁₆"	N/A	1"	1 ½"
Boxwood Tool	8B	8"	½ oz.	⁵⁄₁₆"	N/A	2 ¾"	1 ½"
Boxwood Tool	9B	8"	½ oz.	½"	N/A	1"	¼"
Boxwood Tool	10B	8"	½ oz.	½"	N/A	¾"	2 ½"
Boxwood Tool	11B	8"	½ oz.	½"	N/A	1 ¼" point	1 ⅛" point
Boxwood Tool	12B	8"	½ oz.	½"	N/A	1"	¾"
Boxwood Tool	13B	8"	½ oz.	½"	N/A	2"	¼"
Boxwood Tool	14B	8"	½ oz.	½"	N/A	¾"	½"
Boxwood Tool	15B	8"	½ oz.	¼"	N/A	⅝"	1"
Boxwood Tool	16B	8"	½ oz.	½"	N/A	¾"	¾"
Boxwood Tool	17B	8"	½ oz.	½"	N/A	1 ½"	2"
Boxwood Tool	18B	8"	½ oz.	½"	N/A	1"	1"
Boxwood Tool	19B	8"	½ oz.	½"	N/A	3"	1 ½"
Boxwood Tool	20B	8"	½ oz.	¼"	N/A	¾"	½"
Boxwood Tool	21B	8"	½ oz.	½"	N/A	1"	3"
Boxwood Tool	22B	8"	½ oz.	½"	N/A	1"	1"
Boxwood Tool	23B	8"	½ oz.	¼"	N/A	1" point	1 ½"
Boxwood Tool	24B	8"	½ oz.	½"	N/A	1"	3"
Boxwood Tool	25B	8"	½ oz.	½"	N/A	1 ¾"	1 ½"
Boxwood Tool	26B	8"	½ oz.	½"	N/A	¾"	1 ½"
Boxwood Tool	27B	8"	½ oz.	⁵⁄₁₆"	N/A	¾"	1 ½"

Tool Type	Item No.	Length	Weight	Handle Diameter	Handle Length	Left Edge	Right Edge
Boxwood Tool	28B	8"	½ oz.	⁵⁄₁₆"	N/A	1 ½"	1 ½"
Boxwood Tool	29B	8"	½ oz.	⁵⁄₁₆"	N/A	2 ½"	1 ¾"
Boxwood Tool	30B	8"	½ oz.	½"	N/A	2"	1"
Boxwood Tool	31B	8"	½ oz.	½"	N/A	1 ½"	2"
Boxwood Tool	32B	8"	½ oz.	⁵⁄₁₆"	N/A	1 ¹⁄₁₆"	½"
Boxwood Tool	33B	8"	½ oz.	⁵⁄₁₆"	N/A	1 ½"	1"
Boxwood Tool	34B	8"	½ oz.	½"	N/A	¾"	1 ½"
Boxwood Tool	35B	8"	½ oz.	⁵⁄₁₆"	N/A	2"	1 ½"
Boxwood Tool	36B	8"	½ oz.	½"	N/A	1 ¼'	2"
Boxwood Tool	37B	8"	½ oz.	¼"	N/A	2"	½"
Boxwood Tool	38B	8"	½ oz.	⅝"	N/A	¾"	1 ½"
Tool Set	38AZ8 Set of 38 tools	19 oz.					
Mini Boxwood Set	MSAZ Set of 12 tools (6") 3 oz.						

Modeling Accessories

Tool Type	Item No.	Inside/Outside	Weight
Aluminum Caliper	3C12	12"	2.6 oz.
Aluminum Caliper	C-12	12"	2 ½ oz.
Aluminum Caliper	C-8	8"	1.3 oz.
Aluminum Caliper	C-6	6"	1 oz.
Proportional Caliper	PC18	18"	8.3 oz.
Proportional Caliper	PC30	30"	11.3 oz.
Proportional Caliper	PC42	42"	1 lb. 5.2 oz.

Tool Type	Item No.	Length X Width	Weight
Flexible Steel Palette	P4	2" x 3"	.1 oz.
Flexible Steel Palette	P5	2" x 4"	.2 oz.
Flexible Steel Palette	P5A	2" x 4"	.2 oz.
Flexible Steel Palette	P6	2" x 4"	.2 oz.
Flexible Steel Palette	P7	2" x 4"	.2 oz.
Tool Set	P4AZ Set of 5 tools		.9 oz.
Finishing Rubber, Medium	P8	3 ½" x 1 ¾"	.4 oz.
Finishing Rubber, Large	P8A	4 ½" x 2 ¼"	.9 oz.
Tool Set	P8AZ Set of 2 tools		½ oz.

Tool Type	Item No.	Length	Diameter	Weight
Almaloy Armature Wire	907A	32'	1/16"	1.9 oz.
Almaloy Armature Wire	907B	20'	1/8"	2.3 oz.
Almaloy Armature Wire	907C	10'	3/16"	5.3 oz.
Almaloy Armature Wire	907D	10'	1/4"	8.8 oz.
Almaloy Armature Wire	907E	10'	3/8"	1 lb. 5.7 oz.

Wax Tools

Tool Type	Item No.	Length	Weight	Handle Diameter	Handle Length	Left Edge	Right Edge
Wax Tool	153	5 1/2"	1 oz.	1/8"	4"	7/16"	1/4"
Wax Tool	154	6"	1 oz.	1/4"	4"	7/16"	5/8"
Wax Tool	155	7 1/2"	1 1/2 oz.	1/4"	5"	1 1/2"	1"
Wax Tool	156	6 1/2"	1 oz.	1/4"	3 1/2"	1 3/4"	1/2"
Wax Tool	158	5 1/4"	1/2 oz.	3/8"	3 1/2"	3/8"	3/8"
Wax Tool	159	5 1/4"	1/2 oz.	3/8"	3 1/2"	3/4"	1/8"
Wax Tool	160	8"	1 oz.	1/4"	3 1/2"	1/4"	1/4"
Wax Tool	161	6 1/2"	1 1/2 oz.	1/4"	4"	3/8"	1/4"
Wax Tool	162	6 1/2"	1 1/2 oz.	1/4"	4"	7/16"	5/16"
Wax Tool	163	7"	1 1/2 oz.	1/4"	4"	7/16"	1/2"
Wax Tool	164	6"	1 oz.	5/16"	3"	1/8"	5/16"
Wax Tool	165	7"	1 oz.	3/16"	3 1/2"	5/16"	3/16"
Wax Tool	166	7 1/2"	1 oz.	1/4"	3 1/2"	2"	1"
Tool Set	150 AZ Set of 13 tools	14 oz.					
Minarette	01	7"	1 oz.	3/16"	5"	11/16"	3/4"
Minarette	02	6 1/2"	1 oz.	3/16"	4 1/2"	3/16"	3/16"
Minarette	03	6"	1/2 oz.	3/16"	3"	1/4"	3/16"
Minarette	04	6 1/2"	1/2 oz.	3/16"	4"	1/8"	1/8"
Minarette	05	6 1/2"	1/2 oz.	3/16"	4"	1/4"	1/4"
Minarette	06	6"	1/2 oz.	3/16"	4"	3/8"	3/8"
Minarette	07	6"	1/2 oz.	3/16"	4"	1/8"	1/8"
Minarette	08	6 1/2"	1 oz.	3/16"	3/16"	1/8"	1/4"
Minarette	09	6"	1/2 oz.	3/16"	3 1/2"	3/8"	1/16"
Tool Set	0AZ Set of 9 tools	6 oz.					

Steel Tools

Tool Type	Item No.	Length	Weight	Handle Diameter	Handle Length	Left Edge	Right Edge
Steel Plaster Tool	62	7 ¼"	1 oz.	¼"	3"	1 ¾"	1 ¾"
Steel Plaster Tool	63	8 ¼"	1 oz.	¼"	2 ½"	2"	2 ½"
Steel Plaster Tool	64	9 ¼"	2 oz.	¼"	3 ¼"	2 ½"	3"
Steel Plaster Tool	69	7"	1 oz.	¼"	3"	1 ¾"	2 ¼"
Steel Plaster Tool	70	7"	½ oz.	¼"	3 ½"	1 ½"	2"
Steel Plaster Tool	71	10"	1 ½ oz.	¼"	3"	2 ½"	2 ½"
Steel Plaster Tool	73	7 ½"	1 oz.	¼"	2 ½"	2"	¼"
Steel Plaster Tool	74	7 ½"	1 ½ oz.	¼"	2 ½"	½"	1 ¾"
Steel Plaster Tool	75	9 ¾"	1 ½ oz.	¼"	3"	½"	2 ½"
Tool Set	64AZ Set of 9 tools		11 oz.				
Large Handmade Tool	38	10 ½"	2 ½ oz.	¼"	4"	2 ¼"	3 ½"
Large Handmade Tool	39	10"	2 oz.	¼"	3 ½"	2 ¼"	3"
Large Handmade Tool	43	10"	2 oz.	¼"	3"	2 ½"	3"
Large Handmade Tool	45	12"	3 oz.	⁵⁄₁₆"	4"	3 ½"	3 ½"
Large Handmade Tool	46	7 "	2 oz.	¼"	4"	1"	1"
Large Handmade Tool	76	13"	2 ½ oz.	¼"	4"	3 ½"	3 ½"
Large Handmade Tool	77	12 ¾"	3 oz.	⁵⁄₁₆"	3 ½"	3 ½"	3 ¾"
Tool Set	46AZ Set of 7 tools		17 oz.				
Fine Steel Tool	32	7"	½ oz.	³⁄₁₆"	4 ½"	¼" point	⁵⁄₁₆"
Fine Steel Tool	33	7"	½ oz.	³⁄₁₆"	5"	¼" point	¼"
Fine Steel Tool	34	7"	½ oz.	³⁄₁₆"	4 ½"	⅜" point	⅜"
Fine Steel Tool	36	7"	½ oz.	³⁄₁₆"	4"	³⁄₁₆"	³⁄₁₆"
Fine Steel Tool	37	7"	½ oz.	³⁄₁₆"	4"	1"	1"
Fine Steel Tool	40	7"	½ oz.	³⁄₁₆"	4 ½"	⅜" point	⅜" point
Fine Steel Tool	41	7"	½ oz.	³⁄₁₆"	3"	³⁄₁₆"	³⁄₁₆"
Fine Steel Tool	42	7"	½ oz.	³⁄₁₆"	4"	¼"	⅜"
Fine Steel Tool	48	7"	½ oz.	¼"	4"	¼" point	½"
Fine Steel Tool	50	7"	½ oz.	³⁄₁₆"	5"	¼"	½"
Fine Steel Tool	52	7"	½ oz.	³⁄₁₆"	3 ½"	⁵⁄₁₆"	½"
Fine Steel Tool	60	7"	1 oz.	¼"	4"	¼" point	1 ½"
Fine Steel Tool	68	7"	1 oz.	¼"	3"	½"	1 ½"
Fine Steel Tool	86	7"	½ oz.	¼"	3"	⅛"	⅜"
Tool Set	50AZ Set of 14 tools		8 oz.				

Tool Type	Item No.	Length	Weight	Handle Diameter	Handle Length	Left Edge	Right Edge
Fine Steel Tool	44	7"	1 oz.	¼"	3 ½"	1 ¾"	1 ¾"
Fine Steel Tool	51	7"	1 oz.	¼"	3"	½"	2" point
Fine Steel Tool	53	7"	1 oz.	¼"	3"	1 ¾"	1 ¾"
Fine Steel Tool	56	7"	1 oz.	¼"	3"	2"	2" point
Fine Steel Tool	57	7"	1 oz.	¼"	3 ½"	½"	5⁄16"
Fine Steel Tool	58	7"	1 oz.	¼"	3"	2"	2 ¼"
Fine Steel Tool	59	7"	1 oz.	¼"	4"	½"	5⁄16"
Fine Steel Tool	61	7"	½ oz.	3⁄16"	3 ½"	½"	½"
Fine Steel Tool	65	7"	1 oz.	¼"	3"	½"	1 ¾" point
Fine Steel Tool	85	7"	1 oz.	¼"	3 ½"	¼"	5⁄16"
Tool Set	85AZ Set of 10 tools		9 ½ oz.				
Professional Steel Tool	81	7 ½"	1 oz.	¼"	3"	2"	1 ¾"
Professional Steel Tool	82	9"	2 oz.	¼"	4"	1"	1"
Professional Steel Tool	170	6 ½"	½ oz.	¼"	4"	5⁄16"	¼"
Professional Steel Tool	172	10"	2 oz.	¼"	3 ½"	1"	¾"
Professional Steel Tool	174	11"	3 ½ oz.	5⁄16"	4"	1"	3"
Professional Steel Tool	179	9"	2 oz.	¼"	3 ½"	2 ½"	2 ¼"
Professional Steel Tool	184	9"	2 ½ oz.	¼"	3 ½"	3"	¾"
Professional Steel Tool	186	8 ½"	1 ½ oz.	¼"	3"	2 ½"	2 ½"
Professional Steel Tool	187	10"	2 ½ oz.	¼"	4"	3"	2 ½"
Professional Steel Tool	188	11"	3 oz.	¼"	4"	3 ½"	3"
Tool Set	188AZ Set of 10 tools		20 ½ oz.				
Cutting & Scraping Tool	223	10"	1 1/2 oz.	½"	4 ½"	1 ¼"	1"
Cutting & Scraping Tool	224	9"	1 oz.	½"	4 ½"	1"	¾"
Cutting & Scraping Tool	225	8"	1 oz.	½"	4 ½"	¾"	½"
Cutting & Scraping Tool	226	9"	1 oz.	½"	4 ½"	2"	2"
Cutting & Scraping Tool	227	9"	1 oz.	½"	4 ½"	7⁄16"	¼"
Cutting & Scraping Tool	228	9"	1 oz.	½"	4 ½"	¼"	¼"
Cutting & Scraping Tool	229	7"	1 oz.	½"	4 ½"	¼" square	¼" round
Cutting & Scraping Tool	230	9"	1 oz.	½"	4 ½"	1"	5/8"
Tool Set	2AZ Set of 8 tools		8 ½ oz.				
Plaster Carving Chisel	83	7"	2 oz.	¼"	4"	7⁄16"	½"
Plaster Carving Chisel	84	8"	1 ½ oz.	¼"	4"	¼"	5⁄16"
Plaster Carving Chisel	87	6 ½"	1 ½ oz.	¼"	4"	5⁄16"	½"
Plaster Carving Chisel	88	7"	1 oz.	3⁄16"	4"	3⁄16"	¼"

Tool Type	Item No.	Length	Weight	Handle Diameter	Handle Length	Left Edge	Right Edge
Plaster Carving Chisel	89	6 ½"	1 oz.	³⁄₁₆"	3"	⁵⁄₁₆"	½"
Plaster Carving Chisel	94	8"	1 ½ oz.	¼"	3 ½"	½"	⁵⁄₈"
Plaster Carving Chisel	95	8"	2 oz.	¼"	3"	¾"	1"
Plaster Carving Chisel	96	8"	2 ½ oz.	¼"	3 ½"	¾"	½"
Plaster Carving Chisel	97	6 ½"	1 oz.	³⁄₁₆"	4"	¼"	⁵⁄₁₆"
Plaster Carving Chisel	98	6 ½"	1 ½ oz.	¼"	4"	⁵⁄₁₆"	³⁄₈"
Tool Set	83AZ Set of 10 tools		15 ½ oz.				

Plaster Tools

Tool Type	Item No.	Length	Weight	Handle Diameter	Handle Length	Left Edge	Right Edge
Plaster Rasp	91	6 ½"	1 oz.	½"	3"	2" flat	1¾" round
Plaster Rasp	92	7 ½"	1 ½ oz.	¾"	3 ½"	2" flat	2" round
Plaster Rasp	93	9"	2 ½ oz.	¾"	4 ½"	3" flat	3" round
Tool Set	91AZ Set of 3 tools		5 oz.				
Plaster Scraper	90A	7 ½"	1 ½ oz.	½"	4"	1 ½" round	N/A
Plaster Scraper	90B	6"	1 ½ oz.	½"	3 ½"	1 ½" round	N/A
Plaster Scraper	90C	7"	1 oz.	3 ¼"	3 ½"	1 ½" curved	N/A
Plaster Scraper	90D	6"	1 ½ oz.	½"	3 ½"	1" curved	N/A
Mold Makers Knife	MM4	4" blade	3 ½ oz.	1"	4 ½"	4"	N/A
Plaster Carving Chisel	MM5	1 ¾" wide	7 oz.	1"	5"	1 ¾"	N/A
Mold Makers Knife	MM6	6" blade	5 ½ oz.	1"	5"	6"	N/A

Wood Carving Tools

In addition to the tools listed below, there are 7 major types of wood carving tools: straight chisel, short bent, long bent, fish tail, straight skew, straight gouge, and straight parting. Each have cutting edges ranging from ⅛" to 2".

Tool Type	Item No.	Length	Weight	Diameter
One-Piece Wood Mallet	H14	9"	12 oz.	2 ½"
One-Piece Wood Mallet	H15	9"	14 oz.	3 ½"
Octagon Handle	H49	5"	¾ oz.	1 ¼"
Octagon Handle	H50	5 ¼"	2 oz.	1"

Tool Type	Item No.	Length	Weight	Diameter
Octagon Handle	H51	5 ¾"	2.3 oz.	⅞"
Leather-Tipped Handle	H50L	5 ¼"	2 oz.	1"
Leather-Tipped Handle	H49L	5"	1 ¾ oz.	1 ¼"
Oversized Handle	OS	6"	3 ¼ oz.	1 ¾"

Tool Type	Item No.	Length	Weight	Handle Length	Left Edge	Right Edge
Wood Carver's Adz	133	14"	14 oz.	12"	1 ¾"	1 ¾"
Wood Carver's Adz	134	13"	12 oz.	12"	flat	1 ½"
Wood Carver's Adz	135	14"	14 oz.	12"	flat	1 ¾"
Wood Carver's Adz	137	14"	18 oz.	13"	3"	2 ¾"

Tool Type	Item No.	Length	Weight	Cutting Edge	Handle Length	Left Edge	Right Edge
Draw Knife	DK9	15"	13 oz.	9 ½" blade	N/A	N/A	N/A
Hook Knife	HK4	7 ½"	4 oz.	3" blade	4"	3 ½"	2 ¾"

Tool Type	Item No.	Length	Weight	Handle Diameter	Handle Length	Left Edge	Right Edge
Straight Chisel	WC6	6"	1 ½ oz.	¾"	3 ½"	¼"v	N/A
Skew	WC5	6"	1 ½ oz.	¾"	3 ½"	⁵⁄₁₆"u	N/A
Parting Tool	WC4	6"	1 ½ oz.	¾"	3 ½"	⁵⁄₁₆"u	N/A
Straight Gouge	WC1	6"	1 ½ oz.	¾"	3 ½"	½"\	N/A
Short Bent Gouge	WC2	6"	1 ½ oz.	¾"	3 ½"	⁵⁄₁₆"u	N/A
Long Bent Gouge	WC3	6"	1 ½ oz.	¾"	3 ½"	⅜"-	N/A
Tool Set	K1 Set of 6 tools		9 oz.				
Straight Chisel	WL5	5"	1 ½ oz.	1"	2"	⅜"-	N/A
Skew	WL4	5"	1 ½ oz.	1"	2"	¼"u	N/A
Parting Chisel	WL1	5"	1 ½ oz.	1"	2"	½"\	N/A
Straight Gouge	WL3	5"	1 ½ oz.	1"	2"	¼"u	N/A
Short Bent Gouge	WL2	5"	1 ½ oz.	1"	2"	¼"v	N/A
Tool Set	K7 Set of 5 tools		7 ½ oz.				
Carving Knife	K111	7"	½ oz.	¾"	4 ¾"	¾"	N/A
Carving Knife	K112	7 ½"	½ oz.	¾"	5 ½"	1 ¼"	N/A
Carving Knife	K117	7"	½ oz.	¾"	4 ¾"	1"	N/A
Tool Set	K111AZ Set of 3 tools						

Tool Type	Item No.	Length	Weight	Handle Diameter	Handle Length	Left Edge	Right Edge
Italian Rasp	R20	11 ½"	3 ½ oz.	¼"	6"	2 ¾"	3" point
Italian Rasp	R21	12"	4 oz.	¼"	6"	2 ¾"	3" point
Italian Rasp	R23	11 ½"	3 ½ oz.	¼"	6"	3" point	2 ½" point
Italian Rasp	R24	10"	2 oz.	³⁄₁₆"	4 ½"	2 ¼" point	2 ½" point
Italian Rasp	R25	10"	2 oz.	³⁄₁₆"	5"	2"	2 ½" point
Italian Rasp	R26	10"	2 oz.	³⁄₁₆"	5"	2 ½" point	2" point
Italian Rasp	R27	8"	1 ½ oz.	³⁄₁₆"	3 ½"	2 ½"	2" point
Italian Rasp	R28	8"	1 ½ oz.	³⁄₁₆"	4"	2" point	2" point
Italian Rasp	R29	8"	1 ½ oz.	³⁄₁₆"	4"	1 ¾"	1 ¾"
Tool Set	R30AZ Set of 9 tools						
Steel Rasp	R31	8"	1 ½ oz.	¼"	4"	2"	1 ½"
Steel Rasp	R32	7 ½"	1 ½ oz.	¼"	3 ½"	2" point	2" point
Steel Rasp	R33	7 ½"	1 ½ oz.	¼"	4"	1 ¾" point	1 ½"
Steel Rasp	R35	7 ½"	1 ½ oz.	¼"	3 ½"	2 ½" point	2" point
Steel Rasp	R36	7 ½"	1 ½ oz.	¼"	3 ½"	2" round	2" flat
Combination Rasp	WR1	8"	6 oz.	N/A	8"	3" half round	3" half round
Combination Rasp	WR2	10"	8 oz.	N/A	10"	4" half round	4" half round
Coarse Rasp - Half Round	HR6H	12"	7 oz.	¾"	4 ½"	6" half round	6" flat
Coarse Rasp - Half Round	HR8H	13"	7 ½ oz.	¾"	4 ½"	8" half round	8" flat
Coarse Rasp - Half Round	HR10H	16"	1 lb.	1"	4"	10" half round	10" flat
Coarse Rasp - Half Round	HR12H	18"	1 lb.	1"	6"	12" half round	12" flat
Knife Rasp	RK6	6"	1 ½ oz.	¼" - ½"	5"	2 ½" round	3" flat
Knife Rasp	RK8	8"	1 ¾ oz.	¼" - ½"	7"	2 ¾" round	4" flat
Round Rasp	RR6	11"	4 oz.	1"	4 ½"	N/A	6" round
Round Rasp	RR8	13"	5 oz.	1"	4 ½"	N/A	8" round
Cabinet Rasp	RC6H	10 ½"	4.1 oz.	1"	4 ¼"	6" half round	6" flat
Cabinet Rasp	RC8H	14"	6.8 oz.	1 ¼"	5 ½"	8" half round	8' flat
Cabinet Rasp	R10H	16"	8.2 oz.	1 ½"	5 ½"	10" half round	10" flat
Cabinet Rasp	R12H	18"	10.4 oz.	1 ½"	6"	12" half round	12" flat
Miniature Steel Rasp	R49	6"	½ oz.	⅛"	4"	¼" point	¼" point
Miniature Steel Rasp	R54	6"	½ oz.	⅛"	4"	¾"	¼"
Miniature Steel Rasp	R55	6"	½ oz.	⅛"	4"	¾" point	¾" point
Miniature Steel Rasp	R66	6"	½ oz.	⅛"	4"	¾" point	1 ¼" point
Miniature Steel Rasp	R67	6"	½ oz.	⅛"	4"	1 ¼" point	¾" point

Tool Type	Item No.	Length	Weight	Handle Diameter	Handle Length	Left Edge	Right Edge
Miniature Steel Rasp	R72	6"	½ oz.	⅛"	4"	¾" point	¾" curve
Miniature Steel Rasp	R78	6"	½ oz.	⅛"	4"	¾" point	1" point
Tool Set	R49AZ Set of 7 tools		3 ½ oz.				
Fine Cut Hand Rasp	R183	6"	½ oz.	3/16"	3 ½"	1" point	1" point
Fine Cut Hand Rasp	R184	6"	½ oz.	3/16"	4"	¾" point	1" curve
Fine Cut Hand Rasp	R185	6"	½ oz.	3/16"	3 ½"	1" point	1 ¼" point
Fine Cut Hand Rasp	R186	7"	1 ½ oz.	¼"	3 ½"	1 ½" point	1 ½" flat
Fine Cut Hand Rasp	R187	7"	1 ½ oz.	¼"	4"	9/16" wide	2" point
Fine Cut Hand Rasp	R188	7"	1 ½ oz.	¼"	3 ½"	1 ½" long	1 ½" point
Fine Cut Hand Rasp	R189	7"	1 ½ oz.	¼"	3 ½"	2"	1 ¾"
Fine Cut Hand Rasp	R190	10"	1 ½ oz.	¼"	4 ½"	1 ½" point	1 ½" knife
Fine Cut Hand Rasp	R191	10"	1 ½ oz.	¼"	3"	1 ¾" long	1 ¾" point
Fine Cut Hand Rasp	R192	7"	1 ½ oz.	¼"	3 ½"	1 ¾" round	2" long
Fine Cut Hand Rasp	R193	8"	1 ½ oz.	¼"	4"	2" curve	2" flat
Fine Cut Hand Rasp	R194	9"	1 ½ oz.	¼"	4"	2"	2" point
Fine Cut Hand Rasp	R195	8"	1 ½ oz.	¼"	4"	1 ¾" round	1 ¾" point
Fine Cut Hand Rasp	R196	6"	½ oz.	3/16"	3 ½"	1" knife	1 ¼" point
Fine Cut Hand Rasp	R197	6"	½ oz.	3/16"	3 ½"	1" curve	1 ¼" point
Tool Set	R97AZ Set of 15 tools		17 ½ oz.				
Rasp Brush	FS1	8"	3 oz.	1"	4"	4"	½"

Stone Carving Tools

Tool Type	Item No.	Length	Weight	Handle Diameter	Handle Length	Cutting Edge
Chisel	SC1	8"	4 oz.	5/16"	7"	¾"
Chisel	SC2	8"	7 oz.	½"	7"	1"
Chisel	SC3	8"	7 oz.	½"	6"	1 ¼"
Chisel	SC4	8"	7 oz.	½"	6"	1 ¼"
Chisel	SC5	8 ½"	7 oz.	½"	8"	½" point
Chisel	SC6	7 ½"	3 oz.	¼"	7"	⅜" point
Chisel	SC7	8"	3 oz.	¼"	7 ½"	¼" point
Chisel	SC8	8 ¼"	3 oz.	¼"	8"	¼" point
Chisel	SC9	8 ½"	3 oz.	¼"	8"	½"
Chisel	SC10	8"	4 oz.	⅝"	7 ½"	½"

Tool Type	Item No.	Length	Weight	Handle Diameter	Handle Length	Cutting Edge
Chisel	SC11	8"	4 oz.	⅝"	7 ½"	½"
Chisel	SC12	8"	2 oz.	¼"	7"	⅜"U
Chisel	SC13	8"	4 oz.	⅝"	7"	9⁄16"
Chisel	SC14	8"	4 oz.	⅝"	7"	¾"
Chisel	SC15	8"	1 oz.	½"	6 ½"	1 ¼"
Miniature Stone Tool	M1	8"	2 oz.	¼"	7 ¾"	¼"
Miniature Stone Tool	M2	8"	2 oz.	¼"	7 ½"	½"
Miniature Stone Tool	M3	8"	2 oz.	¼"	7"	¾"
Miniature Stone Tool	M4	8"	3 oz.	¼"	7"	¾"
Miniature Stone Tool	M8	8 ¾"	2 oz.	¼"	8"	¼"
Miniature Stone Tool	M9	8"	2 oz.	¼"	7"	¼"
Miniature Stone Tool	M12	8"	2 oz.	¼"	7"	¼"U
Miniature Stone Tool	M13	8"	3 oz.	¼"	7"	¼"
Miniature Stone Tool	M14	8"	2 oz.	¼"	7"	½"
Miniature Stone Tool	M15	8"	2 oz.	⅝"	7"	¾"

Tool Type	Item No.	Length	Weight	Length of Head	Handle Length	Left Face	Right Face
Bush Hammer	H1	12"	1 lb. 8.2 oz.	4 ¾"	10 ¾"	1" x 1"	1" x 1"
Bush Hammer	H2	11"	15.3 oz.	4 ¾"	10 ¼"	¾" x ¾"	¾" x ¾"
Bush Hammer	H8	10 ½"	8.5 oz.	4 ¾"	10"	½" x ½"	½" x ½"
Bush & Pick	H3	11"	14.3 oz.	6"	10"	¾" point	¾" x ¾"
Bush & Pick	H9	10 ¼"	7.9 oz.	5 ½"	9 ¾"	½" point	½" x ½"

Tool Type	Item No.	Length	Weight	Handle Diameter	Handle Length	Cutting Face
Frosting Tool	H5	8"	1 lb. 3.5 oz.	⅜" square	8"	⅜" x ⅜"
Frosting Tool	H6	8"	8.5 oz.	¾" square	8"	¾" x ¾"
Frosting Tool	H7	8"	4.8 oz.	½" square	8"	½" x ½"
Hammer	H16H	7 ¼"	1 lb.	1"	6 ½"	1" x 1"
Hammer	H17	8 ¾"	1 ½ lbs.	1 ¼"	7 ½"	1 ½" x 1 ½"
Hammer	H20	8 ¾"	2 ½ lbs.	1 ¼"	7 ½"	1 ¾" x 1 ¾"

Tool Type	Item No.	Length	Weight	Handpiece Diameter	Handle Length
Pneumatic Handpiece	PHP3	6 ½"	1 lb. 3 oz.	¼"	N/A
Pneumatic Handpiece	PHP4	6 ½"	1 lb. 9 oz.	3"	N/A
Pneumatic Wood Carving Tool Set	PWC5		2 lbs. 9.3 oz.		

Tool Type	Item No.	Length	Weight	Handpiece Diameter	Cutting Edge
Pneumatic Hand Tool	WCP1	8 ¼"	9.3 oz.	½" shank	1 ⅜"
Pneumatic Hand Tool	WCP2	8 ¼"	9.5 oz.	½" shank	1 ⅛"
Pneumatic Hand Tool	WCP3	8 ½"	9.5 oz.	½" shank	1 ¼"
Pneumatic Hand Tool	WCP4	8 ¼"	9.4 oz.	½" shank	¾"
Pneumatic Hand Tool	WCP5	8 ¾"	9.2 oz.	½" shank	1"
Pneumatic Tool ½" Shank	PSC15	8 ¼"	9.8 oz.	½" shank	1 ¼" chisel
Pneumatic Tool ½" Shank	PSC14	8 ¼"	9.9 oz.	½" shank	1" chisel
Pneumatic Tool ½" Shank	PSC13	8 ¼"	9.1 oz.	½" shank	½" chisel
Pneumatic Tool ½" Shank	PSC6	8 ¾"	10.2 oz.	½" shank	½" point
Pneumatic Tool ½" Shank	PSC1	8 ¼"	10.1 oz.	½" shank	¾" tooth
Carbide Tip Pneumatic Tools ½" Shank	PCT150C	8"	9.9 oz.	½" shank	½" flat chisel
Carbide Tip Pneumatic Tools ½" Shank	PCT153A	8 ¼"	10 oz.	½" shank	½" tooth chisel
Carbide Tip Pneumatic Tools ½" Shank	PCT151C	8 ¼"	9.5 oz.	½" shank	½" point chisel

Ceramic Tools

Tool Type	Item No.	Length	Weight	Handle Diameter	Handle Length	Left Edge	Right Edge
Loop Tool	PC1	5 ¼"	2 oz.	1"	4"	1 ½" pear	N/A
Loop Tool	PC4	5 ½"	2 oz.	1"	4"	1 ½" triangle	N/A
Loop Tool	PC6	5 ½"	2 oz.	1"	4"	1" circle	N/A
Loop Tool	PC8	6"	2 oz.	1"	4"	1" oval	N/A
Loop Tool	PC9	6"	2 oz.	1"	4"	1 ½" triangle	N/A
Potters Rib	121	4"	1 oz.	2" wide	N/A	N/A	4" straight
Potters Rib	122	5 ½"	1 ½ oz.	2 ¾" wide	N/A	N/A	5 ¼"
Modeling Rib	123	11 ½"	1 ½ oz.	1 ½"	8"	3" x1 ½"	butter knife
Throwing Stick	126	12 ½"	3 oz.	11/16"	10"	2" x1 ¼"	N/A

Tool Type	Item No.	Length	Weight	Handle Diameter	Handle Length	Left Edge	Right Edge
Throwing Stick	127	13"	3 ½ oz.	¾"	10"	3" x ½"	N/A
Toggle Clay Cutter	577	19" wire	½ oz.	⅜"	3"	N/A	N/A
Wooden Potters Rib	116	4 ½"	1 oz.	2" flat	4 ½"	4 1/2"	2"
Wooden Potters Rib	117	4"	½ oz.	2 ¼" flat	3 ½"	2 ¼"	3 ¾"
Wooden Potters Rib	118	7 ½"	1 oz.	1" flat	6 ½"	1 ¼" point	2" teeth
Wooden Potters Rib	119	4"	½ oz.	3 ½" wide	N/A	4"	4"
Wooden Potters Rib	120	4 ½"	½ oz.	1 ½" wide	4"	1 ¾"	N/A

Tool Type	Item No.	Length
Sponge	SP2	2 ¾"
Sponge	SP3	3 ¾"
Sponge	SP4	4 ½"

Tool Type	Item No.	Length	Weight	Handle Diameter	Cutting Edge
Fettling Knife	246	8" notch	1.3 oz.	4"	4" blade
Fettling Knife	247A	8"	1.3 oz.	4"	4" blade
Fettling Knife	247B	8"	1.3 oz.	4"	4" blade
Fettling Knife	247C	10"	1.5 oz.	4"	6" blade
Fettling Knife	247D	12"	1.7 oz.	4"	8" blade

Appendix F • Material Requirements Usage Chart

Model Size	Plastilina per lb.	Moist Clay per lb.	Plaster Powder for Mold Plaster • Water		Plaster Powder for Cast Plaster • Water		Latex Rubber	Paste-maker	Casting Rubber	Casting Fillers Soft • Medium • Hard			White Rubber	Vatican Art	Moulage
HEAD & BUST															
HA-2 13" (½ Life) Head	25 lbs.	25 lbs.	15 lbs.	1 gal.	25 lbs.	2 gal.	1 pt.	1 lb.	2 qts.	0	2-1	1-1	1 gal.	25 lbs.	2 lbs.
HA-3 15" (⅝ Life) Head	30 lbs.	30 lbs.	25 lbs.	2 gal.	25 lbs.	2 gal.	1 qt.	1 lb.	2 qt.	0	2-1	1-1	1 gal.	25 lbs.	5 lbs.
HA-4 20" (Life Size) Head-Bust	35 lbs.	35 lbs.	40 lbs.	3 gal.	75 lbs.	3 gal.	2 qts.	2 lbs.	1 gal.	0	2-1	1-1	2 gal.	75 lbs.	10 lbs.
FIGURE															
FA-1 6" Figure	8 lbs.	8 lbs.	10 lbs.	2 qts.	15 lbs.	3 qts.	1 pt.	1 lb.	1 qt.	0	2-1	1-1	1 qt.	10 lbs.	2 lbs.
FA-3 12" Figure	12 lbs.	12 lbs.	15 lbs.	1 gal.	25 lbs.	2 gal.	1 qt.	1 lb.	1 qt.	0	2-1	1-1	2 qts.	15 lbs.	5 lbs.
FA-4 15" Figure	15 lbs.	15 lbs.	25 lbs.	2 gal.	40 lbs.	2 gal.	1 qt.	1 lb.	2 qts.	0	2-1	1-1	1 gal.	25 lbs.	10 lbs.
FA-5 18" Figure	20 lbs.	20 lbs.	25 lbs.	2 gal.	50 lbs.	4 gal.	2 qts.	3 lbs.	3 qts.	0	2-1	1-1	1 gal.	50 lbs.	10 lbs.
FA-30 30" Figure	60 lbs.	60 lbs.	50 lbs.	4 gal.	100 lbs.	8 gal.	1 gal.	5 lbs.	2 gals.	0	2-1	1-1	2 gal.	100 lbs.	20 lbs.
ANIMAL															
AA-6 6" ANIMAL	3 lbs.	3 lbs.	10 lbs.	4 qts.	10 lbs.	4 qts.	1 pt.	1 lb.	1 qt.	0	2-1	1-1	1 qt.	10 lbs.	2 lbs.
AA-8 8" ANIMAL	8 lbs.	8 lbs.	10 lbs.	4 qts.	10 lbs.	4 qts.	1 qt.	2 lbs.	2 qts.	0	2-1	1-1	1 qt.	10 lbs.	2 lbs.
AA-10 10" ANIMAL	14 lbs.	14 lbs.	20 lbs.	8 qts.	20 lbs.	8 qts.	2 qts.	5 lbs.	3 qts.	0	2-1	1-1	2 qts.	25 lbs.	5 lbs.

FREE FORM Use formula: L x W x H. Apply amounts below in footnote nos. 2,3,and 4 as appropriate.

1. To calculate cubic inches - take height times length times width: H x L x W = cu. In.
2. Plaster powder to water ratio will be approximately two pounds of plaster to one pint of water (H20).
3. One gallon of water weighs 8 lbs., one gallon of rubber weighs 9 lbs., one gallon of casting filler weighs 11 lbs.
4. One cubic inch of plastilina weighs 1 oz., one cubic inch of moist clay weighs 1 oz., all weights are approximate to the ounce.
5. All figures and measurements are based on Sculpture House Inc. materials.

Equivalency Chart

WEIGHTS

Mold Rubber .. 1 quart = 30 cubic inches

Casting Rubber .. 1 quart = 30 cubic inches

Moulage .. 1 pound = 15 cubic inches

PosMoulage ... 1 pound = 10 cubic inches

Moist Clay ... 1 pound = 16 cubic inches

Plastilina .. 1 pound = 16 cubic inches

Plaster Powder .. 5 pounds = 150 cubic inches

Hydrocal Powder .. 5 pounds = 130 cubic inches

Hydrostone Powder .. 5 pounds = 100 cubic inches

Vatican Art Casting Stone ... 5 pounds = 100 cubic inches

Gallon Water .. 1 gallon = 8 pounds

Gallon Rubber - mold or casting 1 gallon = 9 pounds

Gallon Casting Filler ... 1 gallon = 11 pounds

MEASURES

16 ounce = 1 pint
4 quarts = 1 gallon

Glossary of Terms

Abstract Expressionism - Term used to describe free form nontraditional sculpture.

Accelerator - Increases speed of a chemical change.

Acetone - Colorless, volatile, water-soluble, flammable liquid; a solvent for paint and varnish.

Acid Bath - A term used in heat treating and tempering of steel.

Acrylic - A thermoplastic resin, created by mixing proportionate parts of plastic components together, used for cast and molded parts; can be clear or colored.

Adalox Paper - Trade name of Norton Co. Grit paper of Carborundum ranging in mesh from 220 to 1200 used for sanding and finishing. The higher the number the finer the grit.

Adz - Type of double-sided swing tool used to reduce large geometric areas from logs.

Aggregate - Inert rock used to mix with other components to give greater strength, e.g., marble aggregate.

Aging - The process wherein a molecular change occurs with a moist or oil-base clay causing a physical reaction to the nature of the material.

Air Floated - A process that eliminates foreign particles from a clay body making it pure or refined.

Alabaster - A gypsum stone indigenous to Spain, Italy, and the Northwest United States. It can be opaque, translucent, colored, or banded; a dense calcite. A medium grade carving stone.

Albany Slip - Natural clay used in ceramics as a slip for decoration; deep brown in color, it melts above cone 7 and 8.

Alcohol - Colorless flammable liquid used as a thinning agent or solvent; used to thin or remove shellac from a model.

Alcohol Lamp - Used to heat modeling tools for wax detailing; alcohol fueled with wick or possible spout for flame direction.

Alginate - A derivative of marine algae used in mold making and casting; used for small flat items only because of its tendency to tear or rip.

Alkali - Soluble material obtained from plant ashes; primarily a potassium or sodium carbonate.

Alloy - Metal compounds fused together when molten to form bronze for casting. Different component parts will result in different types of bronze.

Almaloy Wire - Pliable aluminum wire used for internal support of sculptures; in gauges 1/16, 3/16, 1/8, ¼, and 3/8 inches.

Alum - Potassium aluminum sulfate used as an astringent.

Aluminum - Malleable light silver-colored metal that resists oxidation (discoloration such as patina).

Aluminum Wire - Pliable aluminum wire used for internal support of sculptures; in gauges 1/16, 3/16, 1/8, ¼, and 3/8 inches.

Amorphous - Having no defined shape or form such as free form sculpture.

Anatomical - Structural make-up of human or animal body parts.

Anneal - To heat and cool steel so that the metal is not brittle.

Anode - The negative terminal of a battery.

Antimony - A brittle crystalline used when working with different alloys.

Apron - Generally cotton duck canvas or leather used for protection against clay plaster and dirt in the classroom or studio.

Arch - To form or bend into a desired shape as in architecture.

Argillaceous - Containing clay or clay minerals.

Arc Welding - Molding steel or metal with electrical current.

Armature - An internal support to hold the outer covering of a sculpture; may be made of various materials such as wood, wax, steel, but generally almaloy or aluminum wire.

Art Plaster - Trade name of U.S. Gypsum Co. A gypsum material with an extremely high absorption rate primarily used in ceramic slip casting molds.

Art School - Trade name of Sculpture House, Inc.; oil-base modeling material of school-grade quality.

Artware - Trade name of Sculpture House Inc.; a low fire ceramic moist clay that vitrifies at cone 04.

Asbestos - An inextinguishable material that separates into long fibers.

Atelier - Studio or workshop, usually of an artist, derived from French.

Autoclave - Super heats steam under extreme pressure for purification purposes.

Aventurine - A type of translucent quartz with traces of mica throughout.

Ball Bearing - A turntable, like a lazy Susan, with hardened steel balls, designed to allow easy movement.

Ball Clay - Base clay for earthenware formulas.

Ball Mill - Grinding device used to mill clay and glazes, with balls rotating in a container.

Banding Wheel - A rotary top on a post or ball bearing that allows clay or a sculpture to be easily turned for working or decorating.

Barium - Silver-white metallic element of alkaline earth; a toxic material used as a pigment or extender.

Basalt Ware - Black stoneware developed by J. Wedgwood.

Base - Holding support for the display of a finished piece of sculpture.

Basic Carving - The primary removal of clay, wood, stone, or other sculpting material to create a basic geometric shape.

Bas Relief - A sculpture that is slightly raised with no apparent undercuts

Bat - Plaster disc or circle used in pottery throwing that allows the potter to remove the piece from the wheel head while still wet, 8, 9, or 10 inches in size, secured with a piece of moist clay.

BAZ - Trade name of Sculpture House Inc.; basic stone carving tool set consisting of five tools and one mallet, in a canvas roll.

Beeswax - A pure yellow natural wax used to dress wood or seal stone sculpture; also used in batik.

Bench Screw - A double screw device that

holds a carving block of wood secure for carving; screws into the block and into the securing device.

Bench Stone - A sharpening stone, possibly of various grits, used to sharpen and hone tools while sitting on a work table.

Bentonite - An absorbing clay used as a filler in clay bodies.

Binder - A clay of wax material that enables other materials to adhere when they normally would not.

Bisque - The first firing of a clay or ceramic piece before glazing. Typical bisque firing is cone 06.

Black Rubber - Also known as "Tuffy," a three-part polysulfide rubber used for professional mold making.

Blanket - A clay cover over the model. After the mold and clay are removed, the mother mold is replaced and a catalytic curing rubber is poured in the resulting cavity between model and mold.

Blanks - In wood and stone carving, pieces of steel not yet forged.

Blistering - Term used when a glaze overheats and causes bubbles to form on the pottery.

Blocked Bust - Head and shoulder showing the basic geometric planes of a figure; usually made of hollow cast plaster.

Blocked Mask - Face mask showing the basic geometric planes of the facial structure.

Block Scraper - Rectangular steel scraping device used in leveling and cleaning molds. Length can vary; can be used with or without teeth.

Bluing - A water-soluble pigment used in the initial cast of a plaster waste mold to alert the mold maker to the closeness of the cast.

Blunger - A mixing machine used for slip and glaze.

Bonded Bronze - A polymer resin mixed with bronze powder to give the feel and simulated weight of a bronze cast without the expense.

Bone Ash - Tribasic calcium from bones calcified in air, used in pottery making.

Bone China - Translucent white china made with bone ash and clay.

Bone Emulsion - Trade name of Sculpture House Inc.; a liquid which when mixed with plaster adds strength to the plaster.

Boneware - Trade name of Sculpture House Inc.; a pure self-hardening clay in red and gray. Used for direct modeling or in plaster press molds.

Books - Instructional or informational publications giving directions or facts directly involving sculpture.

Borax - Material consisting of hydrated sodium borate used as a flux or cleaning agent.

Bowsing/Bousing - Moving an object with the use of a block and tackle.

Boxwood Tool - A modeling tool made of a wood named "boxwood"; in 38 different shapes and several lengths, these tools may or may not now be made of boxwood but of a similar hard wood.

Brass - Alloy consisting of copper and zinc.

Brazing - Joining of metals by use of heat.

Bronze - A combination of copper and tin; the compound may vary in proportions of each.

Bronze Rod - A bronze material used for brazing a joint or doing repair work on a bronze casting.

Brooklyn Mix - Trade name of Sculpture House Inc.; private formula stoneware that turns red-brown when fired to cone 10.

Bruise - Term most commonly used in stone carving. When a piece is dropped on a hard surface, a discoloration or imperfection appears on the surface where the stone made contact.

Brush - A wire or bristle material used in cleaning the interior of molds and in the application of patina on a piece of sculpture.

Bubbling - Caused by the overheating or high

temperature of a kiln during glaze firing of pottery.

Burl - Hard woody hemispherical outgrowth on a tree.

Burlap - An open mesh cloth used in reinforcing molds and sculptures; most commonly impregnated with plaster.

Burma Slip - Slip stone made of Burma stone used for sharpening tools.

Burner - Flame producing burning device such as an oven.

Burnishing - Rubbing in, smoothing, or flattening.

Burnout - The process in which wax is burned from a ceramic shell mold so that molten metal such as bronze may be poured.

Bush Hammer - A cross checked steel hammer used to reduce large sections of stone.

Bush Pick - Tool, one end a bush hammer and the opposite end a straight pick; the striking end comes to a point.

Cabinet Rasps - Medium coarse rasps with teeth attached to a handle of wood; used for reducing and finishing wood and stone.

Cadmium - Ductile malleable material used as a protective coating on steel rasps.

Calcareous - Containing calcium growing on limestone or ground containing lime.

Calcining - Heating to high temperatures for cleaning but without fusing.

Calcium - Silver-white metallic element of alkaline earth.

Calipers - A device of wood or aluminum, generally curved, used for measuring dimensions of a piece for reproduction.

Cape Chisel - A round end stone carving tool used to make gouges or furls like a cornfield.

Carbide - Binary element of carbon with a more electropositive element; extremely hard, brittle metal.

Carbide Tools - Tools with carbide cutting edges brazed and sharpened as tips for longer lasting use without repeated sharpening.

Carburize - To combine or impregnate with carbon; a flame produces the carbon effect on metal.

Carrara - A small town in northeastern Italy where the Carrara marble quarries are found.

Carrara Marble - An Italian stone, in varying grades of color, indigenous to Carrara, Italy; used by Michelangelo

Carving - The act of shaping stone, wood, and plaster by cutting with specially designed tools.

Carving Chisel - A flat, high carbon steel tool, with a flat sharp cutting surface used with a hammer or mallet to carve stone, wood, or plaster. Sweep and width vary with size of the tool and the bevel is at different angles for wood or stone tools.

Carving Tools- Tools used in forming wood, stone, wax, plaster, or clay pieces. Can be made from high carbon steel, most commonly used in wood carving and stone carving.

Case - A container that holds smaller unit sizes; used to carry artists' and sculptors' tools and equipment.

Case Mold - A mold usually constructed as a retaining mold for casting slip.

Casine - A form of paint manufactured for artists.

Cast - A reproduction of an original piece of sculpture in any number of casting materials, most commonly plaster, plastic, or bronze.

Casting - The process that duplicates a model or piece by pouring casting material into a pre- formed mold.

Casting, Investment - Process whereby a model is covered with a ceramic shell investment for the pouring of bronze. This investment or ceramic shell can withstand the high temperature of the molten bronze, whereas other materials cannot.

Casting Plaster - A gypsum product most com-

monly used in casting sculpture. Produced by U.S. Gypsum Co. specifically for casting. It is unlike plaster of Paris which is a commercial more porous plaster used in plasterboard in the housing industry.

Casting Rubber - A latex rubber that is cast into a plaster mold to achieve a positive cast. Flexibility (hardness) from rubber band flexible to wood hard rigid can be increased or decreased by using a filler in proportionate amounts.

Cast Stone - A powder containing marble aggregate and several types of gypsum. When mixed properly with water and cast into a mold, it resembles Noxus marble from Greece.

Cathode - The positive terminal of a primary cell such as a battery. Vital to a sophisticated method for casting metals.

Cavity, Hollow Mold - A type of mold made with a mother mold with a retaining blanket over an original model. Once removed and the outer shell mold replaced, a hollow cavity is formed where a chemically activated rubber may be poured into the resulting hollow cavity thus creating a flexible rubber mold.

Cedar Heights - A natural red clay from the midwest United States mined by and trade name for the Cedar Heights Clay Co.

Cement - A powder of alumina, silica, lime, iron oxide, and magnesia burned together and pulverized to make mortar or concrete.

Centigrade - Temperature range from 0° (freezing) to 100° (boiling). Normally used when casting bronze or polyurethane plastic where temperature will effect the mold material when cast.

Centimeter - Unit of length within the metric system.

Centrifugal - Acting away from the center forcing material outward.

Centrifugal Casting - Small sculpture or cast-ings made with a centrifugal mold by spinning molten material.

Ceramic - A clay material such as earthenware or porcelain made of a non-metallic mineral fired at high temperature.

Ceramic Shell - A slurry coating over a wax model; in the bronze casting process the wax is burned or melted out enabling bronze to be poured, while molten, creating the bronze cast .

Ceramist - A person engaging in ceramics, either casting greenware or making pottery.

Cesta - Nylon reinforced basket or pail with double handles, made of black rubber, used in mold making and casting.

Chasing - Hammering or shaping rough areas or seam lines. Usually associated with bronze work.

Checking - Cracking caused by the absorption or evaporation of moisture in wood products.

Cherry Red - Color of metal achieved in forging or heat treating steel.

Chimney - Flue of an exhaust vent in an oven to release gas and fumes.

Chip Carving - Type of wood working done with handheld palm grip tools.

Chipping- Striking a piece of wood or stone with a tool and/or hammer causing the basic geometric form to change.

Chisel - A stone, plaster, or wood working tool with a flat straight edge. Usually beveled at 45° on one or both sides.

Chromium - Chemical used in electroplating metals.

Chuck - Area that holds the shank or end of a grinding burr or handpiece.

Claw - In stone carving, a tooth chisel or rack.

Clay - Earthen material that is plastic when moist and hard when fired, used in pottery and ceramics.

Clay Bodies - Formulas of different base clays and binders that create moist clays in spe-

cific colors, firing ranges, and consistency. Usually developed by ceramists as private formulas.

Clay Fence - A separating line usually 1 inch high by 1/8 inch wide, used to divide a model into sections for the mold making process.

Clay Flour - Dried and refined air floated natural clay in the dry state (powder). Gathered from primary indigenous regions of the world having specific characteristics particular to earthenware, stoneware, porcelain, etc.

Claystone - Trade name of Sculpture House, Inc. Self-hardening clay with cornstarch hardener and cotton fiber filler to decrease shrinkage and cracking while drying over an armature.

Clay Wall - A separating device in mold making. See Clay Fence

Clay Water - A thin liquid mixture of clay flour and water used as a release in casting and mold making.

Clean Clay - A soft oil-base modeling clay without sulfur.

Clean Up Tools - Different shaped scraping tools used in the removal of seam lines on slip cast pieces.

Cobalt - Greenish blue pigment used in ceramics to color glazes. Contained in silver ore.

Cold Cast - Casting done with plastic polymers or resin. Also casting done with a mixture of bronze powder to simulate bronze.

Cold Pour Rubber - A casting rubber of urethane, usually mixed in three stages using a catalyst that chemically cures rather than air cures. Also known as Black Tuffy, or Cold Pour Mold Rubber.

Colemanite - Hydrous calcium borate having brilliant colors, used in ceramics.

Collet - Device used in securing the shank of different size burrs, either increasing availability or reducing availability, as needed, to fit a handpiece shaft.

Colorado Marble - A white crystalline marble, or Yule marble, of medium hardness with very little veining, indigenous to northern Colorado.

Compound - Mixture of different materials to form a mass used in buffing or polishing. Can be different degrees of coarseness.

Cone - A triangular-shaped heat testing device used in the ceramic firing process. Cones melt at different degrees of temperature indicating the internal temperature of the kiln, and sometimes activating a shut-off device within the kiln to turn the heat off at a specific temperature to prevent over-firing the contents.

Contamination - Occurs when foreign material is introduced to a given process. For example, plaster residue in a clay ceramic piece which causes an explosion in the kiln while firing.

Copper - Reddish metallic element that is malleable, and conducts heat and electricity well.

Core - The center of the mold.

Core Pin - Device that holds the core in place while making a casting.

Cornwall Stone - A type of clay flour used in private or special clay formulas for a specific effect.

Corrosion - A natural hemispheric effect caused by water and oxygen that may result in pitting or discoloration.

Countess - Trade name of H. M. Royal; a clay binder used in the production of plastilina and ceramic clay bodies.

Crackle - A hairline cracking or shattering effect caused by the shrinkage of glaze from pottery and ceramic pieces during firing. Generally caused by incompatibility of the clay contents.

Crawling - Occurs when glaze has been over-applied and runs in pools during the firing process. Or spider web effect or cracking

caused by the improper fit of glaze to the clay. Glaze does not shrink with the clay.

Cream Soapstone - A light, smooth, flawless talc base stone found in India. Has a light pinkish hue.

Crosshatch - Scoring with perpendicular cuts in a checker board fashion, commonly used in wood working or, at times, in stone carving.

Crucible - Container used to hold molten metal for pouring or centrifugal casting.

Crystallization - The act of becoming crystalline in form

Crystal River Marble - White crystalline marble indigenous to northern California. Relatively vein free.

Custom Tools - Tools made to individual specifications to fit a customer's special needs or requirements, used with stone, clay, and/or plastilina.

Damp Closet - A container used to store moist clay to preserve its pliability.

Das Pronto - Trade name of Adica Pongo Inc.; a self-hardening moist pliable material similar to clay, imported from Italy.

De-Air - To remove air from a moist ceramic pottery clay body with vacuum compression.

Decalcomania - Art of transferring pictures from specially prepared paper. For example, transferring decals onto ceramic ware.

Decant - To pour from one vessel to another.

Decomposition - To separate into simpler parts.

Degas - To remove vapor or gas from molten metal before casting.

Dehydration - The removal of bound water.

Della Robbia - Trade name of Sculpture House, Inc. A self-hardening clay that can be fired in a kitchen oven at low temperatures; for decorative use only, nonfunctional pottery.

Denatured - Term describing alcohol which is unfit for consumption due to modification by heating. Used in mold making and casting.

Density - The mass of a substance per unit volume. Usually used in determining amounts of clay required for a project or a piece. Mathematically determine the total cubic inches of the piece to be made (height times weight times depth). One ounce of material equals one cubic inch.

Deoxidation - The removal of oxygen as in reduction firing in ceramics to achieve a specific effect.

Devitrify - To deprive of glassy luster and transparency. To change from a glassy to a crystalline condition.

De-waxing - Removing the wax model from a mold; usually accomplished with heat.

Dextrin - A sticky starch used in adhesives; also used in self-hardening clays.

Die - A device to create multiples of an original by stamping or pressing. Usually made of tool steel with a male and female half.

Dipping - The process in mold making or glazing ceramics in which a piece is submerged to give it a coating.

Dipping Tongs - In ceramics, a tool to hold pottery when dipping it into a glaze solution prior to firing.

Direct Carving - When the final piece is sculpted from an original source, usually in wood, stone, and wax carving.

Direct Metal - Working in metal where no casting is required. Also known as welding or direct molding with sculpt metal.

Dolomite - Ceramic base material used to enhance plasticity in ceramic clay bodies.

Double Wire End - A tool made with cutting wires on each end with a wooden or metal tapered handle to secure the two working ends; used in clay modeling and plaster work

Dover White - Trade name of Sculpture House, Inc. Clay derived from Dover area of England known for its fine talc quality.

Draft - Occurs in kiln firing to control temperature in down draft kilns.

Draw Knife - A flat or concave beveled blade with perpendicular handles so that the blade can be drawn or pulled toward the body of the user. Used in boat making and wood carving.

Dremel Tool - Trade name of Dremel Company. Electrical power tools that turn at high speed in a rotary motion, used for grinding, shaping, and finishing.

Dresden Clay - Trade name of Sculpture House, Inc. An English talc pottery clay that contains grog.

Dryness, Short - When a mixture contains too much clay flour in proportion to its liquid bonding agent, in either water-base or oil-base materials.

Ductile - Capable of being fashioned into a new form, as in aluminum wire or almaloy wire.

Durite Screen-Bak - Screen mesh sand abrasive in sheet form in different grits or grades; used for finishing or sanding.

Duron, Modeling Compound - Plastic air dry oven baked modeling material that can harden in a kitchen oven. Discontinued in the early 1970's for lack of raw materials.

Duron, Modeling Tools - Plastic modeling tools made by injection molding to make different shaped plastic modeling tools. Owned by Sculpture House, Inc.

Dust Mask - Face device, in styles ranging from cotton gauze to cylinder cartridge containers, to protect against inhalation of dust and fumes while mold making and casting.

Dye - A coloration used in waste mold casting to determine when the removal mold is coming close to the cast piece, thus preventing damage to the cast.

Earthenware Clay - Slightly porous clay fired at low temperatures.

Eldorado Stand - Trade name of Sculpture House, Inc. A medium strength modeling stand with gear crank raising and lowering device, three-legged, collapsible, can hold 200 pounds of working material.

Electric Wheel - Potter's wheel run by electricity either at fixed variable speeds or with variable speed foot pedals. May be run with belts or cones; can throw up to 50 or more pounds of clay at one time. Specifications will vary with the manufacturer.

Electrode - A conductor used to establish electrical contact with a nonmetallic part or circuit.

Electrolyte - A nonmetallic electrical conductor in which current is carried by the movement of ions. Used in electroplating castings.

Enameling - Covering, inlaying, or decorating with a colorful surface by fusion of an opaque, nitrous composition to metal.

Epoxelene - A two-part component of plastic or resin base, used for direct casting of sculpture. Used with cold cast bronze when bronze powder is mixed with the resins.

Epoxy Resin - A multiple-part casting material; when mixed with a catalyst, it becomes hard plastic.

Epsom Salt - Colorless white crystalline salt, hydrate magnesium sulfate with cathartic properties. Used with ceramic glaze and in firing techniques.

Extruding - Mixing and forming clay or plastilina into rounds or squares for storage to allow the molecular structure to migrate.

Face Shield - A clear curved plastic protection device with movable shield worn over the head to protect the face and neck from debris while carving stone or wood.

Fahrenheit - A thermometric scale. Boiling point is 212° above zero, freezing point is 32°.

Faience - Earthenware decorated with opaque color glaze.

Fat, Fatty - In working with clay and ceramics, indicates a texture resulting from excessive bentonite or water, making the material dif-

ficult to control.

Fat Oil - Oil derived from animals; has a high acid content.

Feldspar - Constituent of nearly all crystalline rock with aluminum silicates. Used in the ceramic field.

Female - The negative half of a mold or die.

Fettling - Shaping an object.

Fettling Knife - A tool designed to shape and texture models in sculpture and pottery.

Fiberglass - Glass in a fibrous form used in making casts that are light weight but strong.

Fifth Wheel - A heavy gauge ball bearing device from 12 to 36 inches in diameter used to hold and turn heavy pieces of sculpture; sometimes used as a table turning mechanism to rotate live models for sculpture classes. In the early 1900's used to turn trains around to head them back in the direction from which they came.

File - Tool with cutting ridges used to shape sculptures in stone, wood, plaster and resin. These cutting edges are usually cross cut rather than punched, forming small ground cutting surfaces.

Filler - Ingredient which when added to a base material bonds or strengthens the mixture.

Fimo - A self-hardening cellulose body of light weight that dries white.

Fine Cut Rasps - Smoothing and finishing tools that have close cut surfaces for extra fine finishing in the last stages of reduction.

Finishing Material - Sanding, rasping, or buffing compounds used in the final stages of sculpture.

Firebox - Chamber that contains a heated area such as a kiln

Fire Brick - The insulating brick or interior walls of ceramic kilns used in firing pottery.

Fire Clay - Clay that can withstand the high temperatures used in ceramics and pottery. Also used to make fire brick for the interior walls of ceramic kilns.

Firing - The process of heating ceramic clay to a temperature at which the particles merge and become hard. In glazes the dried material liquefies and becomes glasslike when cooled. With clay the material becomes non-porous in its final state, not always necessary when firing pottery.

Firing Range - The temperature that a clay can withstand without distortion or warping either in the bisque or glaze firing; generally in cone ranges 014 to 10, temperatures from 1418° to 2345°. The point at which vitrification occurs (merging of the molecular structure) as stated in cone number.

Firing Scale - The temperatures at which different clays can be fired, given in cone ranges.

Firmer - In wood working a type of chisel with a thin flat blade cut at an angle.

Fish Tail - A wood working tool where the sweep or cutting edge fans out on both sides, resembling a fish tail.

Fissure - Break or crack, in stone carving and sometimes in bronze casting.

Fit, Clay/Glaze - When a ceramic glaze adapts well to a certain clay body without grazing, cracking or pooling. It can be a long experimental process to find a fit, especially with special formula clays and glazes.

Fitch - Section of wood prepared to be dried prior to carving. It is usually sealed and arranged so moisture evaporates naturally to prevent checking (cracking) in the future.

Flaking - Pieces of fired glaze chipping off pottery after firing, usually caused by incompatible clay and glaze.

Flashing - A web-like residue on casting material where the seam lines meet and the casting material has escaped, common in most castings (bronze, slip, and plaster casting). The flashing is removed by cutting, scraping, and finishing.

Flash Point - The temperature at which an

item or material will combust. In sculpture used when working with wax or bronze.

Flat Chisel - A tool with a straight flat cutting edge used in wood and stone carving.

Flaw - Defect in a cast or forging, even a stone, that renders the material unusable.

Flexible Bowls - Rubber bowls of varying diameters and sizes used in mixing plaster for casting and for repair work. Casting material is easily removed by flexing the bowl.

Flexible Mold - A mold that can be removed from a cast by stretching.

Flexible Paint - Paint that expands and contracts with an elastic effect when applied to a rubber casting. Usually sprayed on a movable object where flexibility is desired.

Flexible Pallet - A thin scraping device used in mold making, casting, and ceramics to smooth the surface of wet plaster or moist clay.

Flexite Gelatin - Flexible reusable horsehide glue. Used in the production of hollow cavity molds in the early 1900's; use of the material has been discontinued in mold making and casting.

Flint - Mass hard quartz, used as a binder in clay bodies.

Flourspar - Used as a flux in making glazes.

Fluidizing - Making flow like a liquid, as in mixing plaster or ceramic slip for casting.

Flux - A substance used to promote fusion in ceramic and welding bronze sections of a mold.

Footing - Bottom section of a piece of pottery generally raised from the base of the pot or bowl.

Foredom Tool - Trade name of Foredom Electric, Co. Electric, rotating, variable speed, heavy duty grinding machine with interchangeable handpieces. Motors are available in different R.P.M.'s and horsepower.

Forge - Oven in which tools or metal are heated making them easy to shape to spe-cific designs. The process by which a tool for working in stone, wood, plaster or wax is heated and shaped.

Form - To shape to resemble a vision of thought or sight. Free form is an unconventional shape inspired by an inner vision.

Formula - A combination of different materials blended to achieve a desired effect in clay, wax, plastilina, and glazes.

Foundry - A studio wherein molten metal, usually bronze, is cast into sculpture.

Fracture - To break or go beyond the limits or tolerance of an object, usually occurring in bronze casting or ceramic firing. Can also be a break in a boulder to be used in stone carving.

French Clay - Known to sculptors of the early 1900's as a fine quality smooth modeling clay for marquees or models of their sculpture. Replaced in the 1990's by Hugo Grey Clay.

Frit - A component used in making glaze and glass of varying meshes and colors.

Frosting Tool - Tool with multiple pointed cutting edges on a squared surface, somewhat like a waffle iron, mounted on a hammer type handle. It may vary in dimensions from ½ to 2 inches. Its primary use is to reduce stone for sculpture.

Fuller's Earth - A clay that lacks plasticity, used as a filler in certain clay bodies to bind other plastic clays together.

Furnace - A chamber used to fire pottery or enamels at high temperatures. Also known as a kiln.

Fuse - To join together as in ceramic slip firing of glazeware. Bronze or plaster pieces that cannot be cast in a single piece are fused in sections to make the total casting complete.

Galvanize - To coat iron or steel with a thin layer of zinc.

Gate, Gating - A single vent used to allow gas to escape during casting of sculpture. A series of gates and vents are used with more

difficult pieces where air bubbles may form.

Gating System - Series of vents that allow gases to escape from the mold in the casting process of molten metals to avoid air pockets, damage, or even explosions.

Gauze, Impregnated Plaster - Also known as Paris craft, trade name of Johnson & Johnson, Co.; discontinued since the mid 1980's. Gauze strips impregnated with plaster which when soaked in water, become active and malleable. When set they form a strong hard plaster piece. Also used in the medical profession for plaster casts.

Gelatin - Horsehide glue used in the early 1900's for hollow cavity molds. It has been replaced with chemical and natural rubber materials, such as latex and polyurethane.

Gemstone - A precious or semi-precious stone used in jewelry.

Gesso - Liquid sealer used by artists over canvas for better adhesion of oils and paints. Can also be used in sculpture as a sealer for molds.

Gild - To overlay with a coat of gold, used in sculpture creating a type of patina.

Glass - A transparent or translucent substance consisting of a mixture of silicates. Used in ceramics for glazes.

Glaze - To coat or cover with glass or silicates and pigments that will fuse together for decorative effect on ceramics.

Glue Pot - Heated container used to melt gelatin pellets to a liquid state for mold making in hollow cavity molds.

Gouge - A "U" shaped tool used to cut a furrow in stone or wood. Depth and sweep (width) vary in size.

Granite - Hard natural igneous rock used in building and monuments. Occasionally used by stone sculptors for carving but due to its hardness is not considered a primary carving stone.

Greenware - In ceramics, the first casting of items prior to firing. The items are fragile and porous and the seam lines must be cleaned and repaired before bisque firing.

Grinder - An electric or foot powered device used to shape or sharpen steel tools for stone, wood, and plaster work.

Grog - Fired clay ground to small mesh and added to clay bodies to enhance their strength for working in large pieces; also gives texture. Mesh (granular size) varies from powder to sand grit and larger.

Gypsum - Hydrous calcium sulfate primarily used with plaster products, pottery plaster, casting plaster, Hydrocal, and Hydrostone.

Hacksaw - A thin-blade, hand-held saw for cutting small thin pieces of material.

Hammer - A percussion instrument of soft iron or steel used in sculpture. Designed for use on stone so the impact will not injure the stone.

Handles - Attachments to tools providing a working hand hold and securing hammer heads, wire ends, or wood carving tool blades.

Hand Made Tools - Custom designed modeling or carving tools shaped or fashioned by craftsmen by hand rather than by machine.

Handpiece - In electric or pneumatic usage, the piece of machinery that holds the working blade or tool.

Hard Edge - The tip of a tool or wire that has been hardened or tempered to perform a specific cutting job. Wood carving and stone carving tools have different hardnesses depending on their use.

Hardwood - Wood that has sure hardness greater than that of normal base woods. Lignum vitae, purple heart, and boxwood are hardwoods, whereas walnut, birch, oak, and mahogany are considered base woods.

Heartwood - The center piece of a log.

Heat Treating - A bath or chemical process used to harden steel, such as a salt bath or electrical induction.

Hercules Stand - Trade name of Sculpture

House, Inc. A heavy duty sculpture stand raised and lowered by cranking. Made in the United States, it is the largest stand of its type and can hold up to 750 pounds of working material.

Hollow Casting - Thin layers of casting material built up on the inside of the mold to make a hollow rather than solid casting, in bronze created by the wax thickness but with plaster casting the interior walls are built up to form this hollow casting. Plaster can also be cast solid.

Honing - Razor sharp finishing done by hand or machine as an extra step in the sharpening process. Tools that have been honed are usually covered with a protective plastic that can be removed by striking the edge on wood.

Hook Knife - A knife with a curved cutting edge and severe hook on the tip end. Used to clean horses' hooves in Austria and Germany, but also used in wood carving.

Horse Hide Glue - Gelatin pellets melted to form a glue for mold making in the early 1900's. This material has been replaced by latex and polyurethane rubbers.

Hot Metal Plaster - A gypsum material that can withstand high temperatures, although not so high as to be able to cast bronze. Lead, tin, and pewter can be cast into this plaster material.

Hugo Grey - Trade name of Sculpture House, Inc., sculpture or pottery clay, gray in color, but fires white at cone 6. Replaces French modeling clay as a sculpture material in that it is well suited for modeling since it takes shadows well and is pliable, smooth, and plastic.

Humidity - Is measured by the moisture in the air; it can cause discrepancies in setting or drying times of certain mold making and casting materials.

Hydrocal - Trade name of U.S. Gypsum Co. A strong gypsum material used for casting rather than mold making, stronger than casting plaster but not as strong as Hydrostone.

Hydrostone - Trade name of U.S. Gypsum Co. A gypsum product of the greatest hardness, used for casting only, not mold making.

Igneous Rock - Formed by solidification of molten magma, volcanic rock.

Igniter - Device used to start a kiln (wood or gas) torch.

Impregnated Plaster Gauze - Also known as Paris craft, trade name of Johnson & Johnson, Co.; discontinued since the mid 1980's. Gauze strips impregnated with plaster which when soaked in water, become active and malleable. When set they form a strong hard plaster piece. Also used in the medical profession for plaster casts.

Ingot - Molded block of solid material (lead, bronze, silver, etc.) so fashioned for storage purposes.

Inlay - To rub, beat, or fuse into an incision in wood, metal, or stone.

Insulating Brick - Material made of fired clay, used for walls of an electric or gas fired kiln.

In The Round - Three-dimensional piece of sculpture, generally of stone or wood.

Investment - In bronze casting, an outer layer, slurry, or coating that can withstand the heat of the bronze after the wax model has been melted away.

Iron Oxide - Any of several oxides of iron, used in the ceramic field for glazes.

Italian Tools - The finest tools available, although high in price, have been made by hand for centuries by Italian craftsmen, for example, a handmade rasp where the teeth are punched in one at a time.

Jasperware - Colored stoneware with white raised decorations.

Jig - Device that forms the same shape repeatedly by the use of a die or forming mechanism.

Jigger - A revolving mold on which ceramics are made.

Jolly King - Trade name of Sculpture House, Inc., an oil-base school grade modeling clay that does not contain sulfur.

Junior Power Arm - Bench or table top holding device that secures a piece of sculpture so it can be rotated to various angles. Usually used in wood working.

Kaolin - White clay used in pottery and ceramics as a filler or extender.

Kerf - A width or cut made by a cutting saw or torch.

Key, Key Groove - A square or circular indentation made in or on a mold wall to prevent the halves from shifting while casts are being poured.

Kick Wheel - Potter's wheel turned manually by kicking with the foot. The base of the wheel or flywheel is formed of cement bricks or heavy metal.

Kiln - Gas, electric, or wood burning oven or chamber that can be heated to extremely high temperatures for glazing and firing ceramics or pottery.

Kiln Furniture - Shelves, posts, stilts, and holding devices for pottery and ceramic pieces, used in the firing process of a kiln.

Kiln Wash - Used on the interior walls of a kiln so glazes and clay will not adhere to its shelves or walls. It is a dry material, not meant to wash the kiln.

Kits, Sculpture - Sets of primary tools designed for specific uses in various sculpture fields such as ceramics, wood, stone, and wax.

Knife Rasp - Tooth rasp rounded on one end and shaped like a knife blade on the other, specifically designed and produced for wood and stone sculpture.

Latex - A natural rubber extracted from rubber trees and processed and vulcanized into a paintable liquid; used in mold making.

Lead - Heavy soft malleable ductile metal used in low temperature casting.

Leather Hard - The first stage in drying pottery or ceramics where the outer skin becomes tough but not hard. At this stage, the piece is trimmed or footed before bisque firing.

Leather Tip - Handle of a wood carving tool made of leather to soften the impact of the blow of the carving mallet.

Lignum Vitae - Hardwood from Haiti used to make carving mallets of heavy weight and long durability. Dark outer and light inner characteristics. Availability is like "the fish catch of the day in the Sahara."

Lime - Calcium oxide used with plaster in building materials for strength.

Limestone - Formed by accumulation of organic remains - generally shells and coral. A coarse stone used for carving.

Lithium - The lightest metal known of the alkali group. Sometimes used for casting but its cost is limiting.

Long Bent Tools - Wood carving tools with a long sweeping curved shape that cuts deeply into wood, available in many shapes and sweeps.

Loop Tools - For work in ceramics, tools with heavy wire ends used to cut or trim leather-hard pottery. Available in triangular, square, or snub nose shapes according to function.

Lost Wax - Process in casting where the model is converted into wax and then melted from the mold in which bronze or other casting material will be cast.

Luster - Glow of reflected light or sheen from a type of glaze used in ceramics or pottery decoration.

Luting - Packing a joint or coating a porous surface to make it impervious to liquid.

Majolica - Earthenware covered with a thin opaque glaze for a special effect.

Male - Protruding or positive side of a mold or die.

Malleable - Able to be shaped with mallet or by hand.

Mallet - A striking tool with a rounded head, usually made of wood. Used in wood carving, as opposed to a hammer which is metal and used in stone carving.

Marble - Crystallized calcium carbonate from limestone formed under extreme pressure.

Master Model - In sculpture the original model which has been cast and set aside after producing a mold from which casts are drawn. As the mold deteriorates another mold is made from the master mold and casting continues.

Maturing - Occurs when molecules in a formula have migrated over a period of time to give the optimum performance from the combination of ingredients.

Melting Point - Temperature at which a metal or material will melt.

Metamorphic Rock - Rock with a crystalline content produced by high degrees of heat and pressure.

Microcrystalline Wax - A nut brown wax derived from crude oil; soft medium hardness modeling material also known as Victory Brown wax. Extensively used in casting bronze.

Micro Wax - See Microcrystalline Wax.

Minarettes - Trade name of Sculpture House, Inc. A series of small steel metal tools used for fine detail work in wax, plaster, plastilina, and clay. Available in various shapes, they are hand ground and forged.

Miniature Tools - Trade name of Sculpture House, Inc. Small stone carving tools designed for detail work and finishing. Made of high carbon steel tempered for hard stone.

Mixing Bowls - In sculpture flexible containers made of rubber ranging in capacity from 3 ounces to 5 gallons. Used in mixing plaster or slurry for mold making and casting. Dried plaster will not adhere to the rubber and its flexibility makes the plaster easy to remove. The 3 inch diameter size is most commonly used for repair work, while the 5 gallon size is for batch mixing for casting.

Model - The original sculpture or human model used in making a sculpture. Arguments have raged for years whether or not the actual sculpture, the first cast, or the master is considered the original.

Mold - Hollow cavity produced around a subject for use in creating duplicates of that subject in plaster, bronze, cast stone, etc. The mold is considered the negative and produces a positive cast.

Mold Knives - Heavy steel high carbon knives with four or six inch blades used to remove mold sections, to cut rubber, and to clean mold walls. Handles are made of wood and the blade is continuous through the handle for strength.

Mold Lotion - Liquid separating agent facilitating the easy removal of a cast or separation of the mold from the model.

Mold Making - Constructing a covering, shell, or coating, in single or multiple pieces, from which reproductions of the original can be made.

Mold Rubber - Natural or synthetic rubber used in the mold making process to reproduce multiple, inexpensive, long lasting casts.

Molten - Liquid state gained from heating a metal so it can be poured.

Monochrome - Picture with a single hue.

Monumental - Larger than life, normally applied to sculptures over 8 feet high.

Mother Mold - Outer casing or securing mold to hold rubber to its natural shape when a cast is being poured. Without the mother mold elasticity of the rubber can distort dimensions of the cast.

Mottling - Having spots or blotches on the surface.

Moulage - Trade name of Douglas & Sturgess.

Reusable flexible mold rubber derived from alginate. Used in mold making of the human body and delicate pieces. Moulage can be reused, up to one hundred times without adverse effect, by heating it and adding water.

Negative Space - Areas not used properly resulting in loss of that space, such as air bubbles in bronze and plaster casting.

Nichrome - Metal that can withstand high degrees of heat. Wire used in firing ceramic beads.

Nickel - Metal used extensively in alloys as a catalyst.

Nonferrous - Containing no iron.

Notches - Used in the side walls of a plaster mold to prevent shifting when casting is poured.

Noxious - Harmful to humans.

Ochre - Yellow iron used as a pigment in clays and glazes.

Octagon Handle - Wood handle with 8 sides used for wood carving tools and rasps. The handle's shape gives the user a good grip.

Opacity - State of a substance impervious to rays of light.

Opaque Alabaster - Medium hard grade carving stone, indigenous to Italy and the western United States, through which light cannot pass.

Organic Forms - Containing carbon.

Organic Materials - Materials produced without chemical aid.

Original - First model or cast produced by a sculptor.

Oversized Handle - Large, normally round, handle used for wood carving with the larger sweep tools, generally over 2 inches in diameter.

Oxblood - Reddish medium brown color used as a pigment for glazes.

Oxidation - Color change in metals due to exposure to oxygen; forms a patina or coloration on bronze statues.

Oxide - A binary compound of oxygen with another element.

Ozark Stone - An extremely fine grain sharpening stone from the southern region of the United States used to sharpen wood and stone carving tools.

Pantograph - Machine used in enlarging and reducing sculpture; also known as a pointing machine.

Parting Agent - Spray liquid or paste that assists in the separation of the model from the mold or the cast from the mold.

Parting Tool - A "V" shaped wood or stone carving tool, also referred to as a veiner. Comes in different sizes with varying angles or degrees of slope.

Patina - Coloring of a sculpture in plaster, bronze, plastic, etc. with acids or pigments. Variations are countless due to the variety of color mixes. The natural bronze patina on statues is caused by oxidation and the weather.

Peeling - Occurs when the glaze does not adhere to the clay after firing. Caused by the mismatch of the clay body and glaze formula.

Percussion - Striking or hitting a stone or wood carving tool with force to make it function.

Permeable - A state such that water or moisture can pass through. A clay body is water permeable when it has not vitrified and water leaks through the piece.

pH - Used to express acidity and alkalinity on a scale from 0 to14, 7 being neutral.

Pick - A pointed dual-sided stone carving tool used to reduce a basic geometric stone form rapidly; usually has a long 10- to 12-inch handle. Also called bush and pick.

Pickling - A cleaning process for bronze and other metals.

Piece Mold - Mold made of multiple sections for ease of construction. Generally used

when severe undercuts are present.

Pietrasanta - Small town in northwestern Italy renowned for its sculpture studios and bronze foundries.

Pig - Solid volume of raw material in bulk, facilitating storage by foundries. For example, pigs of bronze.

Pin Holes - Small holes formed on a glazed piece in firing caused by incompatibility of the clay and glaze or by the firing temperature being too low. May also occur when mixing chemically activated, multiple-part rubbers.

Pink Alabaster - Common to the western United States, a light pink medium hard grade stone with minor to medium veining. Sometimes with a crystalline structure and often with iron deposits or fragmentation from dirt.

Pins - Metal or wood dowels that secure a sculpture to the base or pedestal, or hold sections of the sculpture together.

Plasteline - Generic name for oil and wax based modeling clay. See plastilina.

Plaster Of Paris - A generic term for industrial grade plaster or gypsum found in hardware stores. Not recommended for mold making, casting or sculpture, because of its softness and porosity.

Plaster Rasps - Specially designed rasps used for plaster work in sculpture. They are designed to look like a cheese grater so that dried plaster can be removed without clogging the tool.

Plaster Scrapers - Tools for plaster work specially designed to work against heavy resistance in the material. Made of high carbon steel, sometimes with wood handles.

Plaster Tools - Steel tools used in working plaster. They have flexible ends so they can flow with the material when wet.

Plasticine - Generic name for oil and wax base modeling clay. See plastilina.

Plasticity - Resistance and smoothness of a clay body.

Plasticium - Generic name for oil and wax base modeling clay. See plastilina.

Plastic Tools - Low cost injection-molded tools in the primary modeling shapes.

Plastilina - An oil- and wax-base non-hardening modeling material. Comes in two primary grades, professional and school. The professional grade becomes more pliable with age and is sought after by professional sculptors especially after it has been used for 20 or more years. Estates have auctioned quantities of old plastilina at five times its original purchase price. Used material is refurbished by adding oil, wax, and at times clay binders. The professional grade material often contains sulfur which inhibits certain mold making materials, but causes the high quality effect. All pieces created with this material must be cast.

Pliacre - Trade name of Philadelphia Resins. A two-part epoxy resin used for direct modeling.

Pliatex - Trade name of Sculpture House, Inc. Used in mold making and with casting materials such as Pliatex Mold Rubber and Pliatex Casting Rubber.

Plug - Created on the top or sides of a mold for a pouring and for material removal access in the mold making process of larger pieces.

Pneumatic - Operated with air. Pneumatic handpieces are used in sculpture as are rotary sanders that run on forced air from a compressor.

Point - Sharp stone carving tool for quick reduction of mass material from its bulk geometric form. Sizes vary in diameter from 3/8 inch, ½ inch, and larger.

Pointing Machine - Used in duplicating a sculpture or in enlarging and reducing pieces.

Polishing - The final process, if desired, in fin-

ishing a piece of sculpture.

Polychrome - Colorful decorations on pottery created with stains or glazes.

Polymer - A chemical compound made up of repeating structural units.

Polymer Clay - Plastic modeling material that is moist when modeled and can be fired in the kitchen oven to cure and become permanent.

Polysulfide - A compound that contains sulfur atoms.

Polyurethane - Various polymers used in mold making for flexibility and as an elastomer. May also be a type of casting resin.

Pooled Glaze - Caused by a build up of glaze (an excess of liquid on ceramics or pottery) which melts when fired and pools in a settling area.

Pooling - Caused by too great a build up of glaze.

Porcelain - A fine grolegg clay formula which produces an off-white translucent fired clay at high temperatures. The finest ceramic pieces and most difficult to achieve are made of porcelain. Material may be wheel thrown or slip cast.

Porosity - The percentage of moisture absorption capability contained in a material. Term is used in ceramics and plaster working.

Porous - The ability to absorb liquid or moisture.

Portuguese Marble - A lightly veined pink marble with slight fractures and markings, with a high crystalline structure.

Posts - Devices used in kilns to hold shelves when bisque or glaze firing.

Potash - Potassium carbonate from wood ash used in pottery and ceramic glazes.

Potter - A person who makes pottery either by hand or on a kick or electric wheel.

Potter's Wheel - A wheel, either electric or foot-powered, that enables a potter to produce pottery using a flat level rotating disc

head on a circular pipe device.

Pour-A-Mold - Trade name of Permaflex Mold Co. A catalytic setting two-part rubber used in mold making, mix ratio of one part catalyst to one part base rubber. This material can become thixotropic with use of a third setting agent.

Pouring - The process by which a cast is made in a mold, either hollow or solid, in plastic, bronze, or plaster, etc.

Pouring Gate - An extended section at the top of the mold that enables liquid to be poured easily into the mold without losing material.

Pow-R-Tron - Electromagnetic percussion hammer run by electricity used in stone carving. Discontinued in the mid 1970's.

Pressing - Laying clay in a mold to gain a positive by applying pressure and to achieve details of the mold.

Proportional Caliper - Hand held device used to calibrate exactness for enlarging and reducing sculpture. Sizes vary from 18 to 42 inches.

Puddle - Also known as pooling, a build-up of glaze due to its over-application on a ceramic or pottery piece.

Pug Mill - Mixing machine used in pottery to mix and extrude a clay formula from either dry or moist materials.

Pulverizing - Grinding a material to a given screen mesh or fineness. See Grog.

Pumice - A powder that is mixed with water for use in a last abrasive polishing.

Pumicite - A gritty volcanic ash.

Pure Beeswax - Wax extracted from bee hives. It is used to dress wood sculpture, tie dye clothes, and seal wood. Sometimes used as a direct modeling material, but because of its high cost, not often.

Pure Metal - A single nonbonding metal, without alloys.

PVA-Polyvinyl Acetate - Plastic casting resin.

PVA-Polyvinyl Alcohol - Polymerized vinyl compound condensed into a liquid state.

Pyrometer - Device that measures the temperature in a kiln for ceramic and pottery firing.

Quarry - Site where stone is gathered. Stone suitable for carving is found in specific sites in Italy, Western United States, Vermont, etc.

Quench - To cool metal by submersion in oil or water. Term used in the tempering and heat treating process to harden steel tools.

Rack - A drying device or structure for clay pieces not yet fired that allows them to dry with the least amount of distortion.

Raku - Method of firing a special Raku clay body for a desired effect.

Rasp - Hand tool with teeth rather than serrations, used for wood, stone, plaster, or metal. It can be double-ended or single ended with the opposite end attached to a handle. Teeth are hand punched and sharp. Size and coarseness of the teeth vary.

Raw Glaze - Glaze formula component without additives. These are the primary glaze ingredients such as iron oxide, ochre, etc.

Reducing - Taking a large sculpture and making it smaller using a pantograph or reversing the enlarging process.

Reducing Agent - An additive that cuts or thins a base material. For example, shellac is cut by alcohol before applying to a model in mold making.

Reduction Firing - Firing process whereby oxygen is regulated to create a special effect on the fired clay or glaze.

Refractory - Material fired to a high enough level to withstand the high temperatures of firing in a kiln used for shelves and posts.

Regulator - Device that controls the flow of a material into a mold.

Reinforcement - Addition of metal or wood cross sections either on the outside of a mold or in the casting of delicate pieces where ex-tra strength is required.

Relief - Flat one-sided sculpture, also called bas-relief.

Resin - Plastic liquid material designed for casting into specially constructed rubber that can withstand the heat of the curing process.

Respirator - Safety device worn over the nose and mouth to protect the lungs from harmful dust or vapors. Available in a variety of materials and designs.

Retaining Wall - Fence that separates sections of the mold; outside area on a relief mold that restrains mold making material to a given area. Constructed of various materials such as wood, metal, clay, or plastilina.

Rib - Tool used primarily by potters for shaping wet clay that has been thrown on the wheel. Can also be used for leveling or scraping.

Riffler - Small rasp type tool with fine serrated cutting edges used for finishing stone and wood. Also known as a jeweler's rasp.

Rod - Used to strengthen internal sections of a cast. The rod should be non-corrosive so rust will not bleed through the final casting.

ROMA - Trade name of Sculpture House, Inc. Italian formula plastilina made in the United States using the highest grade materials available. Oil- and wax-base modeling material preferred by professional sculptors.

Roman Joint - Square locking section on a model or mold to keep it from shifting. Used by professional mold makers and casters, it is the most difficult joint to make.

Roman Wax - Hard casting wax used for the investment process in the lost wax casting process. Color may vary from purple to black but its brittleness will remain the same. Usually used for fine detailing before casting rather than for direct modeling.

Roughing Out - Creating the basic geometric form from a large natural piece of wood or stone; also applied to clay and plastilina.

Roundel - Round cape-shaped stone carving tool.

Royal Porcelain - Trade name of Sculpture House, Inc. Porcelain clay formula containing English China clay made exclusively in the United States. Clay is fired at cone 10-12 and produces a translucent effect. It is the most difficult clay material to throw or fire due to its delicate nature.

Running - A build-up of glaze that flows beyond desired boundaries. Also known as pooling.

Running Plaster - Liquid plaster poured before the material sets.

Rust - Reddish coating formed on metal that contains iron, caused by moisture. Rods that are galvanized, when inserted into a cast will sometimes rust through the cast plaster piece.

Rutile - Brown, deep red, or black mineral that gives a brilliant metallic luster to ceramics and pottery when fired in a glaze.

Sager - Box made of fire clay where ceramic pieces are fired. A type of fire clay used in producing high fire pottery.

Salt Bath - A procedure in which steel is heated and treated to harden or temper it.

Salt Firing - Process wherein salt is added when firing pottery to create an unusual effect. The salt is added during the glaze firing.

Salt Glaze - Glaze containing amounts of salt to produce a unique effect when fired.

Sand - Granular material caused by disintegration of rock particles; smaller than gravel but larger than silt. Used in clay bodies for strength and texture.

Sand Bag - Canvas bag filled with sand used to hold stone or wood in place when carving it. Sizes vary with the manufacturer. The bags are secured with Velcro or string. The bags are sold empty.

Sand Blasting - Process to clean stone and bronze using high pressure forced air and fine particles of sand.

Sand Casting - One of the older and more difficult methods of making waxes for bronze casting. Specially designed sand is used to pack the model before the waxes form and the pieces go to the foundry.

Sandstone - Sedimentary rock of quartz sand bound by silica or calcium carbonate. Used for buildings and stone sculpture.

Sapwood - Green wood that still contains its original sap.

Scabbing - Occurs when flakes or small pieces of metal fall from an original cast or metal sculpture.

School Tool - Trade name of Sculpture House, Inc. A double wire end modeling tool, moderate in price, designed for use in elementary and college classes.

Scrafitto - Design made in ceramic ware or pottery with specialty tools.

Scrape - To remove material with a sharp edge, either a wire tool or a rectangular steel scraper.

Scrapers - Heavy duty steel tools used to remove rough resistant material such as plaster when working directly or after casting.

Screen - To sieve or run through a mesh to isolate larger particles or to remove unwanted materials from a formula.

Sculpmetal - Trade name of Sculp Metal, Co. A semi-liquid aluminum direct modeling material that when dry hardens like metal. May be polished or left flat. Add patina or leave plain.

Sculptor - A person who creates sculpture.

Sculptor, Academic - A sculptor who is associated with a school, university or academy, who has knowledge based on formal study.

Sculpt Thumb - A modeling tool designed to extend the working ability of the sculptor's fingers or thumb. Shapes and sizes vary depending on the manufacturer.

Sculpture - An object created by a sculptor.

Seam Line - The line where the mold sections join and through which casting material escapes; this line occurs in all types of casting, ceramic, bronze, plaster, etc. and must be removed before firing or finishing.

Sedimentary Rock - A form of organic rock.

Separol - Trade name of Sculpture House, Inc. A releasing agent for use with plaster molds.

Set - The initial hardening of plastilina after mixing and extruding. This hardening must be removed by a second or third mixing prior to packaging.

Setting - The time required for plaster or resin to become solid, but not necessarily cured.

Settling - Occurs when particles added to a liquid drop to the bottom of a container. Plaster sprinkled over water should be left to settle on the bottom of the container to absorb water.

Shank Ring - End of a tool used in wood carving or stone carving, where the tang in front of the blade acts as a stopper when attached to the handle.

Shard - Piece or section of broken pottery, term applied especially to fragments found in archeological digs.

Shell - The outer coating of hard set plaster of a mold. In bronze casting, a ceramic shell into which molten bronze can be poured without damage. Also known as the mother mold.

Shellac - Coating material used in mold making and casting when sulfur modeling material is used. Also used in mold making as a sealer.

Shelves - Ceramic furniture that holds pottery and ceramics when fired; can withstand the high temperatures of the kiln.

Shim - A separating device to divide sections on a model when the mold is to be made. May be brass, wood, tin, aluminum, clay, or plastilina.

Shivering - An effect of glaze on pottery fired at high temperatures; gives an uneven look.

Shore Hardness - Rigidity, flexibility, or hardness of a rubber used in mold making.

Short - Clay or plastilina that is dry and cracks easily when worked, a condition caused by mixing improper proportions of liquid to dry material in the formula.

Short Bent - Wood carving tool with a curved cutting edge like a "u" in the tip of the tool; creates deep quick cuts in wood.

Shrinkage - The percentage a material contracts at different stages of firing. Ceramic clays may shrink up to 20% from the original to the final fired glaze piece.

Silica - Impure forms of salt that generally occur in crystalline stone. Pulverized, it is a bonding agent in ceramic and pottery clay bodies.

Silicone - Rubber from silicone base material and elastomers used in the production of molds to cast polymers or resins. These molds can withstand the heat of the casting materials when they are mixed and poured creating high temperatures due to their natural reaction .

Single Wire End - A modeling tool with only one cutting end; the opposing end acts as an extension of the fingers in modeling.

Sinter - To cause to fuse together with heat, but without melting.

Size - Glutinous material used to fill pores and as a sealer prior to applying gold leaf.

Sketch - Rough design or model of a sculpture used as a guide to create the final work.

Skew - Diagonally cut carving tool for wood with a 45° angle for cross cutting. Sizes vary from 1/8 to 3 inches.

Skimmer - Professional scoop or spoon used to remove air bubbles from the surface of a mixed solution, such as plaster, before casting.

Skin - Thin covering over latex rubber at the initial setting.

Slag - The refuse of metals or ores.

Slake - To treat with water, as in slaking plaster before casting.

Slip - A liquid clay used in casting ceramic pieces before firing. Usually suspended with a binder to facilitate setting.

Slip Casting - Process in which slip is poured into a mold and left to set to form a layer that can be removed and fired.

Slurry - A liquid composition used in ceramic shell casting. The wax is coated with the material before being burned out so the bronze can be cast.

Smooth-On - Trade name of Smooth-On. A white polyurethane two-part mold rubber chemically activated for use in hollow cavity molds. May be thixotropic.

Soapstone - The softest carving stone, also known as talc block or ore. Available mostly in green and black. Also known as serpentine, Eskimo stone, and steatite.

Soapstone, Black - Extremely hard talc base stone indigenous to Virginia; polishes to a deep black color.

Soda Ash - Sodium carbonate used in ceramic glazes.

Sodium Chloride - Salt.

Solder - A fusing alloy of lead and tin used to join metal.

Soldering - Joining sections together with a soldering gun or by welding with a torch. To attach sections of a sculpture after they have been cast; to rejoin.

Spatula - Flexible oval or round steel tool varying in size, used to smooth models or casts and interior mold wall sections.

Spodumene - Emerald green monoclinic mineral used in ceramic glaze.

Sponge - Natural or synthetic absorbent material used for smoothing and water absorption in pottery and ceramics.

Spraying - Using an air powered tool to coat pottery with glaze or spray rubber in mold making.

Springwood - Soft porous section of wood that develops early in the growing season on the annual ring.

Spur - Hole through which liquid enters the major cavity of a mold when poured into a gate.

Stacking - Process of loading a kiln for firing, placing ceramic ware so it is not inadvertently affected by other pieces.

Stain - Used in ceramics and pottery to give a dull or matte effect in firing. Also used in patination applications as a base coloring.

Steatite - Harder form of soapstone but with the same talc base.

Steel - Iron alloyed with carbon. Creates a hard cutting material with hardness determined by the carbon content; 1095C high carbon steel is used for stone and wood carving tools.

Steel Tools - Sculptors' tools made of high quality steel shaped and formed for specific uses in working with plaster, wax , and clay.

Steel Wool - Various grades of fine to coarse soft steel shavings used in smoothing and finishing wood, stone, and bronze sculpture.

Stilts - Steel- or ceramic-pronged holding devices used to support glazed pottery when being fired to prevent the glaze from sticking to the shelves.

Stone, Carborundum - A polishing or finishing material made of Carborundum.

Stone Carving - Shaping a stone into a piece of sculpture either by hand or with pneumatic tools.

Stone Carving Stand - Heavy duty wood stand used to support large pieces of stone for carving, usually with a concave resting area on which the stone can be rotated.

Stoneware - Ceramic clay fired to high temperatures and becoming non-porous; a harder material than the earthenware clay bodies due to the fermentation and sedimentation of its base ingredients.

Stop Cut - A cross section cut in wood and stone perpendicular to the grain or a cut that stops the normal progression of removal of wood in a specified area.

Straight Gouge - Wood or stone carving tool with a straight flat edge, stone carving tool most likely beveled.

Stratification - Forming layers in casting, generally caused by pouring noncontinuously so the levels cool at different times.

Streaking - Heavy or off-balance coloration in a material, patina, or cast caused when the ingredients have not been properly mixed.

Strike - To hit with a hammer or mallet to remove material from a given area.

Studio - Where amateur or professional sculptors work. Also known as an atelier, from the French.

Stun - Shock treatment, as in dipping hot metal in oil or water in heat treating and tempering.

Styrofoam - Polystyrene plastic of different densities used for casting and direct modeling because of its light weight.

Summerwood - Heavier, less porous part of the annual ring of wood formed during the summer months.

Sweep - The degree or angle of the cutting edge of a tool.

Symposium, Sculpture - Meeting of sculptors, teachers, and students to discuss and demonstrate sculpture techniques. Johnson Atelier regularly sponsors such events.

Synthetic Beeswax - Artificial wax made with oil, with the characteristics of natural beeswax, and costing far less.

Tacky - Not yet dry or set. A sticky state of rubber before setting or curing.

Talc - Magnesium silicate used in various ceramic and pottery formulas as a binder for plasticity. The base of soapstone ore used in carving. The base ingredient of baby powder.

Tanol - Trade name of Sculpture House, Inc. Releasing agent for plaster molds.

Tapdrill - Tool used to make an initial hole or indentation; used in mold making or wood sculpture.

Tare Scale - Scale used to determine tare, the weight of a material found by deducting the weight of the container holding the material from the total weight. Used with polyurethane rubber mixes.

Temper - Hardness of steel when the molecular structure has been altered by heat.

Temperature - Degree of heat an object or container can withstand, as the temperature of a kiln for firing pottery or rubber for casting resin.

Tempering - Process in which steel carving tools are hardened. Under heating treatment, the molecules merge to form a hard material.

Template - Device that copies an original, used as a master form.

Tensile Strength - Strength of an object beyond which applied pressure will cause it to break. Hardness of fired clay and cast plaster objects.

Terra Cotta - An orange red color in sculpture; a red clay with grog or a base color for patina.

Texture - Visual or tactile surface of a body or substance; the feel of a certain material. One textures sculpture in a cutting fashion.

Thermal Shock - Stress or reaction caused by heating. May affect clay when firing or steel carving tools when being tempered.

Thermocouple - Used in a kiln to measure the temperature of the interior so one can adjust it as required.

Thinning - Diluting a base component part by mixing with a reducing agent, as shellac mixed with alcohol.

Throwing - Producing pottery on a potter's wheel (electric or kick wheel) by centering

and forcing the clay to take a desired shape as the wheel turns.

Tiger Eye - A hard alabaster stone from Sicily with gray, yellow, or red markings like a tiger's eye.

Tin - Low melting alloy that is malleable at ordinary temperatures. Used as a component with bronze and lead. Used as a filler and bonding agent.

Tin Oxide - Powder polishing compound that creates a deep luster finish.

Titanium - A strong metallic element used as a binder in refractory materials such as in kiln shelves and posts.

Tongs - Tool used to securely hold a material or ceramic piece while working on it when hand holding it is not feasible.

Tooth - That part of a stone carving tool that cuts a small section; also known as the cutting part on a rack or claw chisel.

Torch - Flame producing device used in wax working and bronze casting; its fuel base is alcohol or propane.

Trailing - Adding a layer or coating of slip or glaze over a ceramic or pottery piece for decorative purposes.

Translucent - Able to transmit light, as in translucent alabaster, a carving stone.

Trimming - Cutting clay away from a piece of pottery or from a footing on a bowl in the leather-hard stage before firing and glazing.

Trimming Tools - Tools designed for trimming pottery.

Triple Beam Balance - Scale used in measuring gram amounts of chemicals and glaze materials for formulas. Most accurate commercial scale used in ceramics.

Tulons - Trade name of Sculpture House, Inc. Wooden tools for burnishing and shaping clay.

Tungsten Carbide - High melting ductile metal used in hardening steel.

Turnette - Small round turntable for working with smaller ceramic objects and sculpture.

Turning - Process by which a piece of wood is shaped on an electric lathe.

Turning Tool - Long-handled high carbon steel wood working tool used to reduce wood forms to the desired effect on a lathe.

Turntable - Platform, generally round, made of wood or metal that turns as one decorates pottery or ceramics. Larger tables on ball bearings are used for large pieces of sculpture.

Umber - Brown earthen mineral used in coloring glaze and clay in ceramics and pottery.

Undercut - An overhang or protrusion of a relatively smooth plane that hinders removal of the mold. Undercuts must be worked around when mold making and casting.

Urethane - Ethyl ester of carbonic acid used as a solvent in an anti-plastic agent. Used in molds and casting material.

"V" Tool - Parting or veining tool used in wood working at 45 and 60 degree angles for furrowing in wood and stone.

Vacuum - State resulting from the removal of air from rubber or clay before use to avoid air bubbles in the final piece.

Vanadium - Polyvalent metallic used as an alloy as in vanadium steel.

Vapor - Gaseous state as opposed to a solid or liquid state.

Variation - The extent to which items or masses may differ. Raw materials used in formulas, for instance, may vary in quality from year to year depending on the mining level.

Vatican Art Casting Stone - Trade name of Sculpture House, Inc. Artificial casting stone made of gypsum and aggregate to simulate marble. Available in different base colors.

Vent - A channel or opening in a mold through which air and gases may escape thereby preventing damage to the cast or air pockets in the cast.

Vermiculite - A moisture absorbing silicate

used as a filler in clay bodies.

Vermont Marble - A hard, white, vein-free marble from Vermont; Barry, Vermont is its center of production.

Vibration - When pouring rubber or plaster, a process of shaking the mold or container to eliminate air bubbles in the rubber or plaster.

Victory Wax - Soft brown wax or Microcrystalline Wax used in bronze casting and direct modeling. Derivative of petroleum.

Viscosity - The rate of flow at which a liquid follows a given path. In sculpture, applied to molten bronze, other castable metals, and plaster.

Vise - Gripping device with jaws to secure a piece of sculpture or wood that is being worked.

Vitrification - The process by which a clay body is heated until it becomes non-porous.

Volatilize - To cause to pass off in vapor.

Volcanic Ash - Produced by volcanic eruption, a material used in ceramic glaze formulas.

Volume - Amount of space occupied by a model measured in cubic units. To find the required amount of clay or plastilina for a model, multiply the area's length times width times depth to get cubic inches; using the ratio: one cubic inch to one ounce of material, calculate the total number of ounces required to make the model. For example, if a cavity of a mold is 5" X 5" X 5" (or 25 cubic inches), you will need 25 ounces of material to fill the cavity.

Warping - Distortion caused by moisture or lack of moisture in wood, and by overfiring in ceramics.

Water Glass - Silicate of sodium and water, used as a protective coating.

Wax - Substance derived from petrolatum refined to be soft, pliable, used for modeling and casting.

Wax, Positive - Wax cast from the mold that will be invested or coated with slurry then melted out. A bronze cast will result when molten bronze is poured into the cavity.

Wax Resist - In pottery and ceramics, the wax coating applied to the interior of kiln walls so glaze will not adhere to the walls in firing.

Wax Tools - Steel tools designed and produced for working with wax. They absorb heat and are especially shaped for their functions.

Weathering - Process of aging outdoors resulting in various colors or patina. Effects will differ depending on geography and climate.

Wedges - Triangular shaped wooden pegs that help secure the tightening of mold straps when casting large pieces.

Wedging - Cutting or rolling a clay body to force out internal air which can cause an explosion or damage when the clay is fired.

Wedging Board - Plaster based slab with a wire cutting device at a 45° angle for cutting pieces of clay to be wedged. May also be made without the cutting wire.

Wedgwood, Josiah (1730 -1795) - Prominent English potter and manufacturer instrumental in raising the manufacture of pottery and china to a fine art.

Weld - To bring separate parts together, as in jointing plaster, wax, clay, or bronze sections to form a completed piece.

Wet-Dry Paper - A finishing material of Carborundum made in different coarsenesses from extra fine to coarse, used with water or dry. Used in one of the final steps in polishing stone.

White Lead - Highly toxic powder or paste with great binding ability. Sometimes used in ceramic glazes and house paint.

White Rubber - A two-part polyurethane rubber with a catalyst setting agent used in making rubber molds.

Whittler - One who works on handheld wood pieces with a small knife.

Wonder Stone, African - An extremely soft (metamorphic) stone, dark gray or black in color, at times with a reddish tint. The color is solid and there is no veining.

Woodcarver - Person who carves wood in three dimensions with tools and a mallet.

Woodworker - Person who works wood either by handheld or powered tools, as a cabinet maker, wood turner, etc.

Zinc - Metallic element of intermediate hardness that becomes ductile with slight heating.

Zinc Oxide - An infusible white solid used as a pigment in compounding rubber and ceramic glaze.

Zirconium - Metallic element with a high melting point and resistant to corrosion. Used in refractory shelves and posts in the ceramic industry.

Index

Please refer to the appendixes (pages 67-104) and glossary (pages 105-129) for additional information.